Over time the boundaries between Japanese and Western fashion styles merged into what is referred to as *Wa-mono*: traditional Japanese items such as kimono obi belts, kanzashi hair pins or geta sandals combined with Western clothes. Even old second-hand kimonos were transformed into more modern-looking skirts. This trend was closely followed by tracksuits which kids would mix and match with the clothes that they wore during exercise classes at school. This tracksuit fashion was very simple but often combined with elaborate accessories such as toys and intricate plastic rings which created a harmonious jingling sound when heard from a distance. This additional visual and musical dimension was referred to as *Decora*.

As these various styles and trends have developed (including Second-Hand Fashion, Cyber Fashion and Wire Accessory Fashion), other more obviously Western-influenced trends have gained dominance. Boys in particular have appropriated American sportswear to create what is known as the *Urahara* look and a whole host of Japanese fashion brands that originated from the hardcore music scene have become prominent. Lately however, this street revolution has increasingly revolved around the Second-Hand Fashion trend and some of the more extreme looks are disappearing.

This is not the only threat to Japanese street fashion. In 1999 *Hoko-ten* (meaning pedestrian paradise) was closed. It used to be the case that cars were not allowed in the main streets of Harajuku on Sundays, and that the entire area became home to fashion designers, underground culture and creative people of every kind. It was here that kids deemed a little strange, different or weird were accepted. Now that Hoko-ten has disappeared, Harajuku is unable to cope with the sheer numbers of teenagers who gather together at the weekends and so is beginning to lose its traditional reputation for tolerance. In my opinion this is a great loss to Japanese culture as a whole. Already street fashion is becoming plainer with new influences such as Casual Fashion gradually becoming accepted. Are we to be swallowed up into this boring, mundane, grey society? It is in an attempt to fight this threat to the street culture of Japan that I actively document street fashion, in order to prevent the images in this book, not the photographs themselves but the energy and creativity that is captured within them, from becoming part of a nostalgic past.

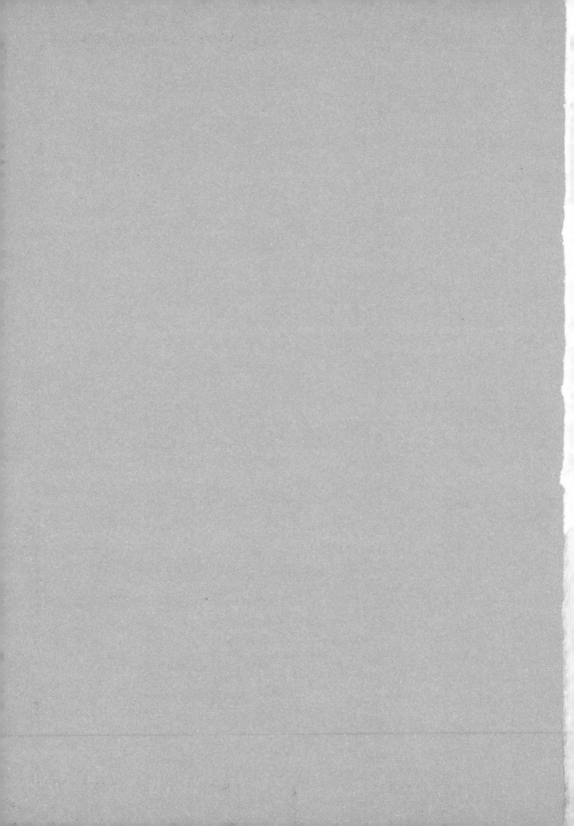

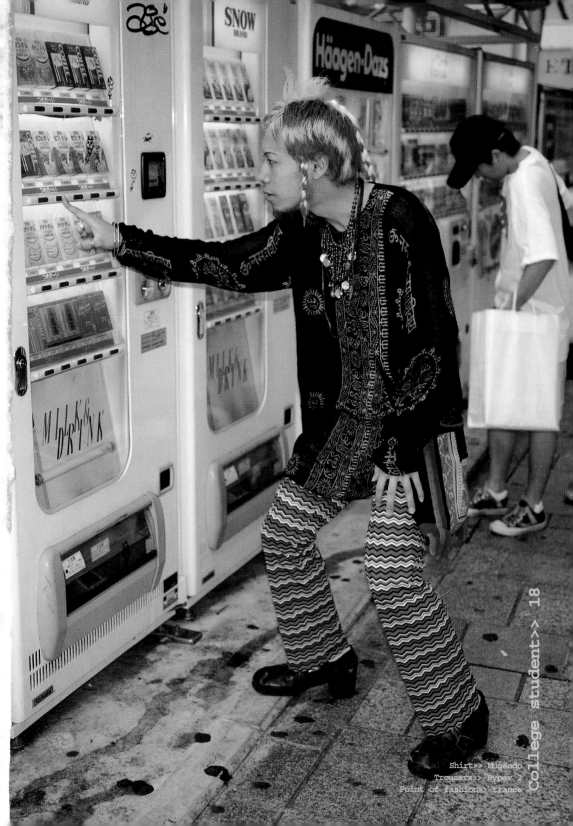

Shirt>> Migando
Trousers>> Hyper 2
Point of fashion>> trance

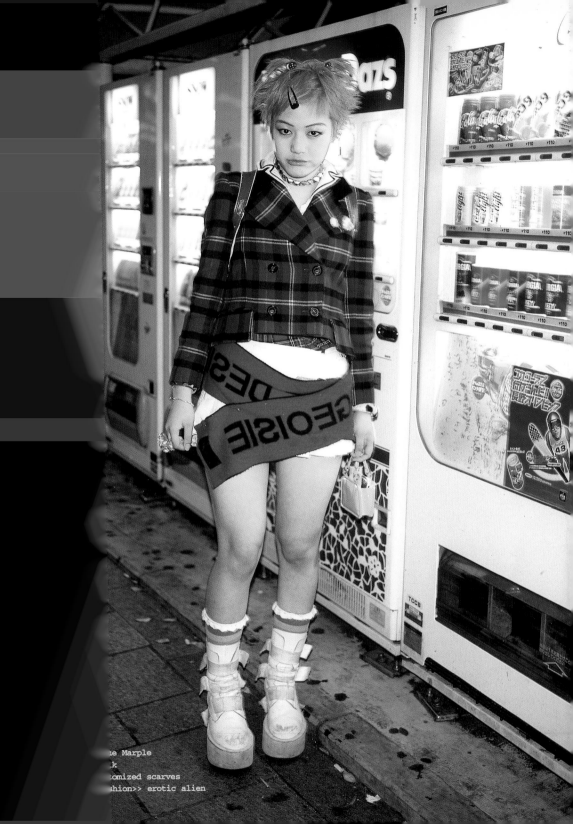

e Marple
k
tomized scarves
shion>> erotic alien

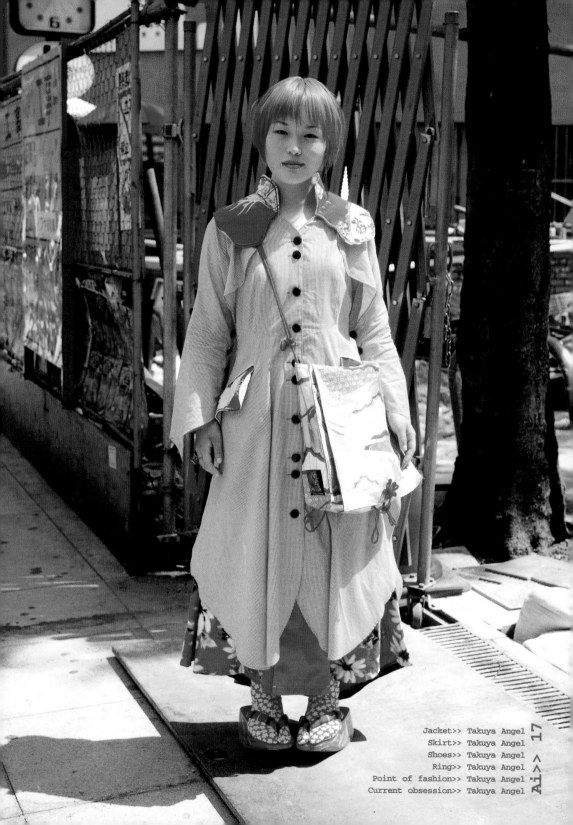

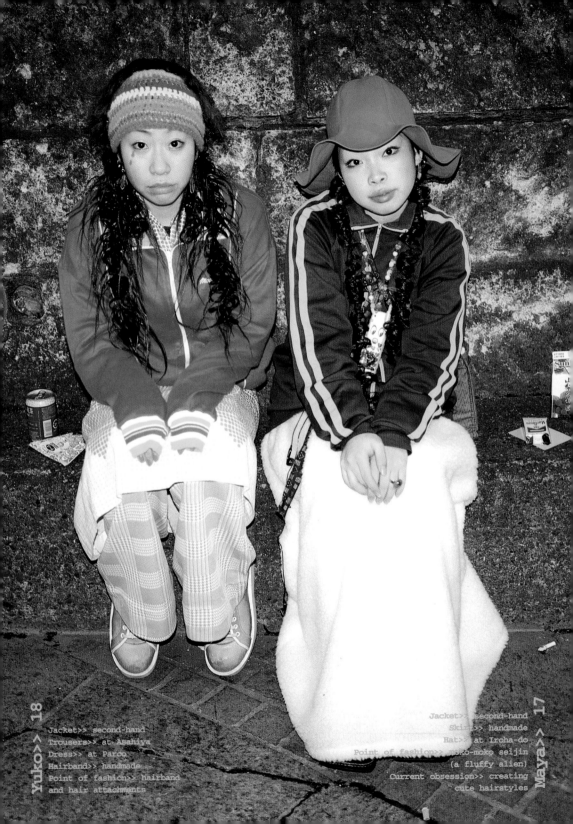

Yuko>> 18

Jacket>> second-hand
Trousers>> at Asahiya
Dress>> at Parco
Hairband>> handmade
Point of fashion>> hairband
and hair attachments

Maya>> 17

Jacket>> second-hand
Skirt>> handmade
Hat>> at Iroha-do
Point of fashion>> moko-moko seijin
(a fluffy alien)
Current obsession>> creating
cute hairstyles

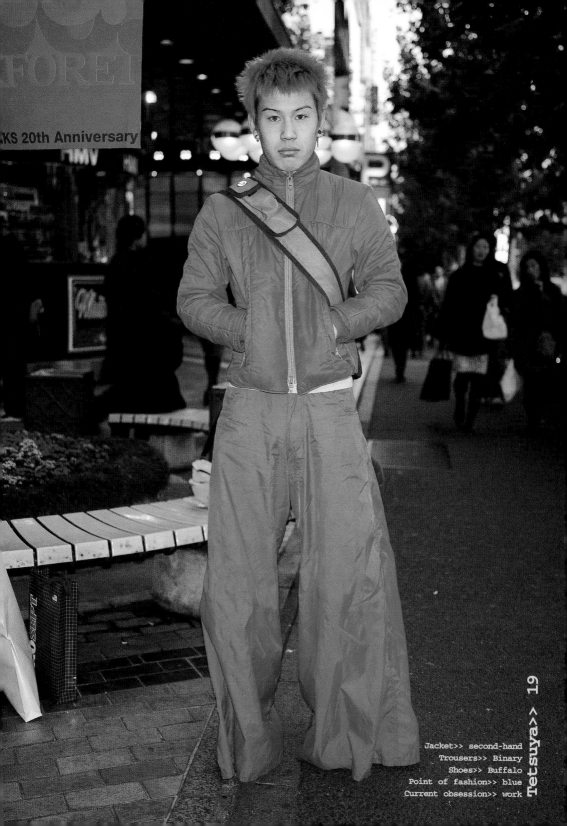

Jacket>> second-hand
Trousers>> Binary
Shoes>> Buffalo
Point of fashion>> blue
Current obsession>> work Tetsuya>> 19

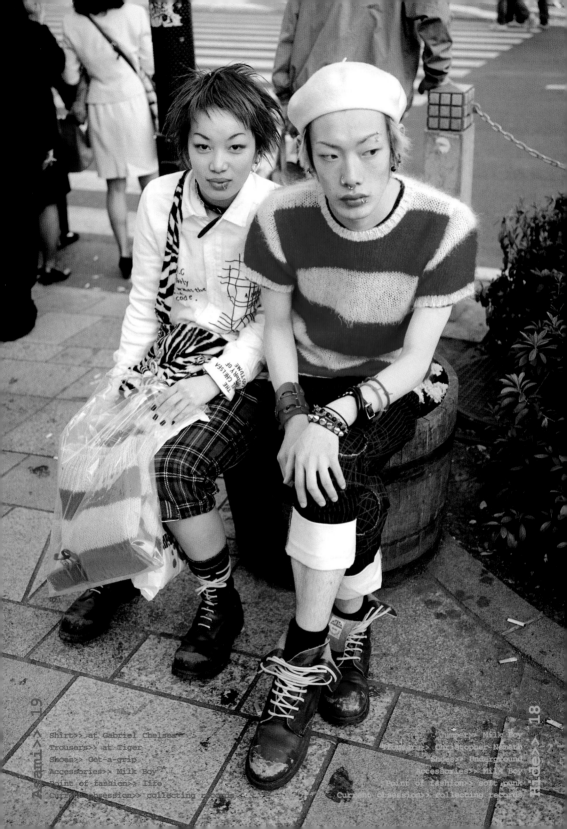

Shirt>> at Gabriel Chelsea
Trousers>> at Tiger
Shoes>> Get-a-grip
Accessories>> Milk Boy
Point of fashion>> life
Current obsession>> collecting records

Jumper>> Milk Boy
Trousers>> Christopher Nemeth
Shoes>> Underground
Accessories>> Milk Boy
Point of fashion>> soft punk
Current obsession>> collecting records

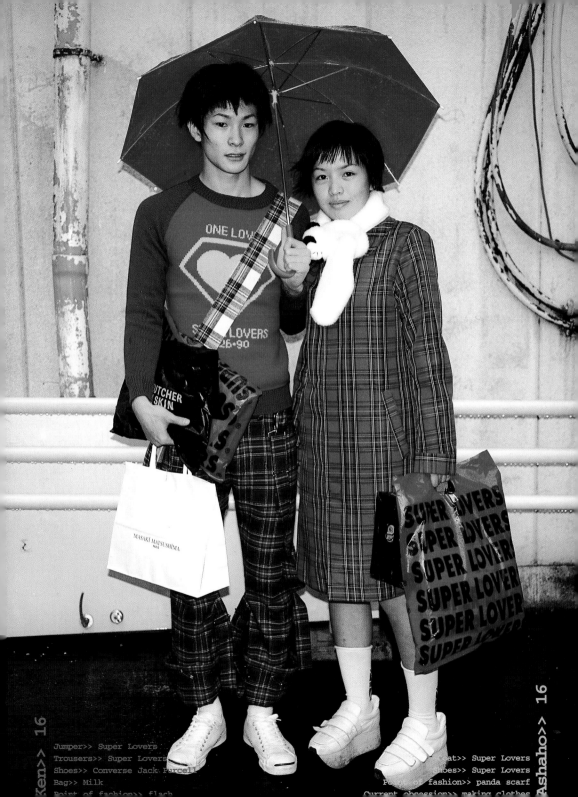

Jumper>> Super Lovers
Trousers>> Super Lovers
Shoes>> Converse Jack Purcell
Bag>> Milk
Point of fashion>> flash

Coat>> Super Lovers
Shoes>> Super Lovers
Point of fashion>> panda scarf
Current obsession>> making clothes

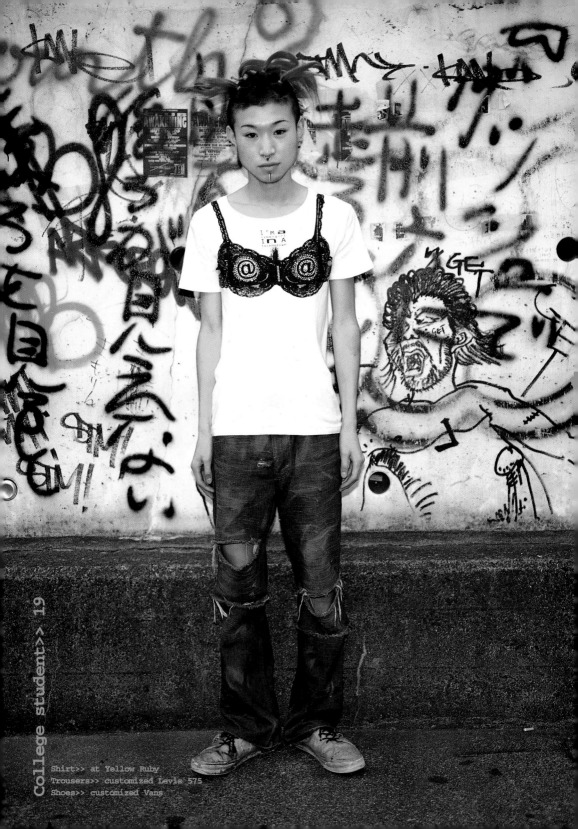

Shirt>> at Yellow Ruby
Trousers>> customized Levis 575
Shoes>> customized Vans

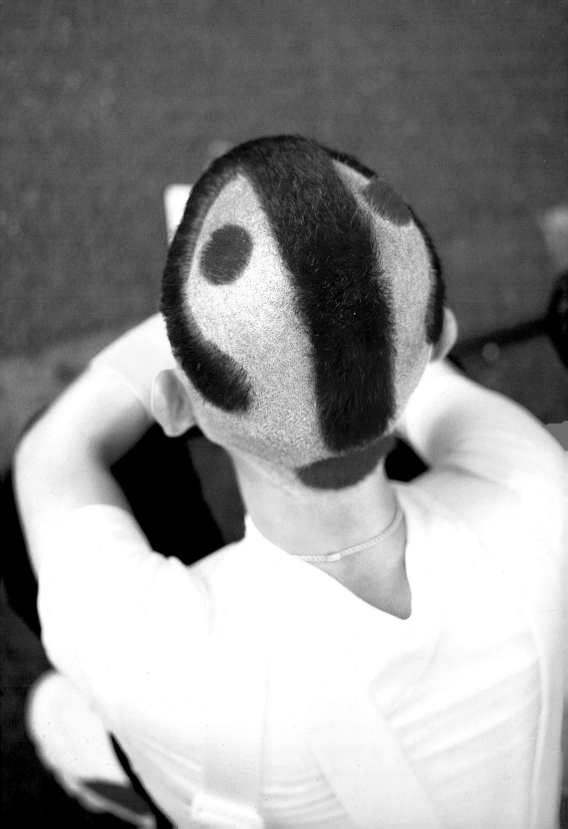

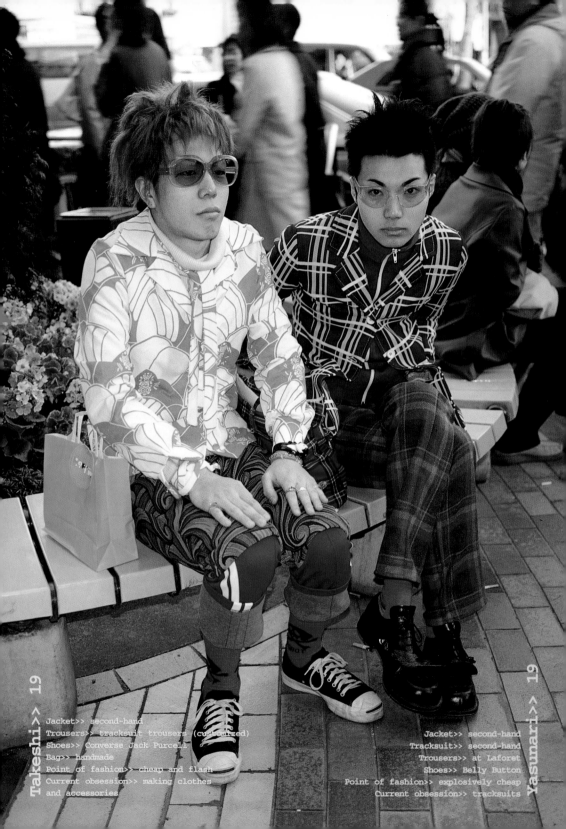

Takeshi>> 19

Jacket>> second-hand
Trousers>> tracksuit trousers (customized)
Shoes>> Converse Jack Purcell
Bag>> handmade
Point of fashion>> cheap and flash
Current obsession>> making clothes
and accessories

Yasunari>> 19

Jacket>> second-hand
Tracksuit>> second-hand
Trousers>> at Laforet
Shoes>> Belly Button
Point of fashion>> explosively cheap
Current obsession>> tracksuits

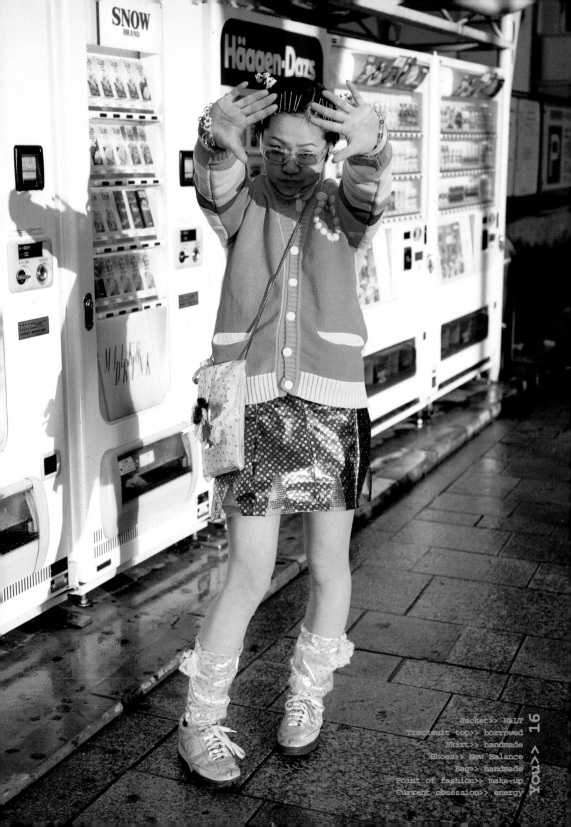

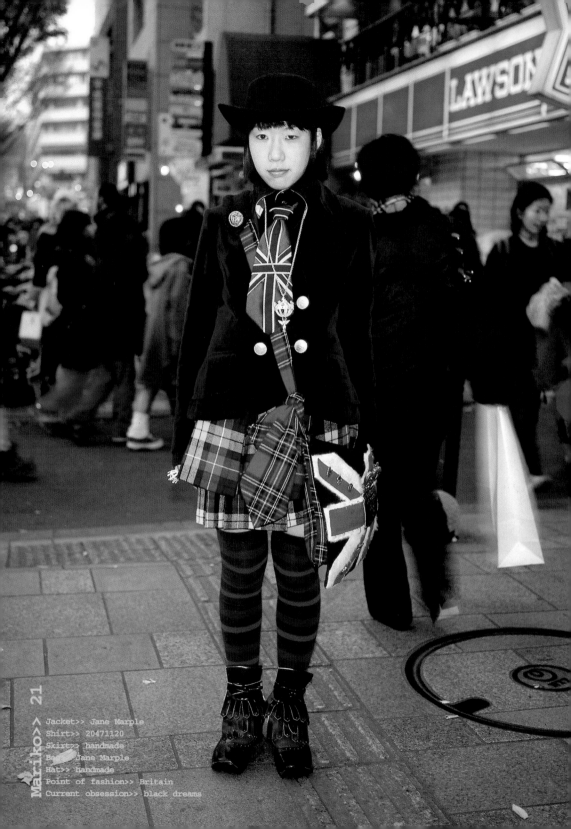

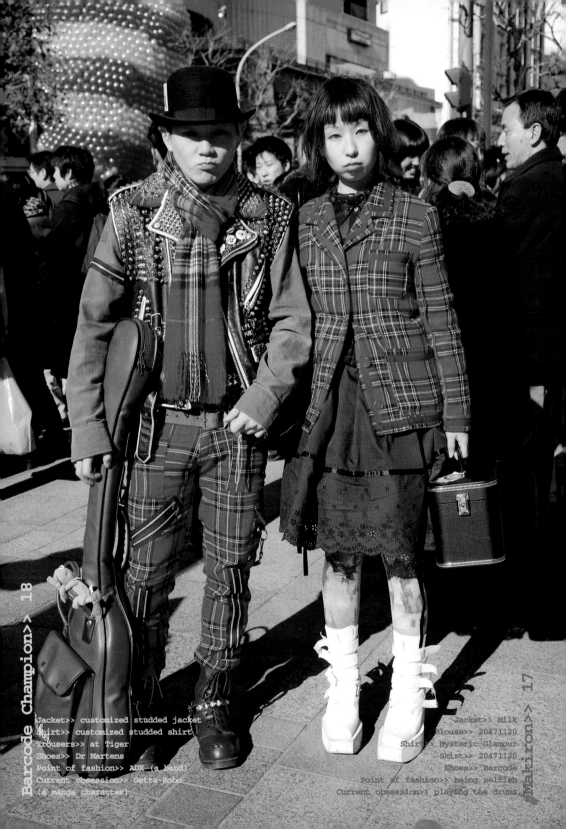

Jacket>> customized studded jacket
Shirt>> customized studded shirt
Trousers>> at Tiger
Shoes>> Dr Martens
Point of fashion>> ADX (a band)
Current obsession>> Getta-Robo
(a manga character)

Jacket>> Milk
Blouse>> 20471120
Shirt>> Hysteric Glamour
Skirt>> 20471120
Shoes>> Barcode
Point of fashion>> being selfish
Current obsession>> playing the drums

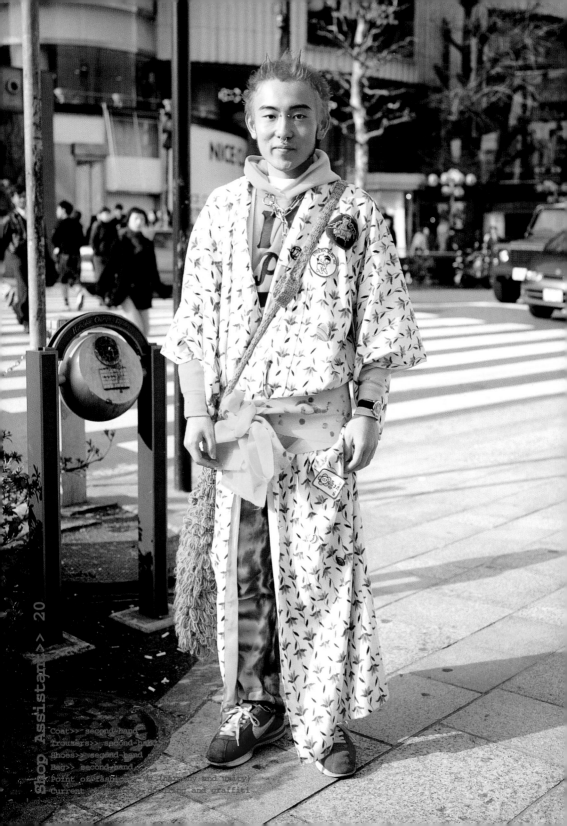

Coat>> second-hand
Trousers>> second-hand
Shoes>> second-hand
Bag>> second-hand
Point of fashion>> Wa (harmony and unity)
Current obsession>> designing and graffiti

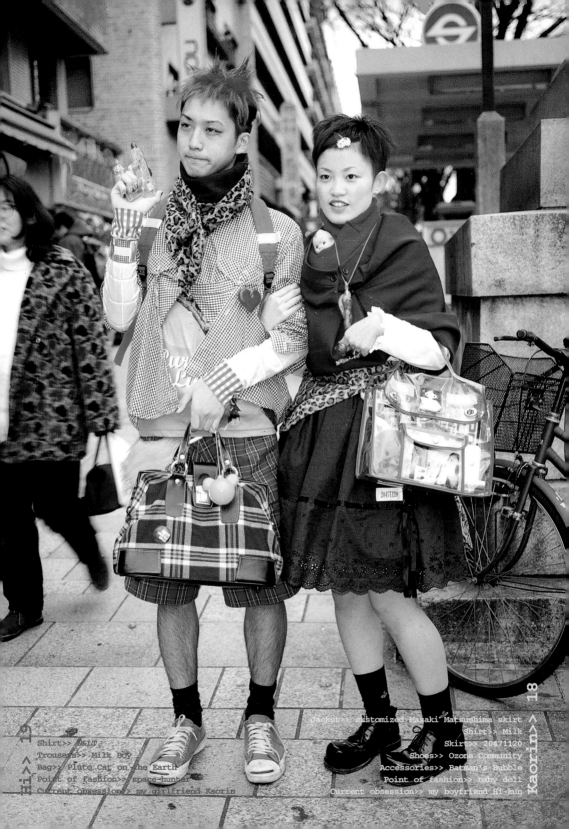

Shirt>> N<
Trousers>> Milk BoY
Bag>> Pluto Cat on the Earth
Point of fashion>> space-hunter
Current obsession>> my girlfriend Kaorin

Jacket>> customized Masaki Matsushima skirt
Shirt>> Milk
Skirt>> 20471120
Shoes>> Ozone Community
Accessories>> Batman's Bubble
Point of fashion>> baby doll
Current obsession>> my boyfriend Hi-kun

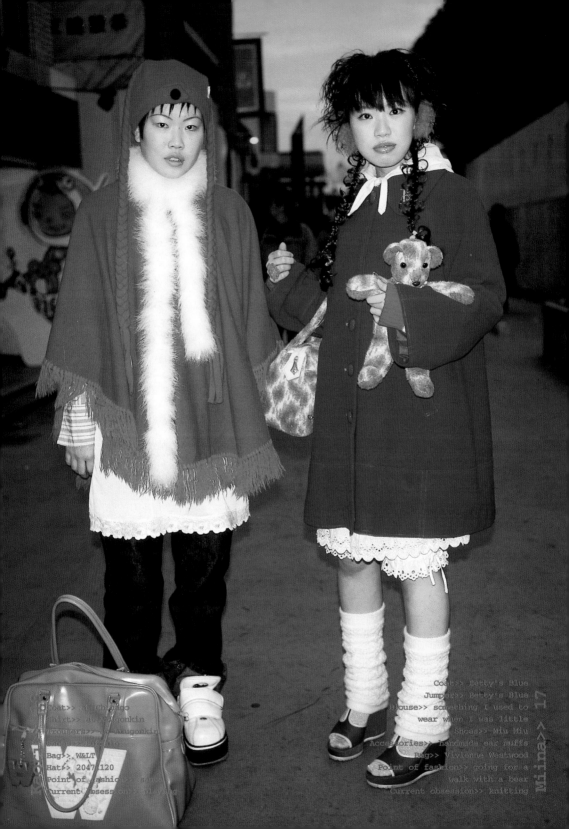

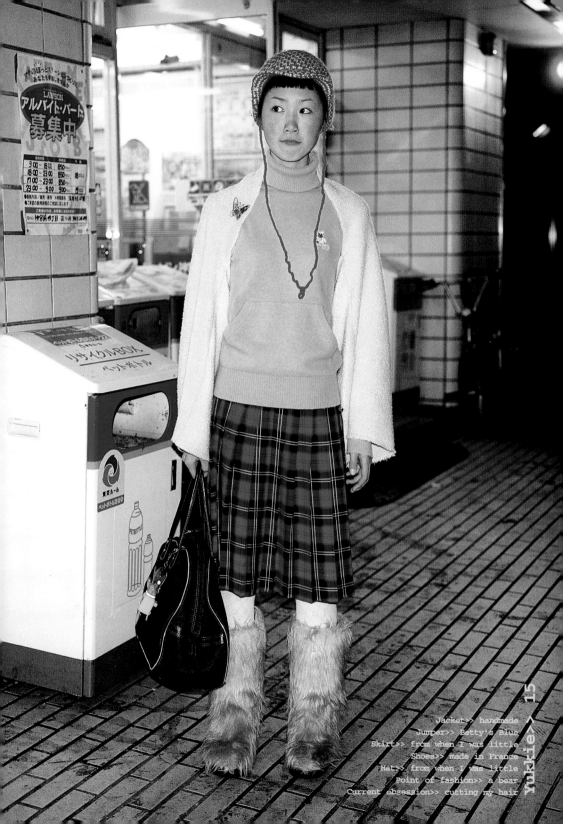

Jacket>> handmade
Jumper>> Betty's Blue
Skirt>> from when I was little
Shoes>> made in France
Hat>> from when I was little
Point of fashion>> a bear
Current obsession>> cutting my hair

Yukkie>> 15

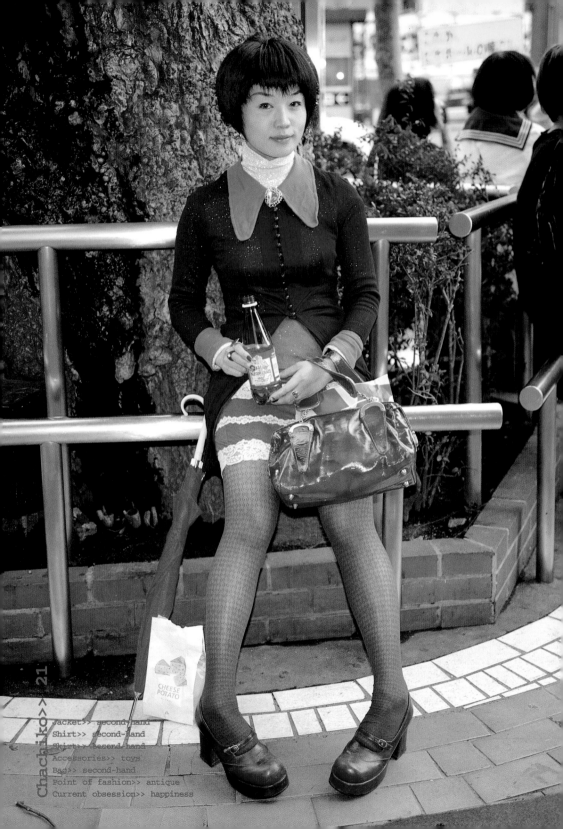

Jacket>> second-hand
Shirt>> second-hand
Skirt>> second-hand
Accessories>> toys
Bag>> second-hand
Point of fashion>> antique
Current obsession>> happiness

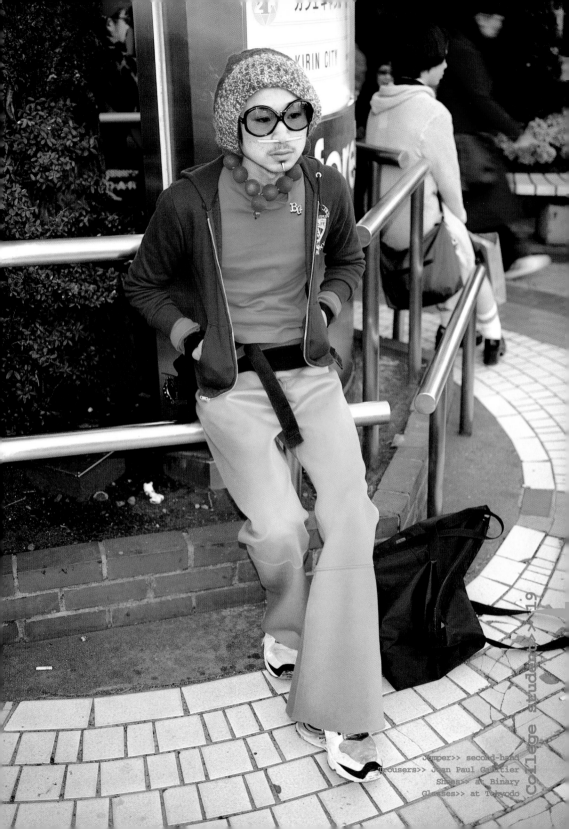

Jumper>> second-hand
Trousers>> Jean Paul Gaultier
Shoes>> at Binary
Glasses>> at Tokyodo

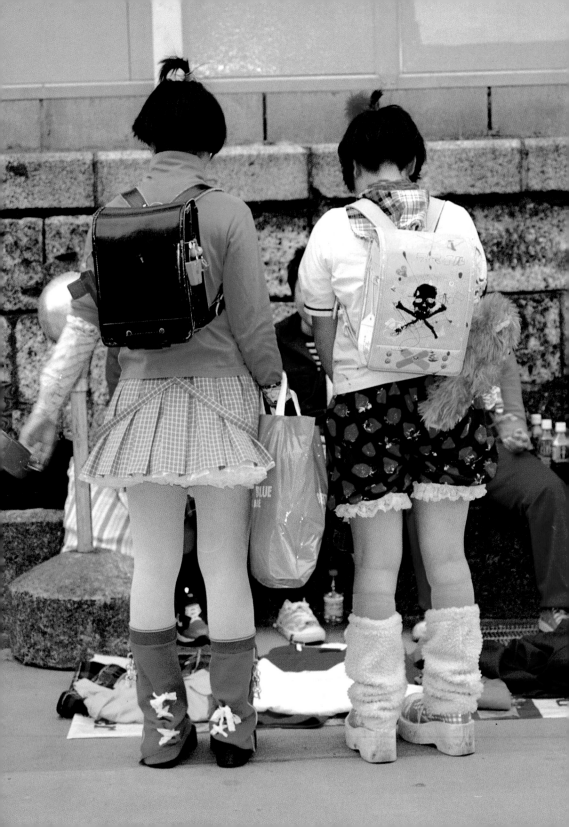

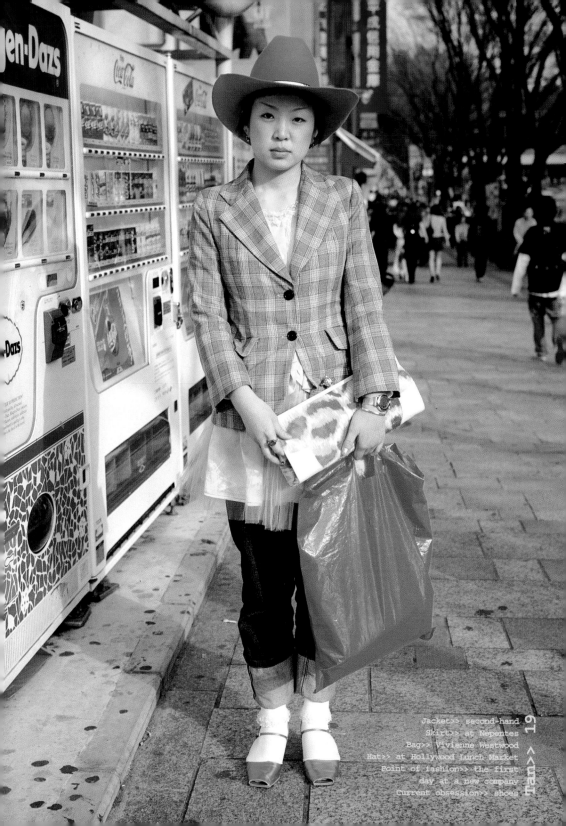

Jacket>> second-hand
Skirt>> at Nepentes
Bag>> Vivienne Westwood
Hat>> at Hollywood Lunch Market
Point of fashion>> the first
day at a new company
Current obsession>> shoes

Nan>> 19

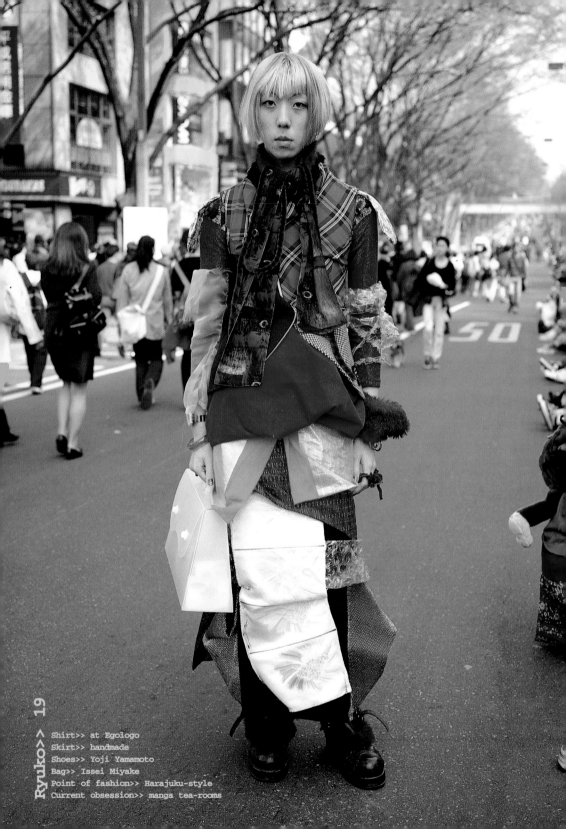

Ryuko>> 19

Shirt>> at Egologo
Skirt>> handmade
Shoes>> Yoji Yamamoto
Bag>> Issei Miyake
Point of fashion>> Harajuku-style
Current obsession>> manga tea-rooms

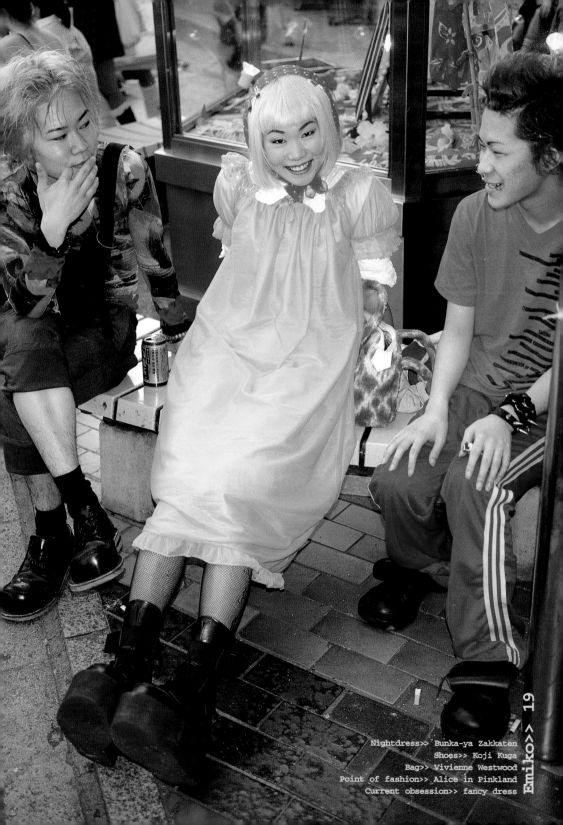

Nightdress>> Bunka-ya Zakkaten
Shoes>> Koji Kuga
Bag>> Vivienne Westwood
Point of fashion>> Alice in Pinkland
Current obsession>> fancy dress

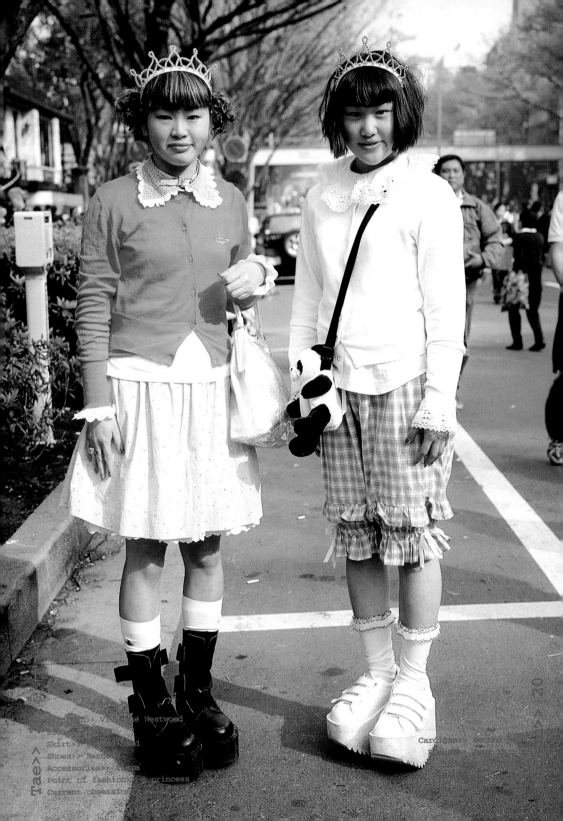

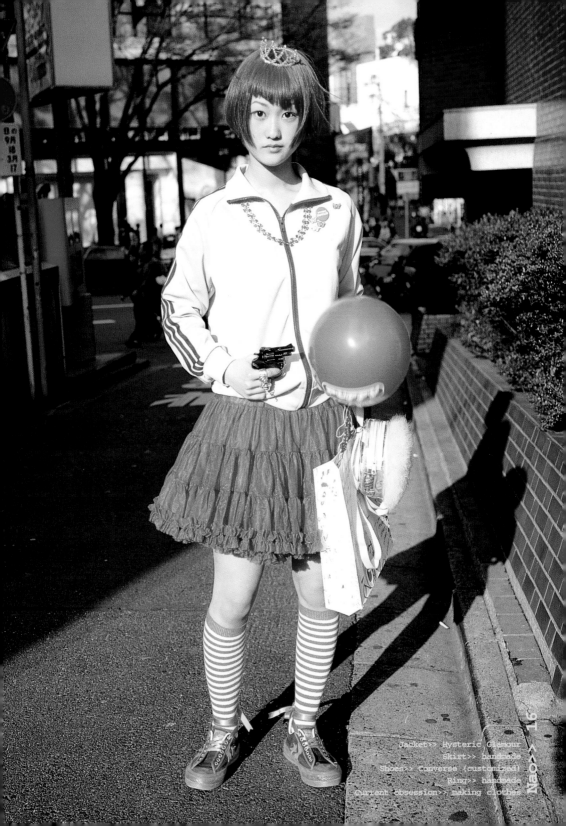

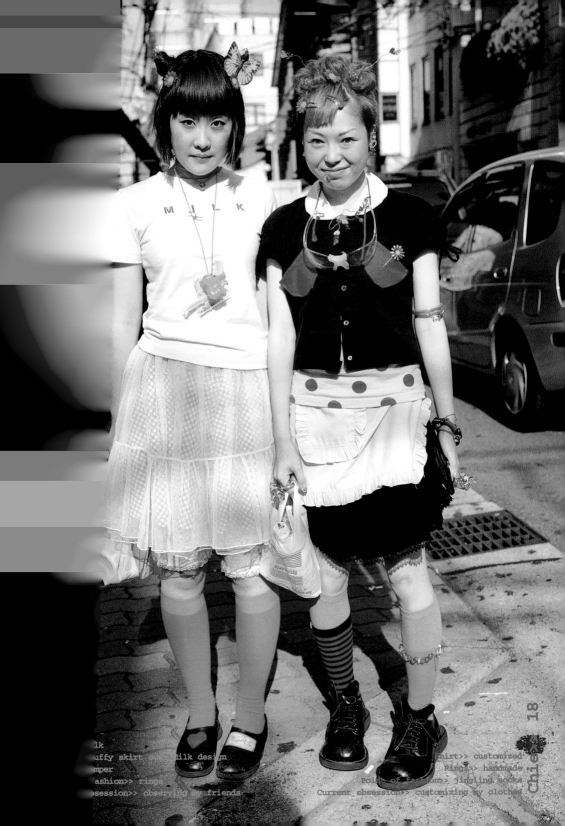

lk
uffy skirt >> Milk design
mper
ashion>> rings
ssession>> observing my friends

Shirt>> customized
Ring>> handmade
Point of fashion>> jingling socks
Current obsession>> customizing my clothes

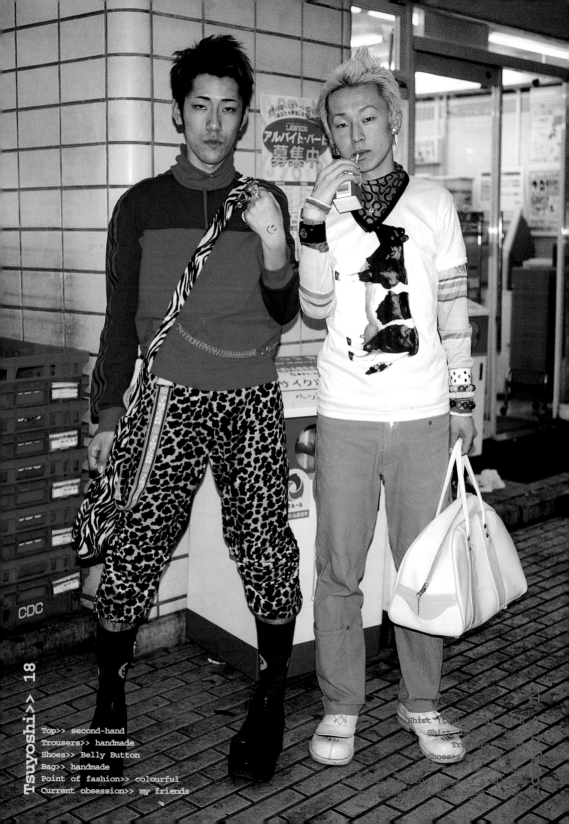

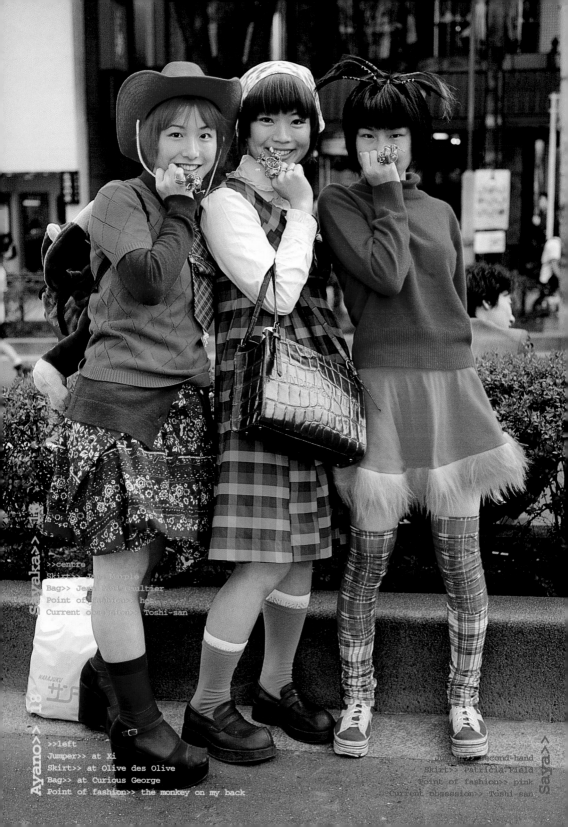

Sayaka>> 18

Ayano>> 18

Saya>

>>centre
Skirt>> Jane Marple
Bag>> Jean Paul Gaultier
Point of fashion>> hat
Current obsession>> Toshi-san

>>left
Jumper>> at Xi
Skirt>> at Olive des Olive
Bag>> at Curious George
Point of fashion>> the monkey on my back

Jumper>> second-hand
Skirt>> Patricia Field
Point of fashion>> pink
Current obsession>> Toshi-san

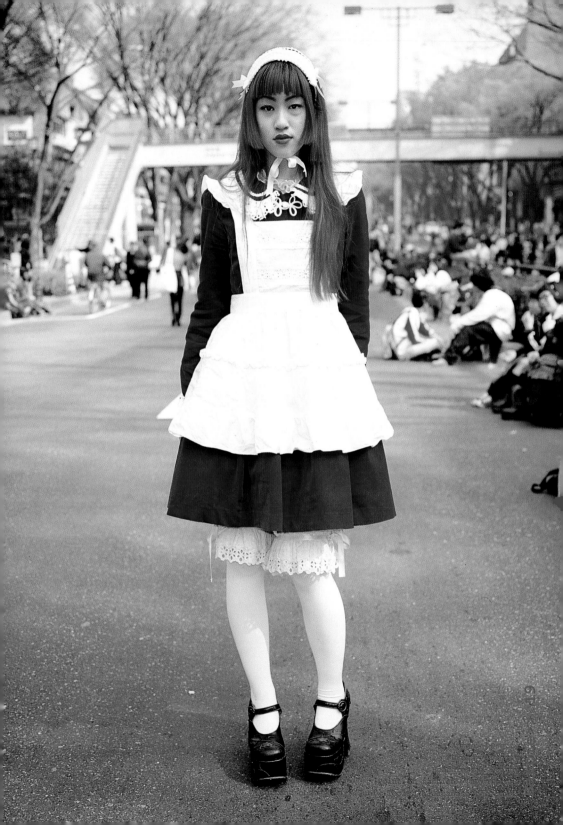

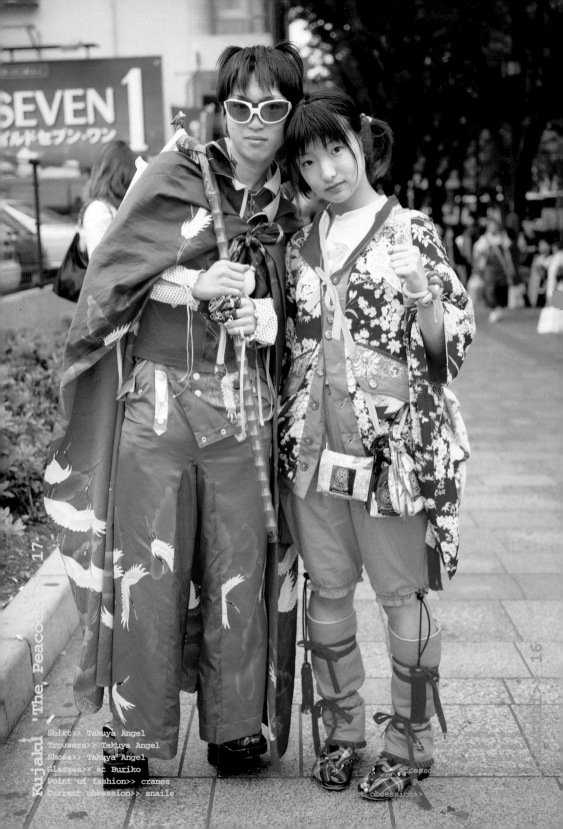

SEVEN 1
ワイルドセブン・ワン

Kujaku 'The Peacock' >> 17

Shirt>> Takuya Angel
Trousers>> Takuya Angel
Shoes>> Takuya Angel
Glasses>> at Buriko
Point of fashion>> cranes
Current obsession>> snails

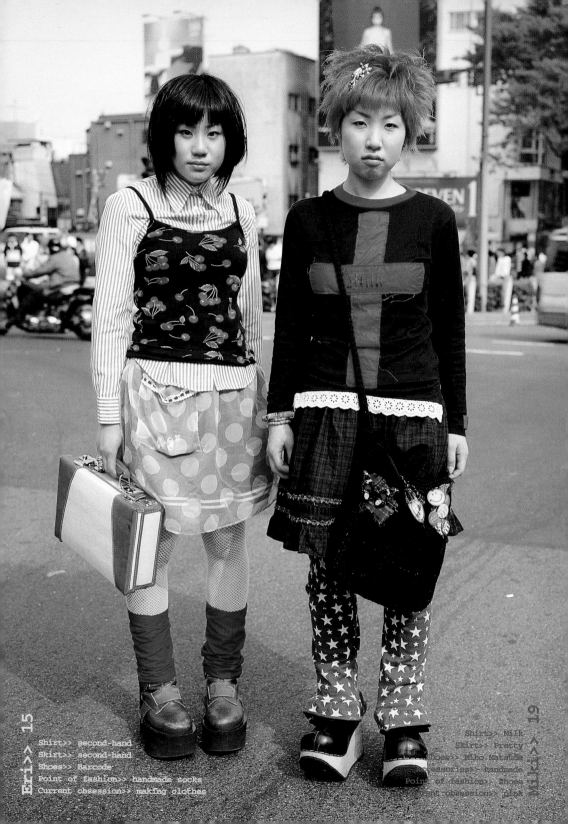

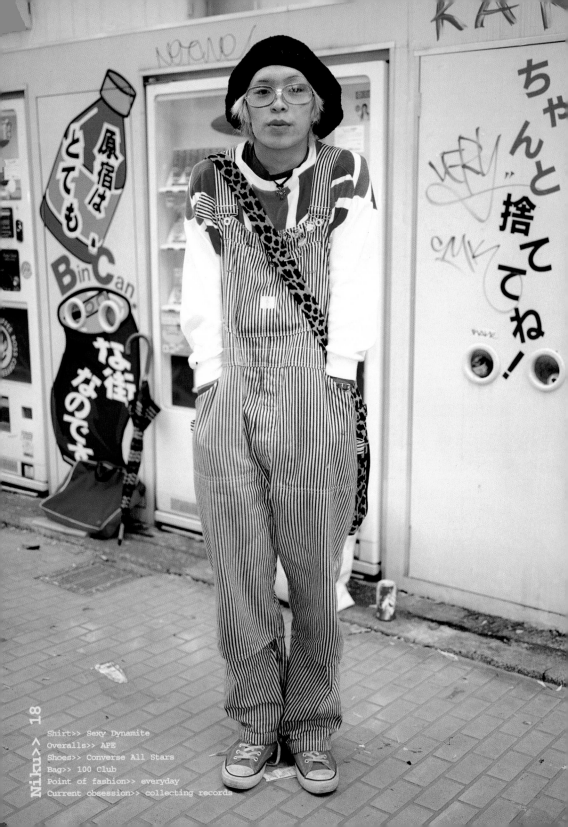

Shirt>> Sexy Dynamite
Overalls>> APE
Shoes>> Converse All Stars
Bag>> 100 Club
Point of fashion>> everyday
Current obsession>> collecting records

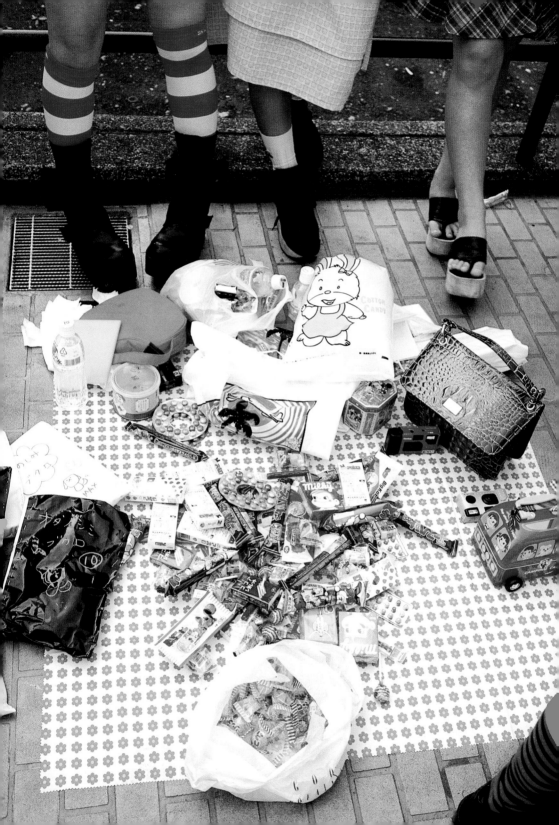

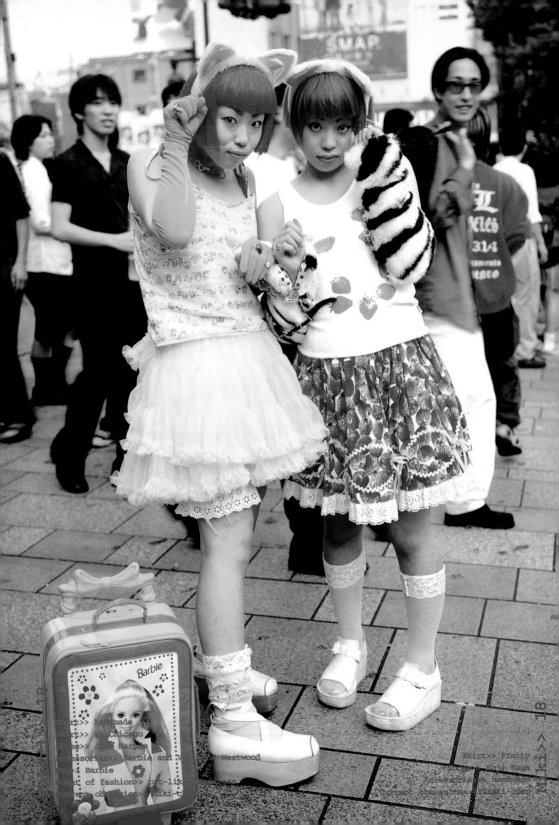

SMAP

Barbie

Skirt>> handmade
Shirt>> at Chicago
Shoes>> Jeff Marble
Accessories>> Barbie and Miki-t & Westwood
& Barbie
Point of fashion>> cat-like dress
Current obsession>> Miki-t

Skirt>> Pretty
Kaga
Accessories>> HappyAge
Point of fashion>> Miki Obi

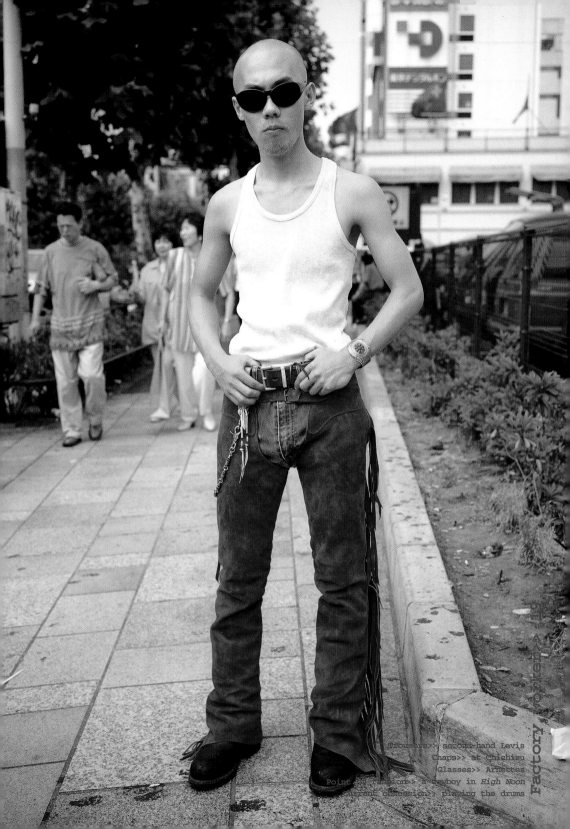

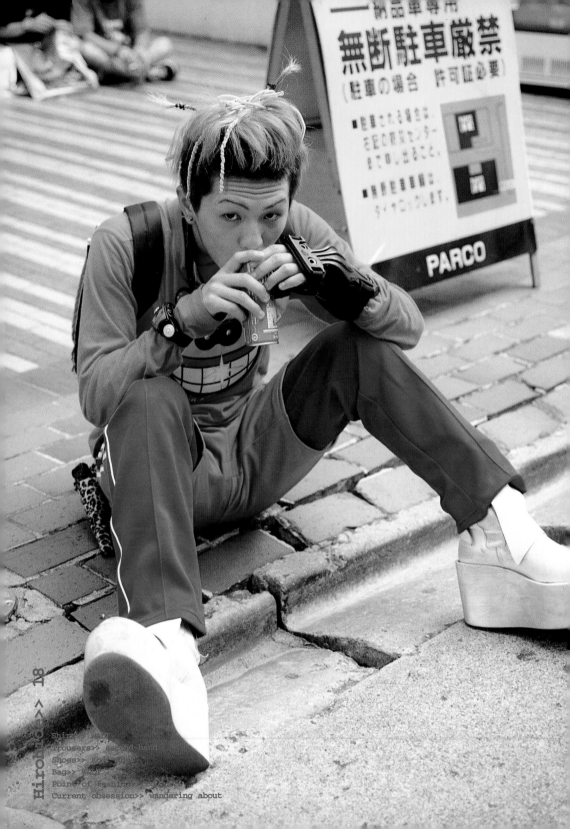

無断品車専用
無断駐車厳禁
（駐車の場合　許可証必要）

■ 駐車される場合は、
　右足の則なセンター
　まで申し出ること。

■ 特別駐車違反は、
　タイヤロックします。

PARCO

Hiroko >> 18

Shirt >>
Trousers>> second-hand
Shoes>> Koenji shop
Bag>> velvet
Point of fashion
Current obsession>> wandering about

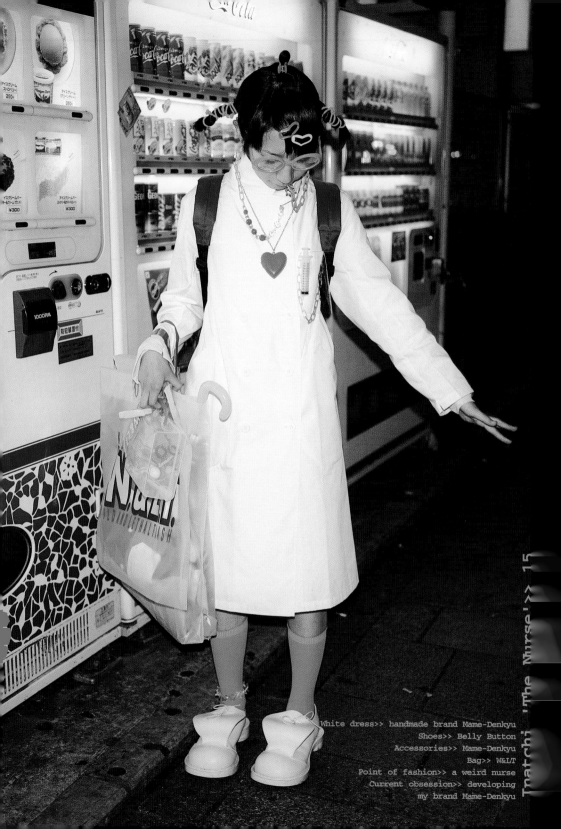

White dress>> handmade brand Mame-Denkyu
Shoes>> Belly Button
Accessories>> Mame-Denkyu
Bag>> W<
Point of fashion>> a weird nurse
Current obsession>> developing
my brand Mame-Denkyu

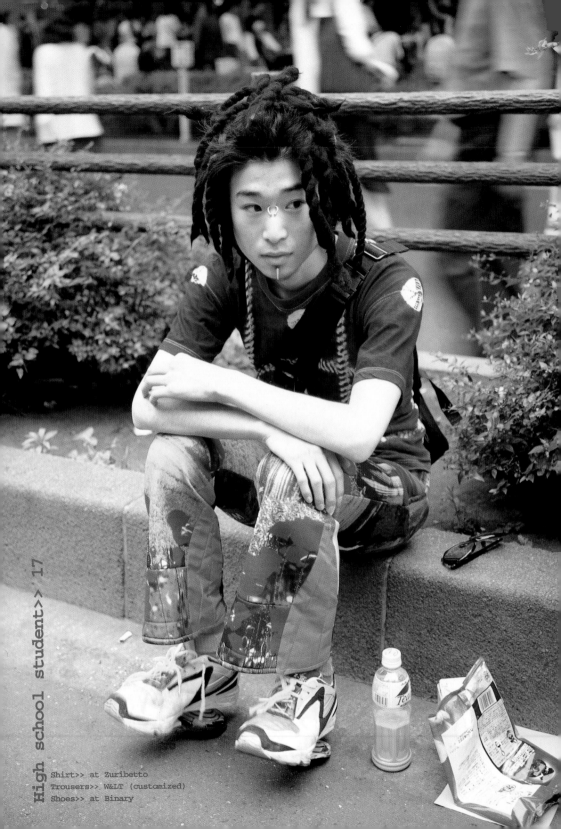

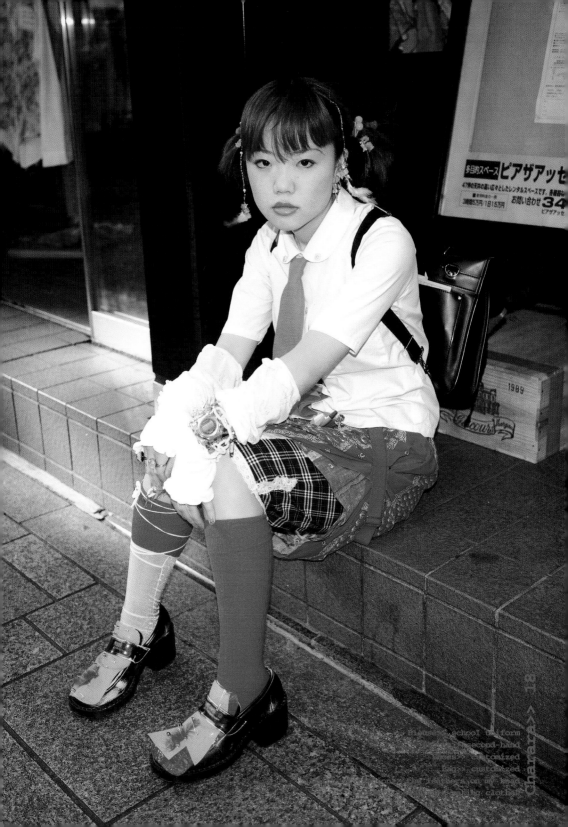

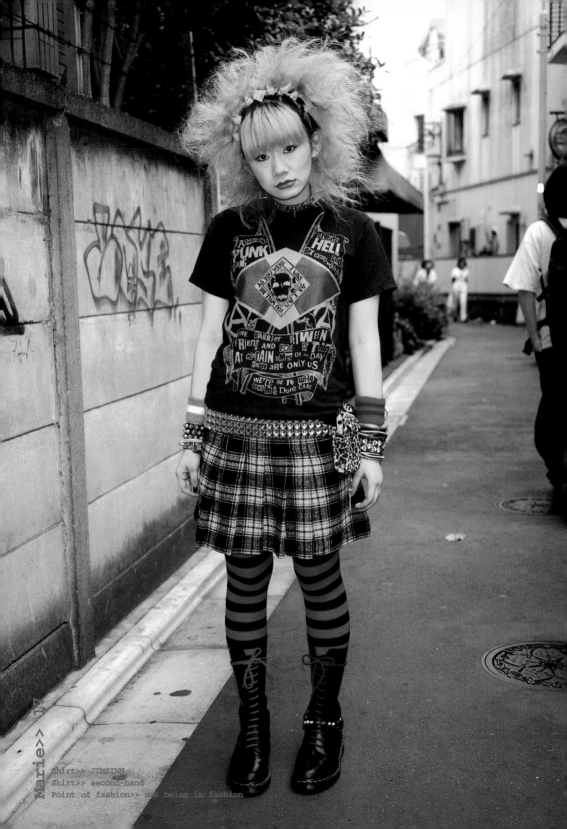

Shirt >> JIMSINN
Skirt >> second-hand
Point of fashion >> for being in fashion

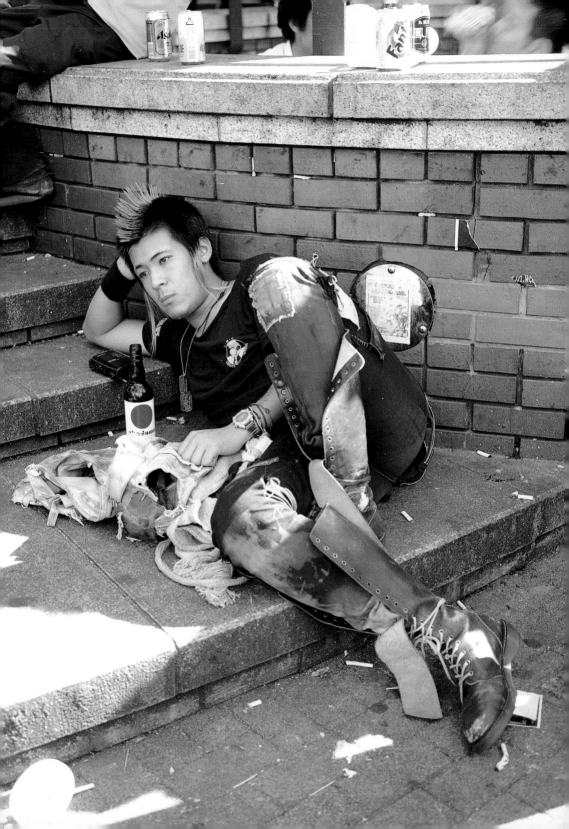

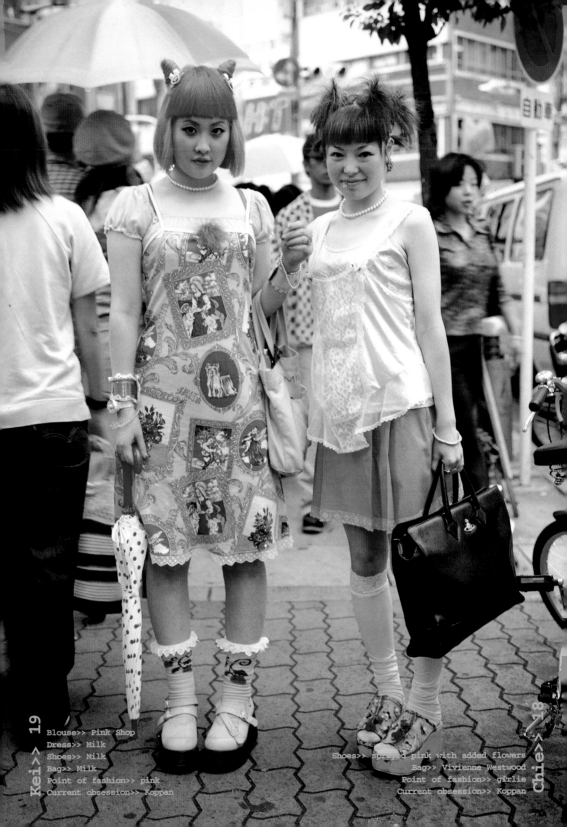

Blouse>> Pink Shop
Dress>> Milk
Shoes>> Milk
Bag>> Milk
Point of fashion>> pink
Current obsession>> Koppan

Shoes>> sprayed pink with added flowers
Bag>> Vivienne Westwood
Point of fashion>> girlie
Current obsession>> Koppan

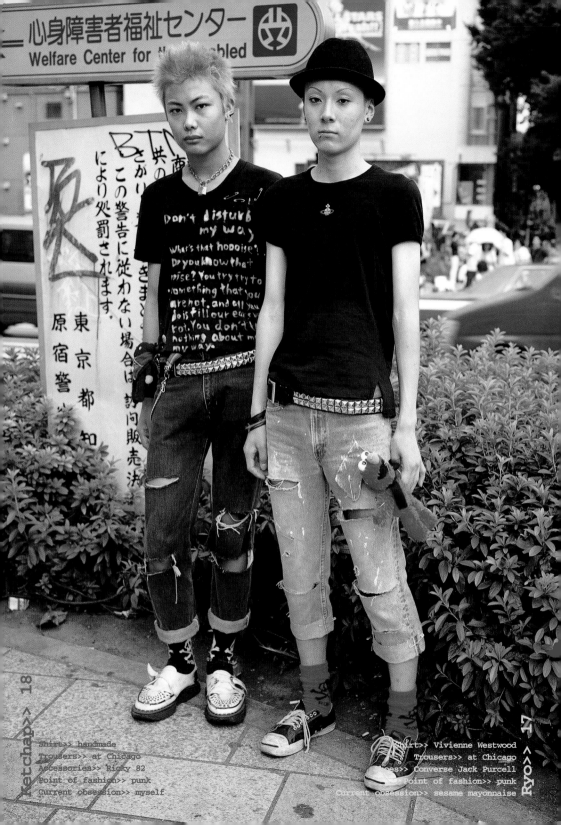

Shirt>> handmade
Trousers>> at Chicago
Accessories>> kicky 82
Point of fashion>> punk
Current obsession>> myself

Shirt>> Vivienne Westwood
Trousers>> at Chicago
...ces>> Converse Jack Purcell
...Point of fashion>> punk
Current obsession>> sesame mayonnaise

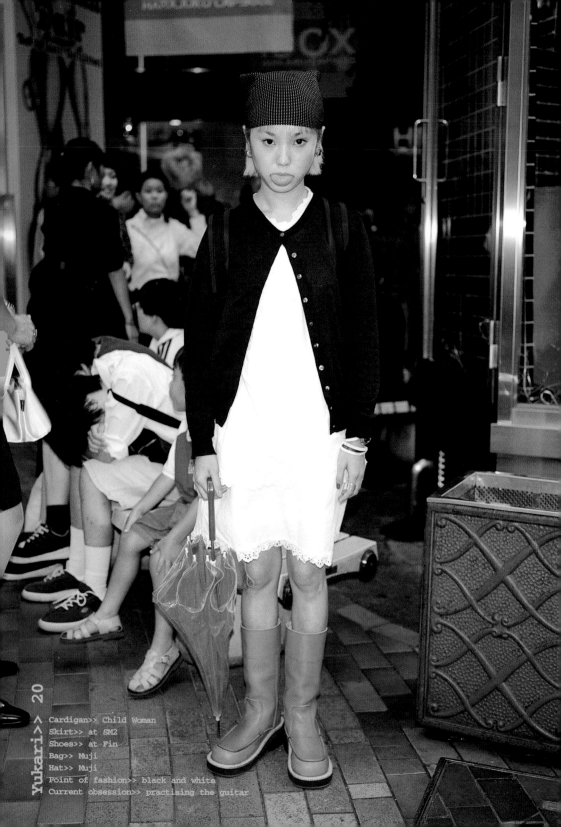

Cardigan>> Child Woman
Skirt>> at SM2
Shoes>> at Fin
Bag>> Muji
Hat>> Muji
Point of fashion>> black and white
Current obsession>> practising the guitar

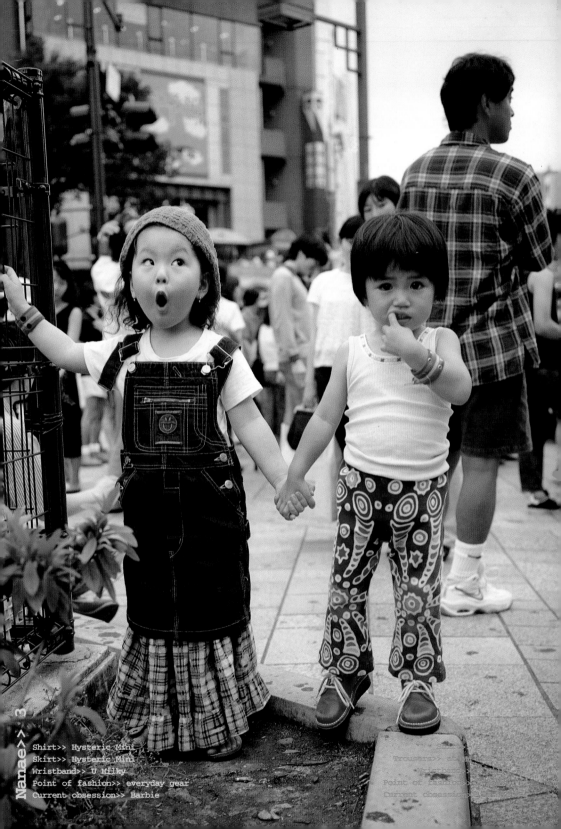

Shirt>> Hysteric Mini
Skirt>> Hysteric Mini
Wristband>> U Milky
Point of fashion>> everyday gear
Current obsession>> Barbie

Trousers>>
Wristband>>
Point of fashion>>
Current obsession>> Barbie

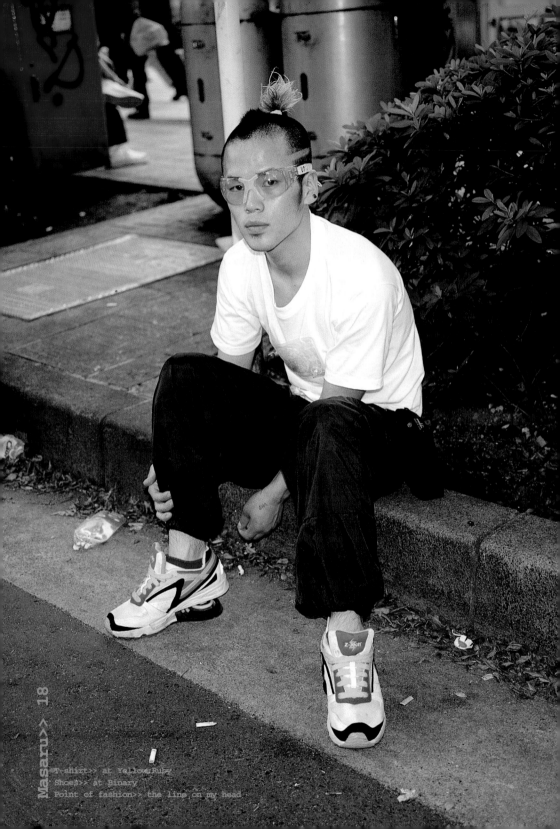

T-shirt>> at Yellow Ruby
Shoes>> at Binary
Point of fashion>> the line on my head

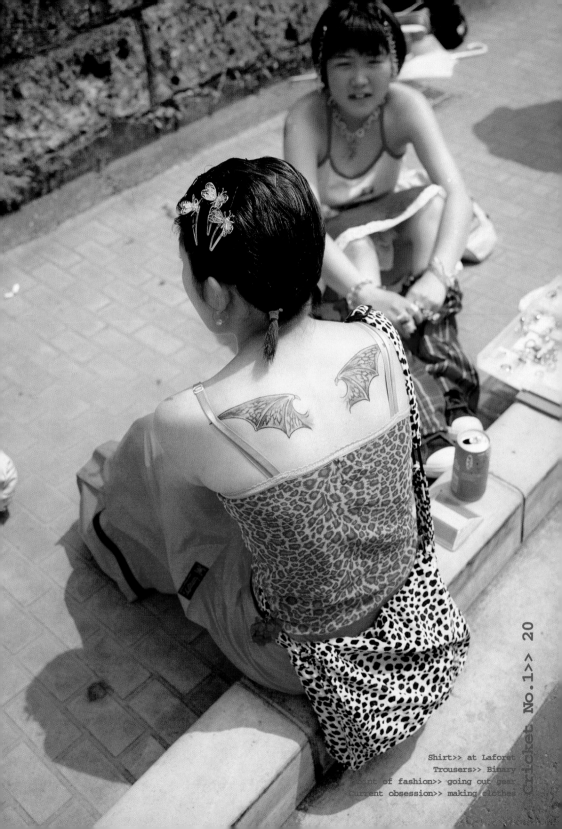

Shirt>> at Laforet
Trousers>> Binary
Point of fashion>> going out gear
Current obsession>> making clothes

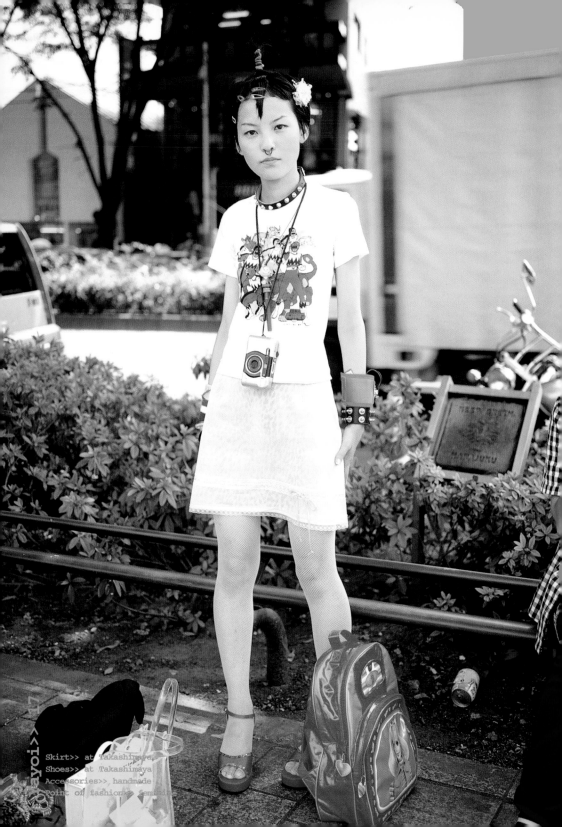

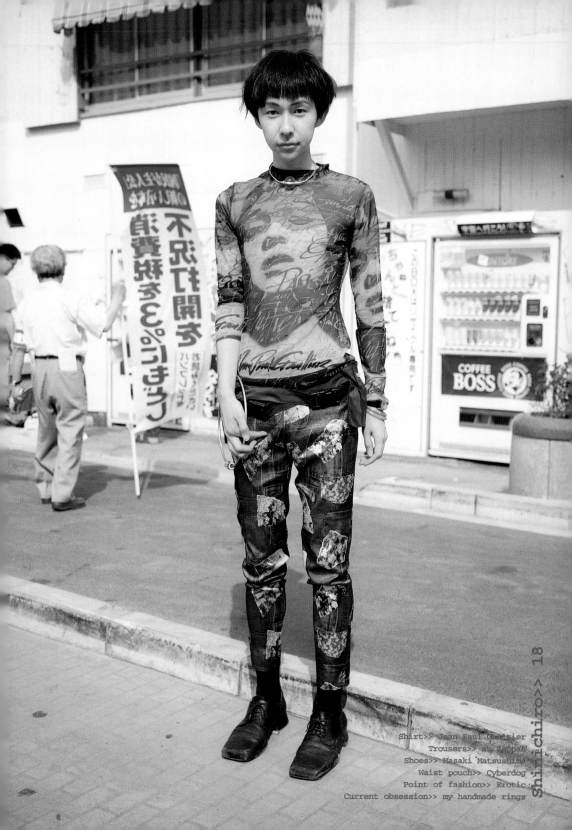

Shirt>> Jean Paul Gaultier
Trousers>> at Zappa's
Shoes>> Masaki Matsushima
Waist pouch>> Cyberdog
Point of fashion>> Erotic
Current obsession>> my handmade rings

Shinichiro>> 18

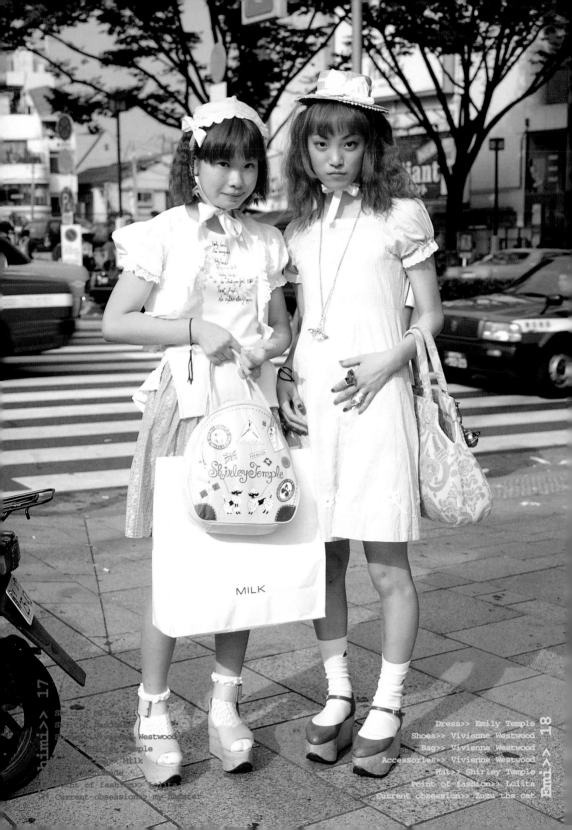

Dress>> Emily Temple
Shoes>> Vivienne Westwood
Bag>> Vivienne Westwood
Accessories>> Vivienne Westwood
Hat>> Shirley Temple
Point of fashion>> Lolita
Current obsession>> Zuzu the cat

MILK

Shirley Temple

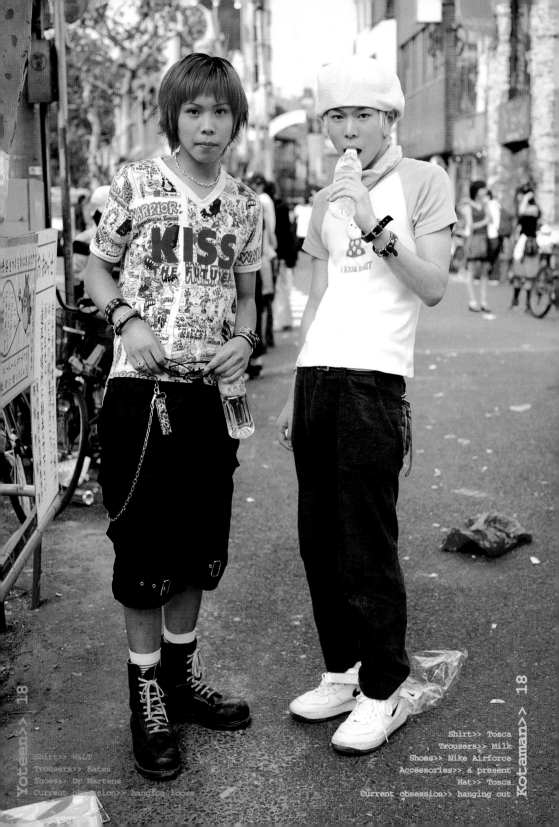

Shirt>> W<
Trousers>> Eatsu
Shoes>> Dr Martens
Current obsession>> hanging loose

Shirt>> Tosca
Trousers>> Milk
Shoes>> Nike Airforce
Accessories>> a present
Hat>> Tosca
Current obsession>> hanging out

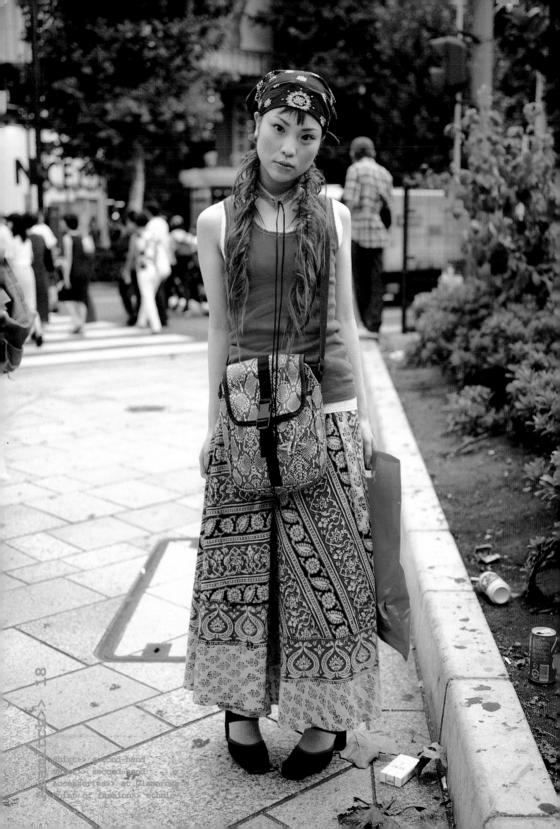

shirt>> second-hand
pants>> second-hand
accessories>> at Glamorous
point of fashion>> ethnic

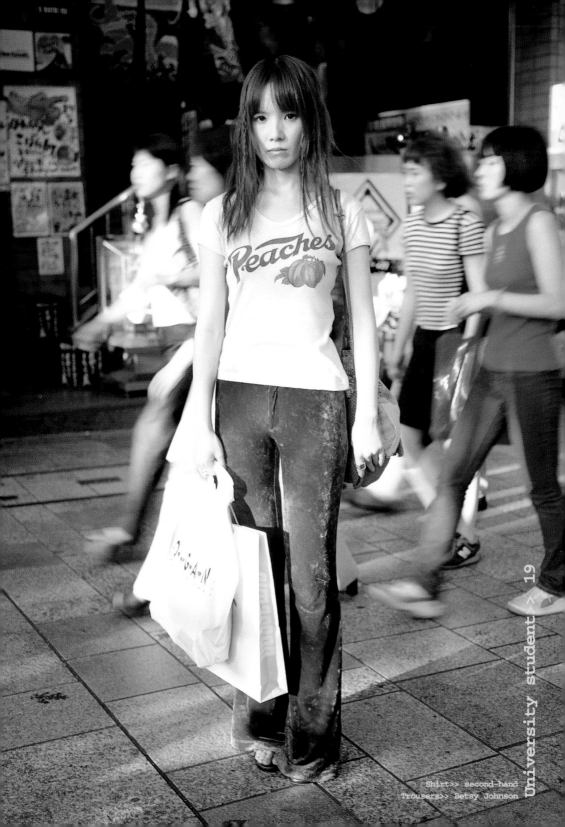

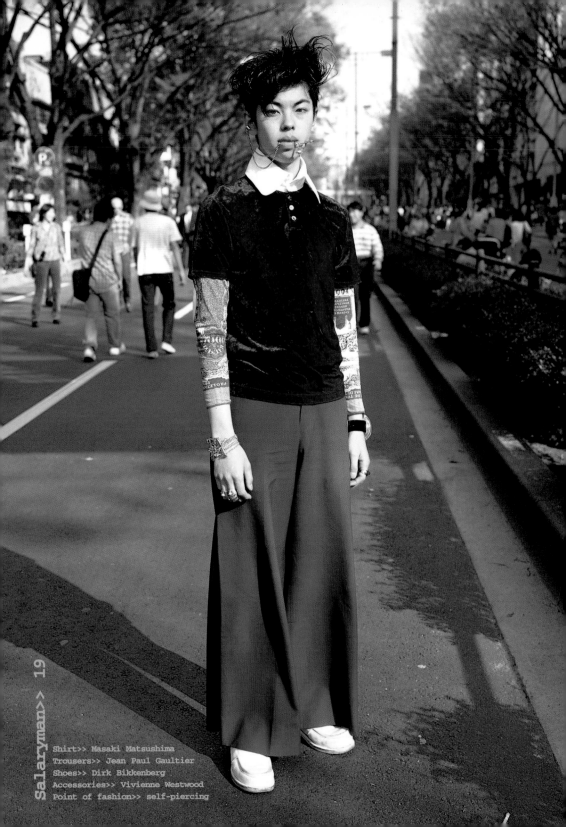

Shirt>> Masaki Matsushima
Trousers>> Jean Paul Gaultier
Shoes>> Dirk Bikkenberg
Accessories>> Vivienne Westwood
Point of fashion>> self-piercing

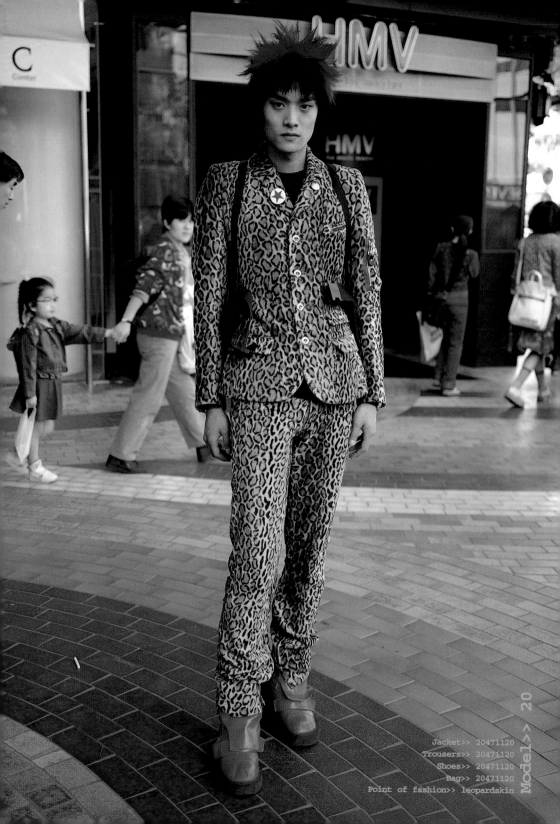

Jacket>> 20471120
Trousers>> 20471120
Shoes>> 20471120
Bag>> 20471120
Point of fashion>> leopardskin

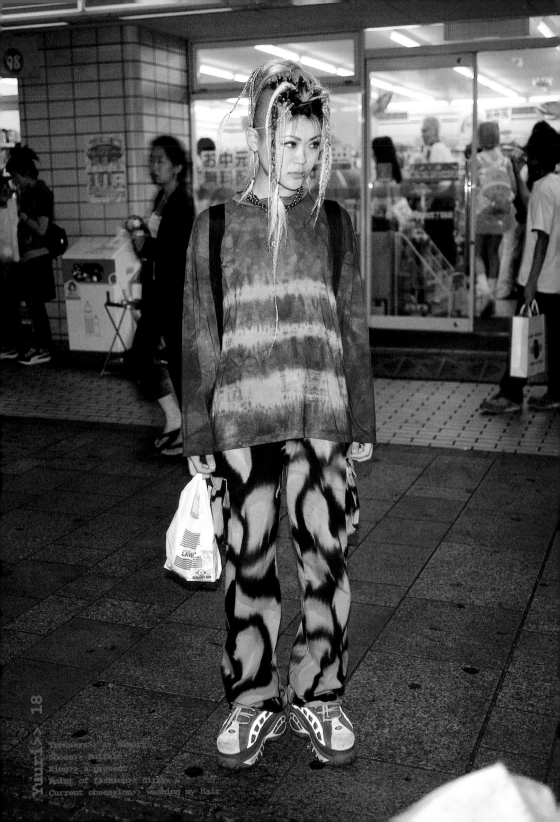

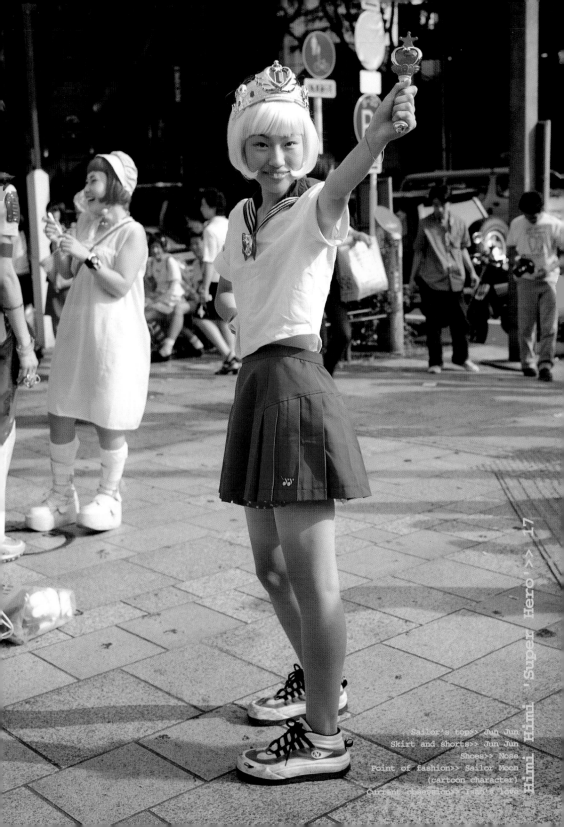

Sailor's top>> Jun Jun
Skirt and shorts>> Jun Jun
Shoes>> Nose
Point of fashion>> Sailor Moon
(cartoon character)
Current obsession>> Isao's love

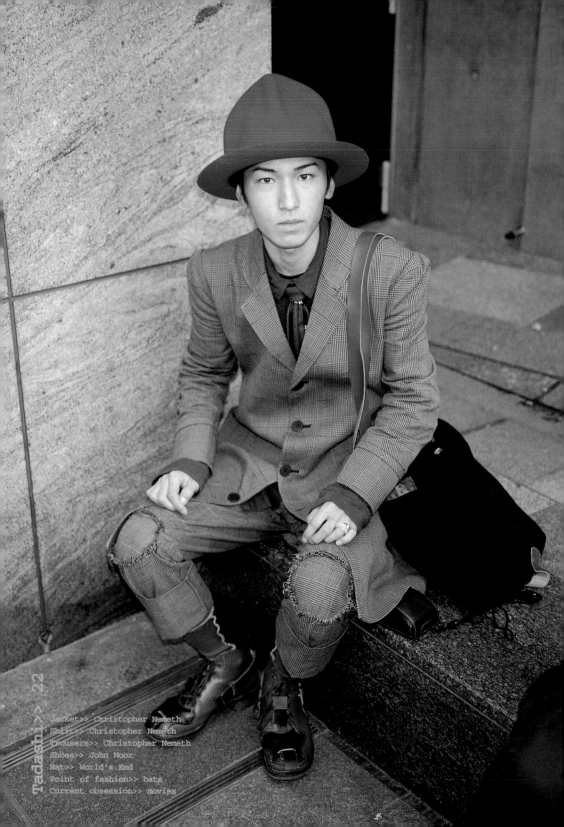

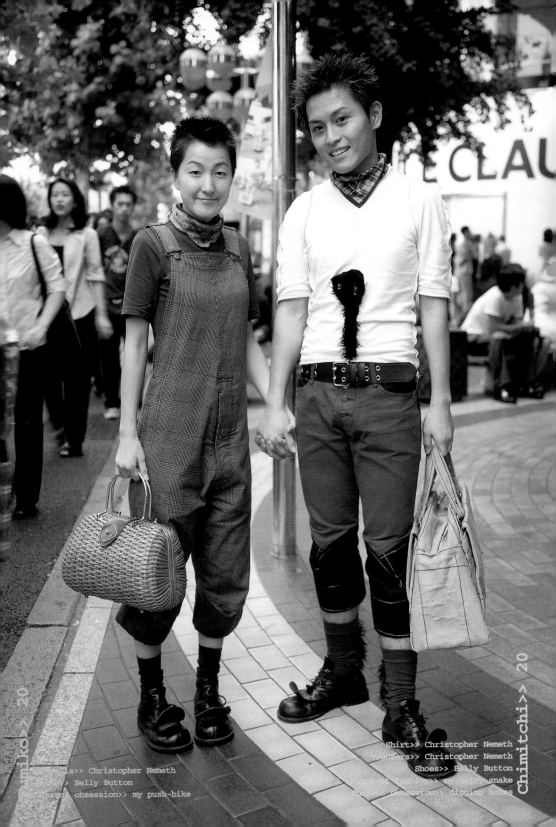

Overalls>> Christopher Nemeth
Shoes>> Belly Button
Current obsession>> my push-bike

Shirt>> Christopher Nemeth
Trousers>> Christopher Nemeth
Shoes>> Belly Button
Point of fashion>> my hairy snake
Current obsession>> digging holes

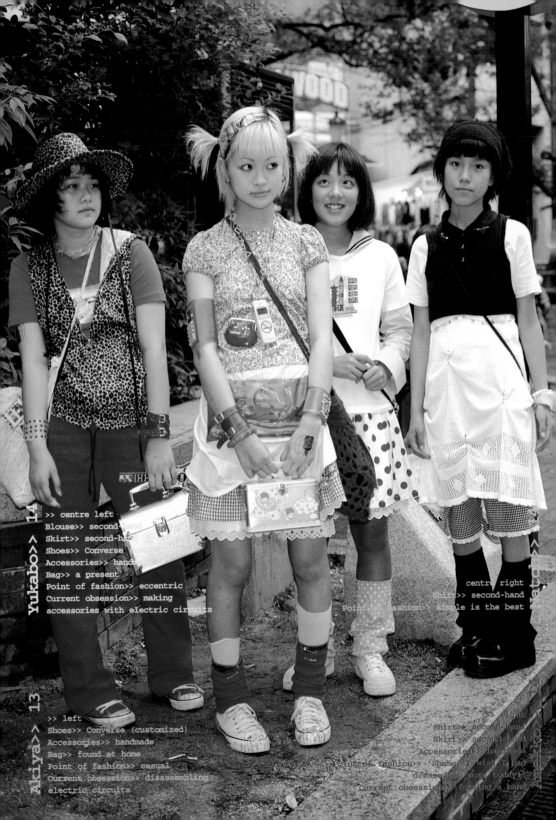

Yukabo>> 14

>> centre left
Blouse>> second-hand
Skirt>> second-hand
Shoes>> Converse
Accessories>> handmade
Bag>> a present
Point of fashion>> eccentric
Current obsession>> making
accessories with electric circuits

Akiya>> 13

>> left
Shoes>> Converse (customized)
Accessories>> handmade
Bag>> found at home
Point of fashion>> casual
Current obsession>> disassembling
electric circuits

centre right
Shirt>> second-hand
Point of fashion>> simple is the best

right
Shirt>> second-hand
Skirt>> second-hand
Accessories>> handmade
Point of fashion>> Shame, I wish I had
dressed up more today!
Current obsession>> forming a band

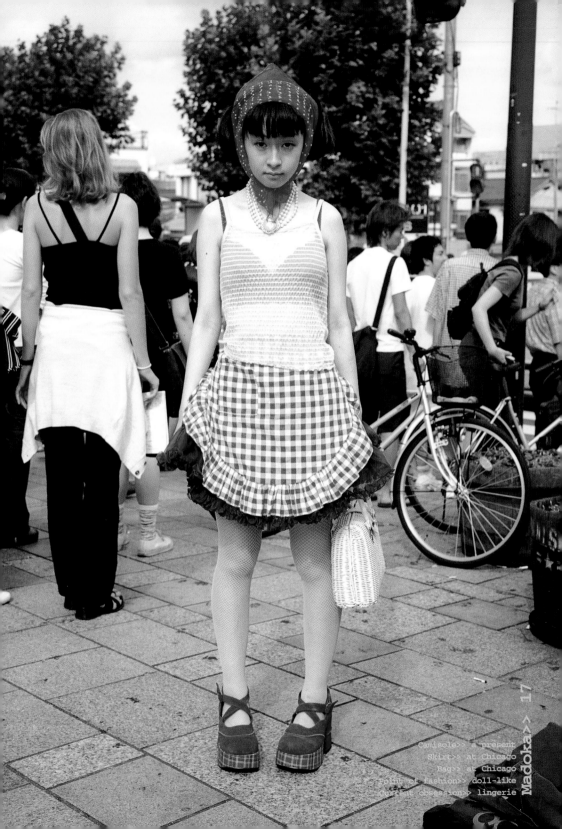

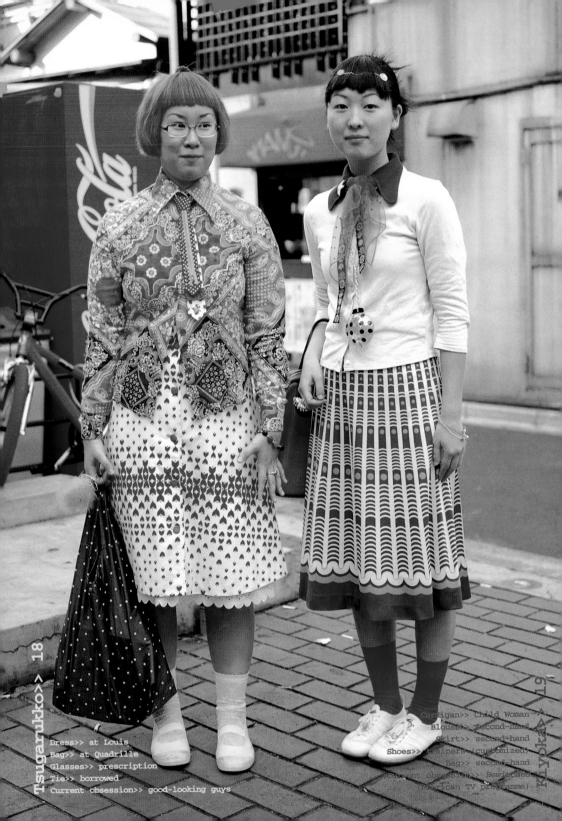

Dress>> at Louis
Bag>> at Quadrille
Glasses>> prescription
Tie>> borrowed
Current obsession>> good-looking guys

Cardigan>> Child Woman
Blouse>> second-hand
Skirt>> second-hand
Shoes>> trainers (customized)
Bag>> second-hand
Current obsession>> Bewitched
(American TV programme)

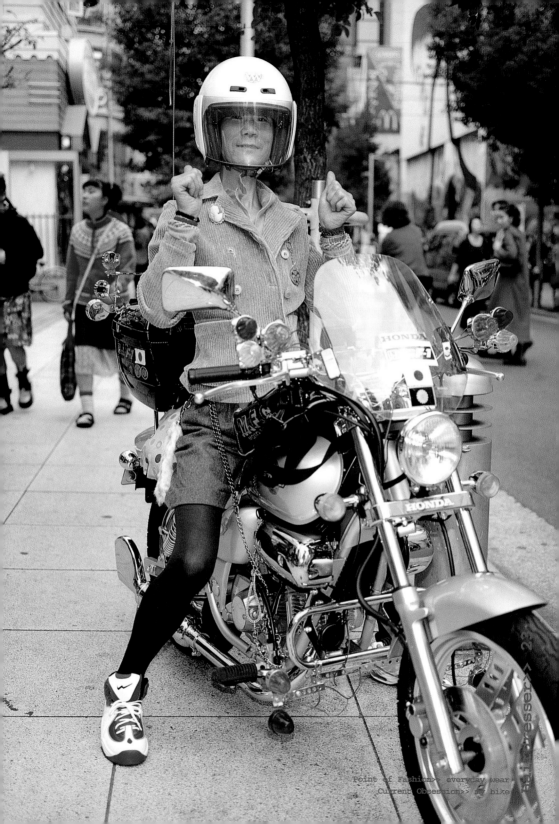

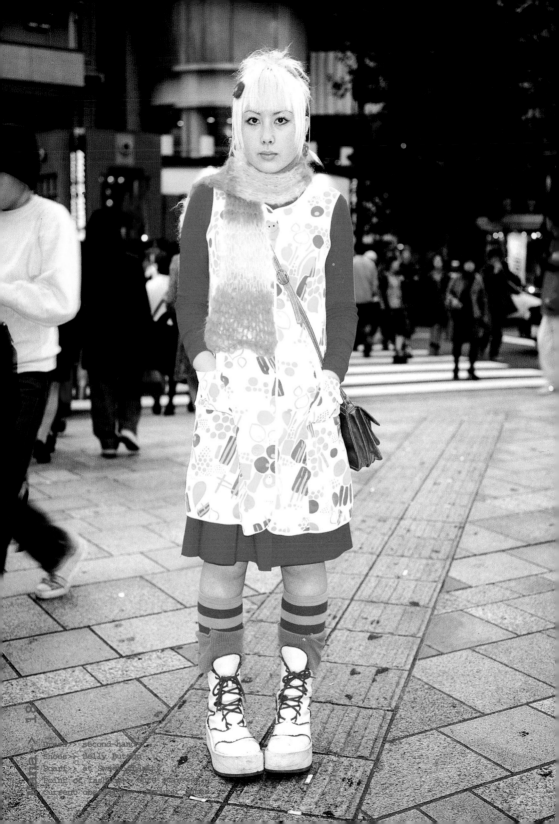

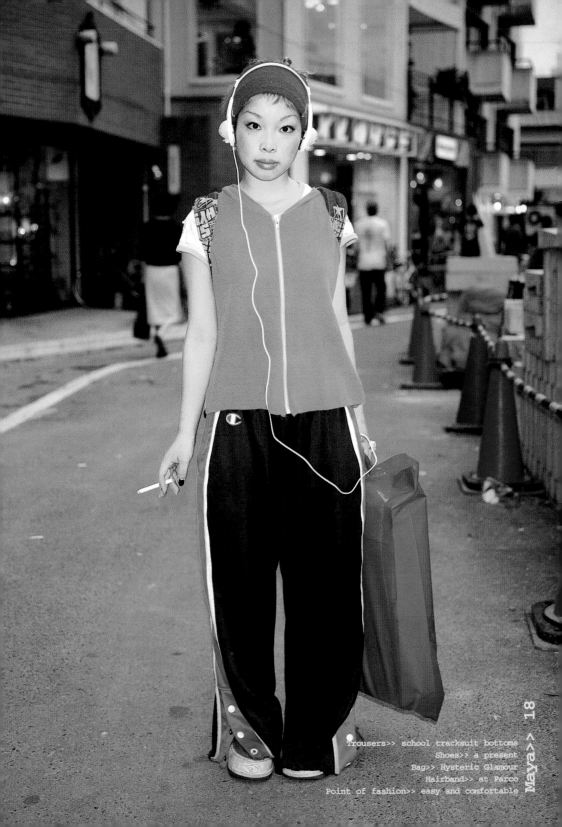

Trousers>> school tracksuit bottoms
Shoes>> a present
Bag>> Hysteric Glamour
Hairband>> at Parco
Point of fashion>> easy and comfortable

Maya>> 18

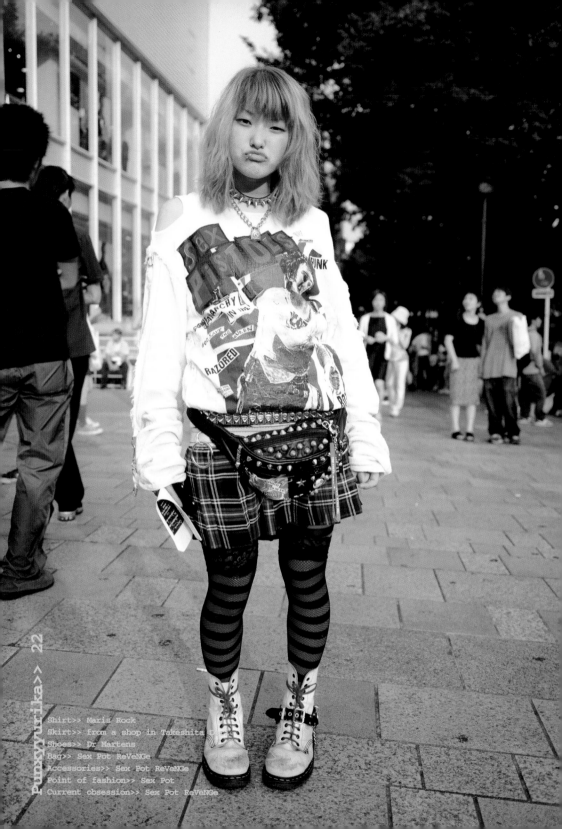

Shirt>> Maris Rock
Skirt>> from a shop in Takeshita t
Shoes>> Dr Martens
Bag>> Sex Pot ReVeNGe
Accessories>> Sex Pot ReVeNGe
Point of fashion>> Sex Pot
Current obsession>> Sex Pot ReVeNGe

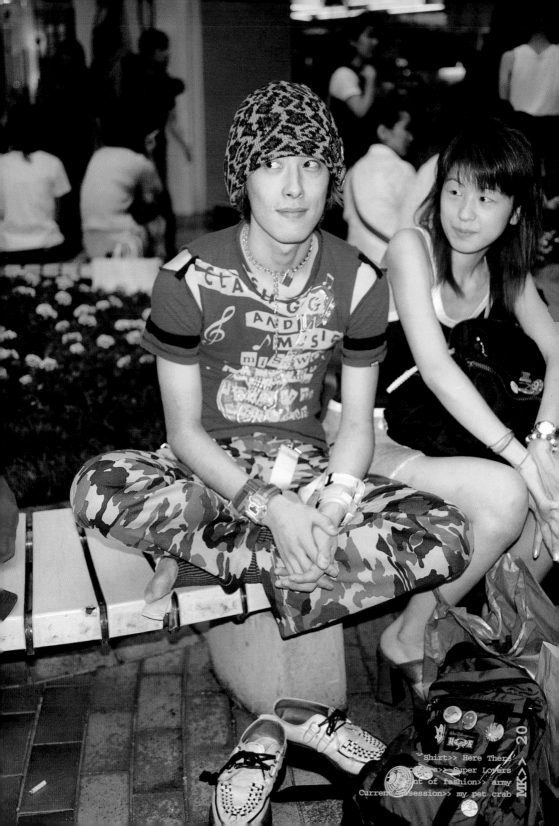

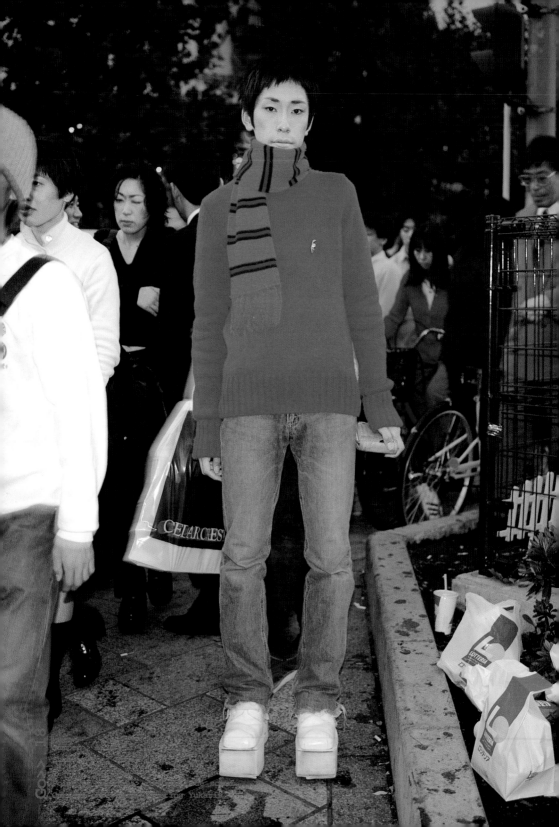

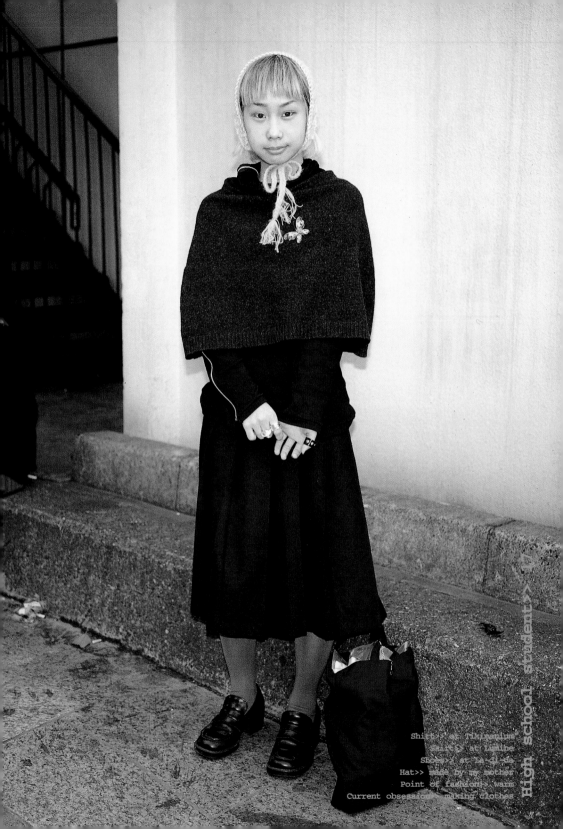

Shirt>> at Thingvellum
Skirt>> at Limbe
Shoes>> at La-di-da
Hat>> made by my mother
Point of fashion>> warm
Current obsession>> making clothes

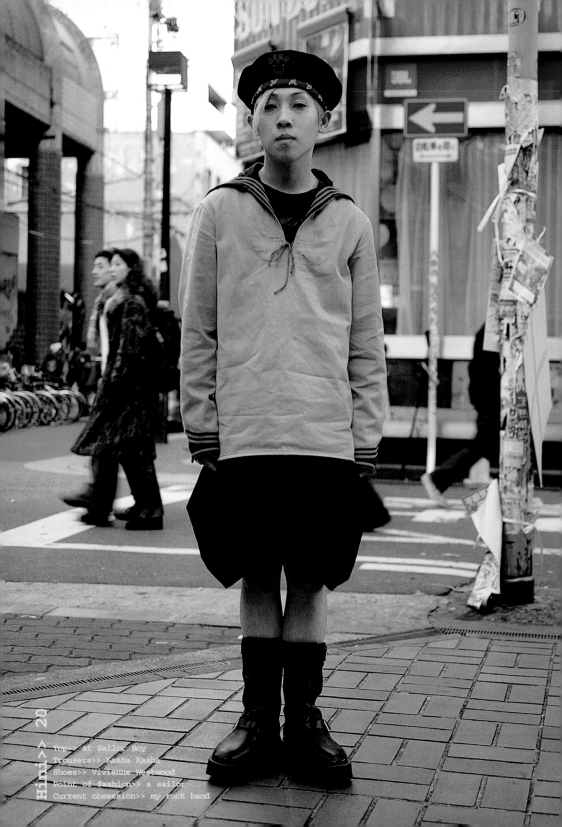

Top>> at Sailor Boy
Trousers>> Kasha Kasha
Shoes>> Vivienne Westwood
Point of fashion>> a sailor
Current obsession>> my rock band

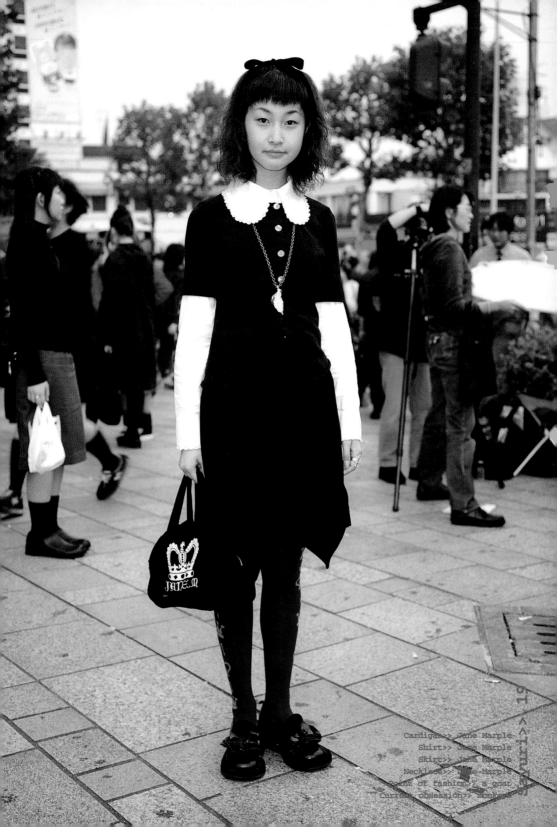

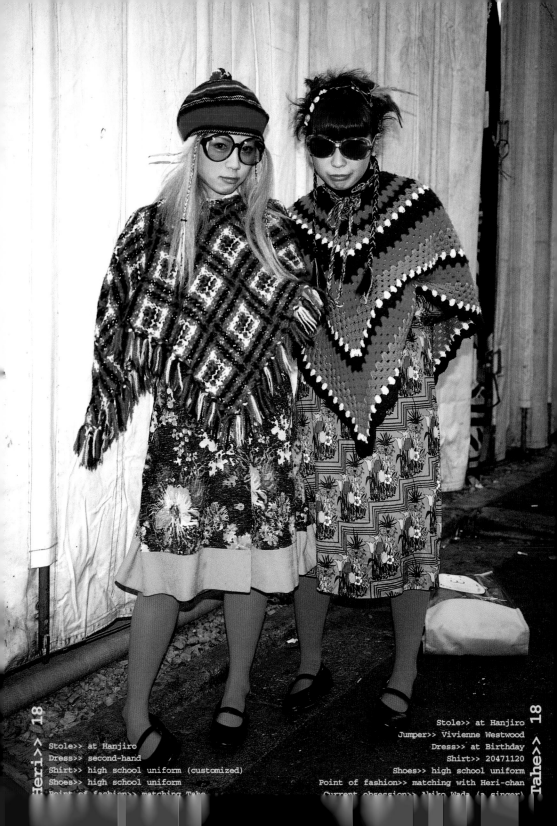

Stole>> at Hanjiro
Dress>> second-hand
Shirt>> high school uniform (customized)
Shoes>> high school uniform
Point of fashion>> matching Tahe

Stole>> at Hanjiro
Jumper>> Vivienne Westwood
Dress>> at Birthday
Shirt>> 20471120
Shoes>> high school uniform
Point of fashion>> matching with Heri-chan
Current obsession>> Akiko Wada (a singer)

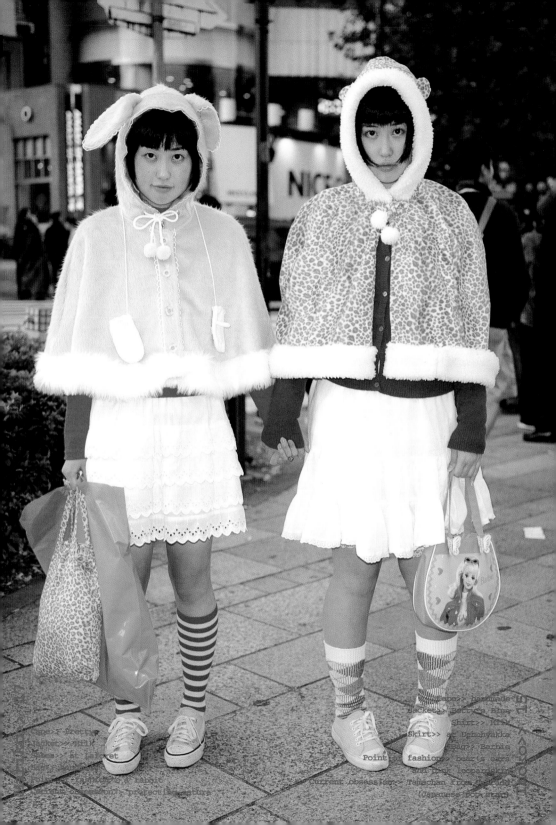

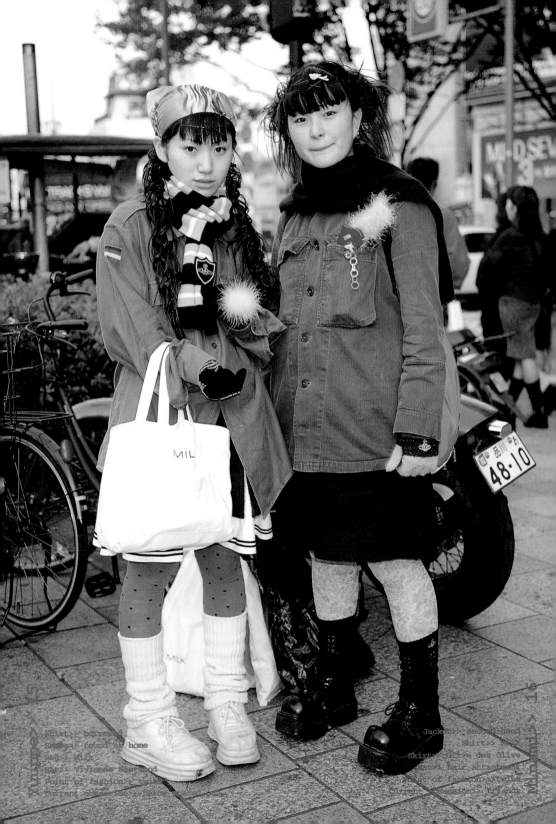

Shirt>> borrowed
Skirt>> found at home
Bag>> MILK
Shoes>> Vivienne Westwood
Point of fashion>> ...
Current obsession>> ...

Jacket>> second-hand
Shirt>> ...
Skirt>> Olive des Olive
...>> hair attachment
Point of fashion>> ...
Current obsession>> friends

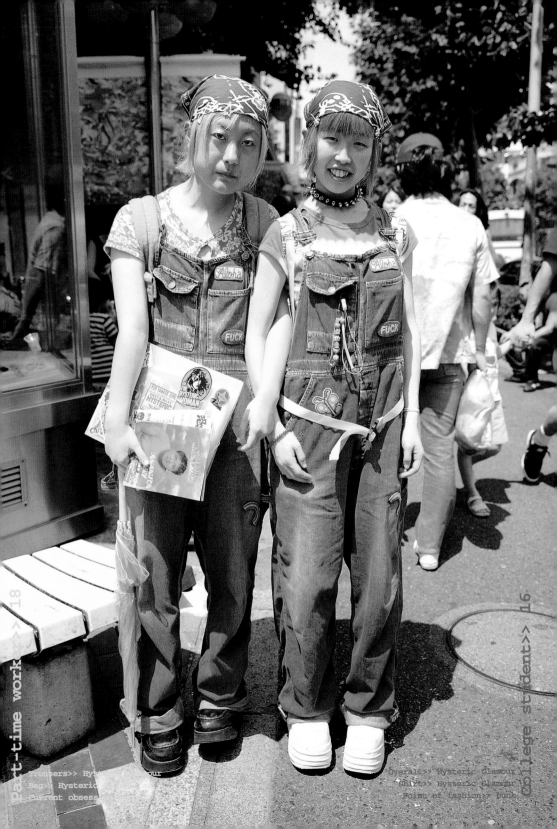

Trousers>> Hys our
Bag>> Hysteri
current obsess

Overall>> Hysteric Glamour
Shirt>> Hysteric Glamour
Point of fashion>> punk

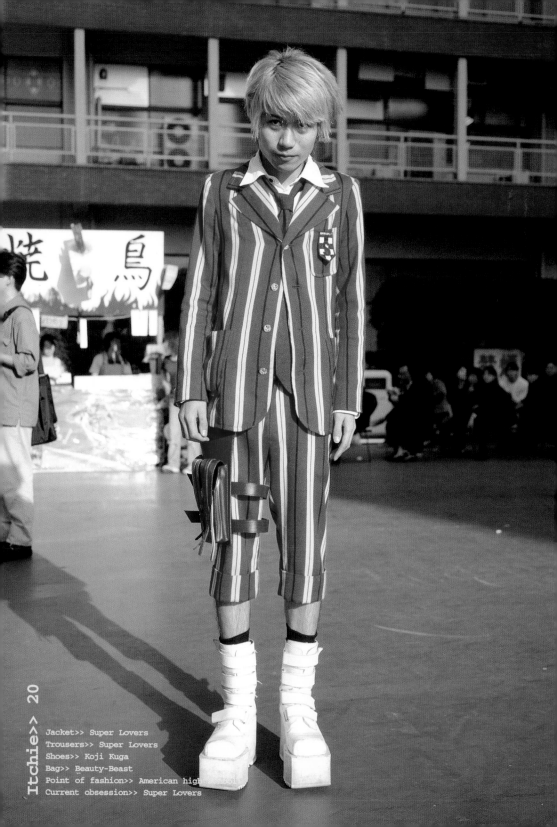

Itchie>> 20

Jacket>> Super Lovers
Trousers>> Super Lovers
Shoes>> Koji Kuga
Bag>> Beauty-Beast
Point of fashion>> American high school
Current obsession>> Super Lovers

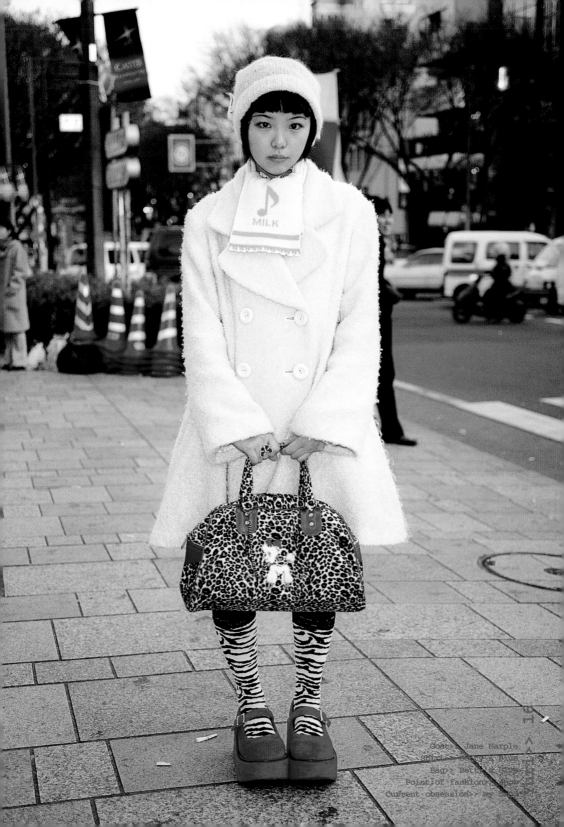

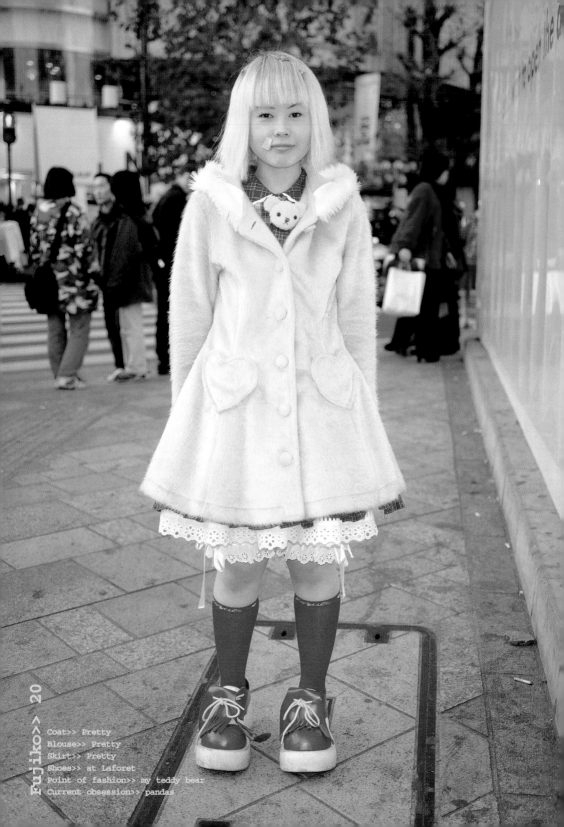

Coat>> Pretty
Blouse>> Pretty
Skirt>> Pretty
Shoes>> at Laforet
Point of fashion>> my teddy bear
Current obsession>> pandas

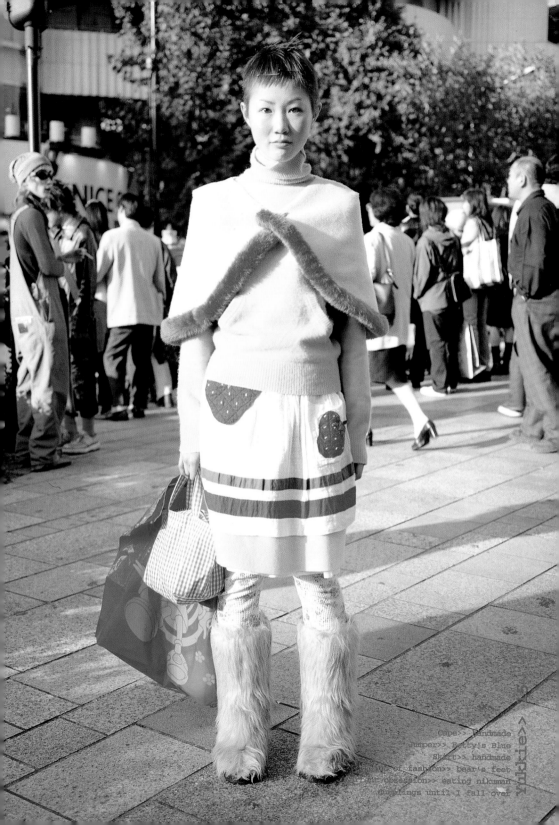

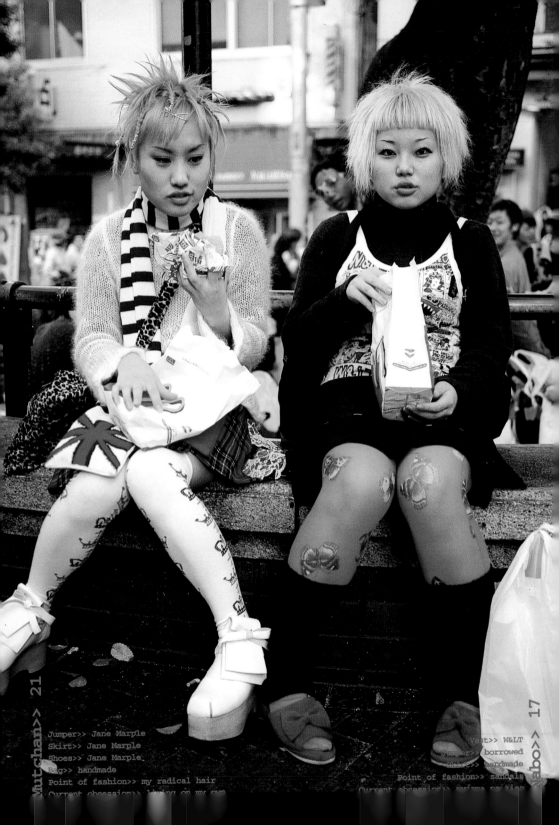

Jumper>> Jane Marple
Skirt>> Jane Marple
Shoes>> Jane Marple
Bag>> handmade
Point of fashion>> my radical hair
Current obsession>> living on my own

Vest>> W<
Jumper>> borrowed
Skirt>> handmade
Point of fashion>> sandals
Current obsession>> prints on ties

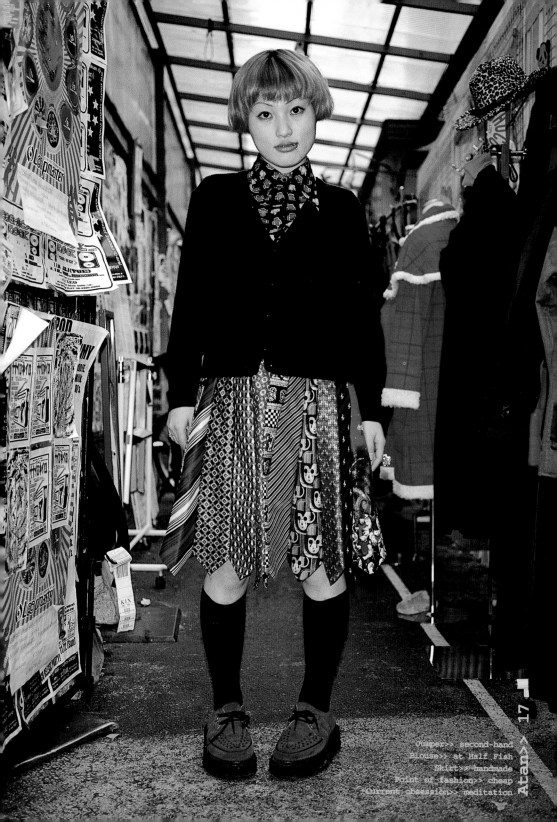

Jumper>> second-hand
Blouse>> at Half Fish
Skirt>> handmade
Point of fashion>> cheap
Current obsession>> meditation

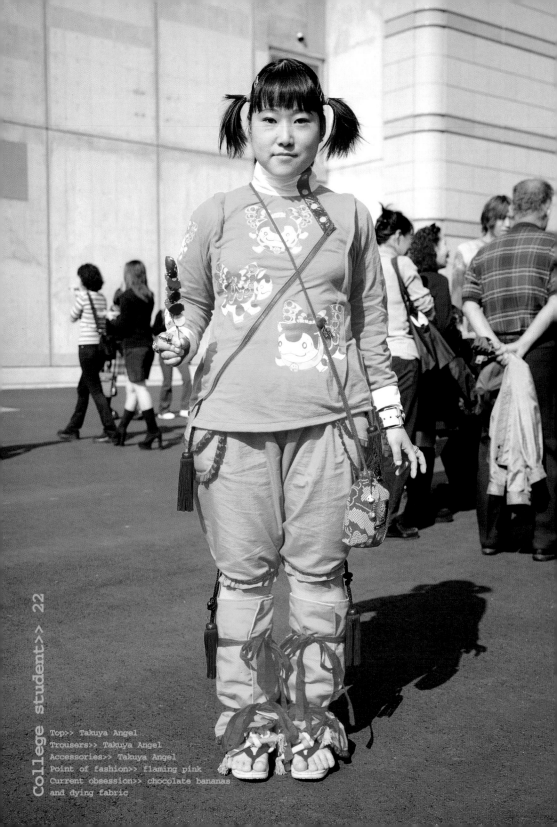

Top>> Takuya Angel
Trousers>> Takuya Angel
Accessories>> Takuya Angel
Point of fashion>> flaming pink
Current obsession>> chocolate bananas
and dying fabric

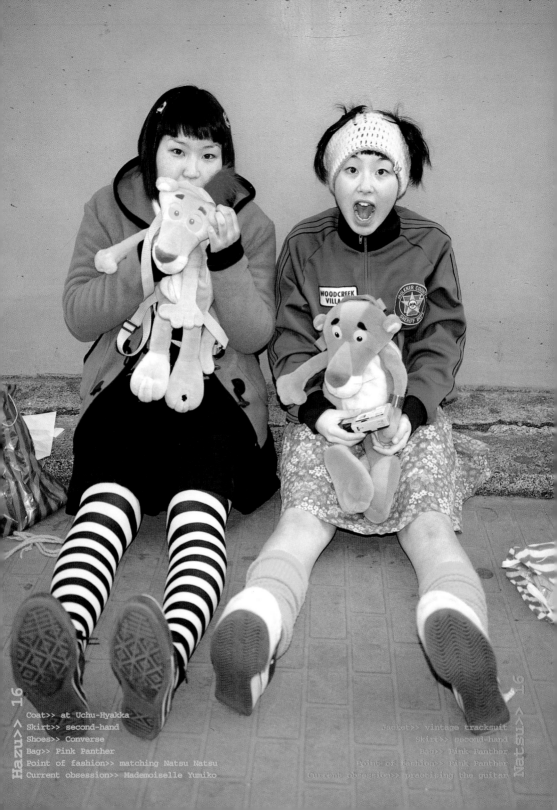

Coat>> at Uchu-Hyakka
Skirt>> second-hand
Shoes>> Converse
Bag>> Pink Panther
Point of fashion>> matching Natsu Natsu
Current obsession>> Mademoiselle Yumiko

Jacket>> vintage tracksuit
Skirt>> second-hand
Bag>> Pink Panther
Point of fashion>> Pink Panther
Current obsession>> practising the guitar

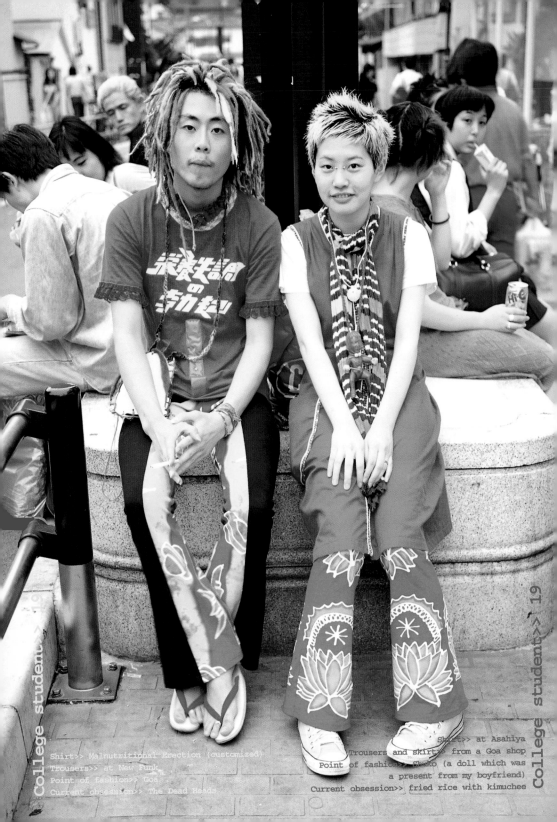

Shirt>> Malnutritional Erection (customized)
Trousers>> at New Funk
Point of fashion>> Goa
Current obsession>> The Dead Heads

Shirt>> at Asahiya
Trousers and skirt>> from a Goa shop
Point of fashion>> Shoko (a doll which was a present from my boyfriend)
Current obsession>> fried rice with kimuchee

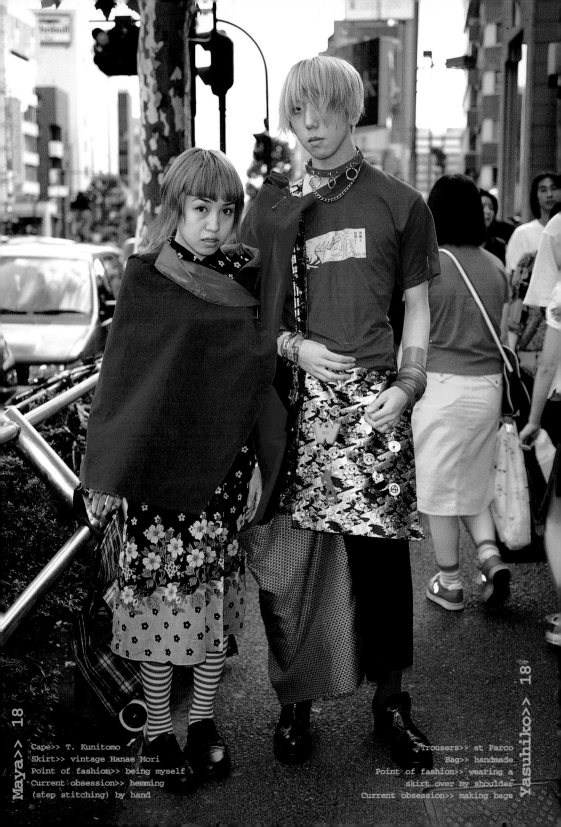

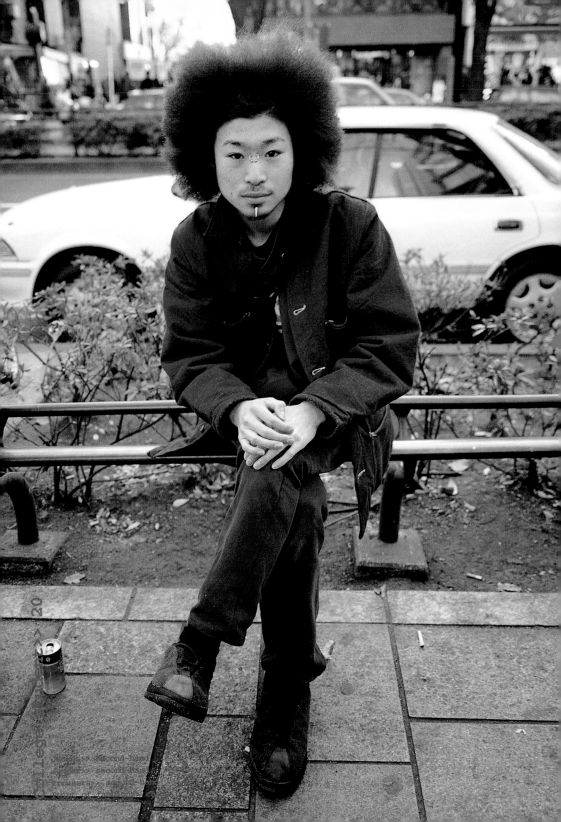

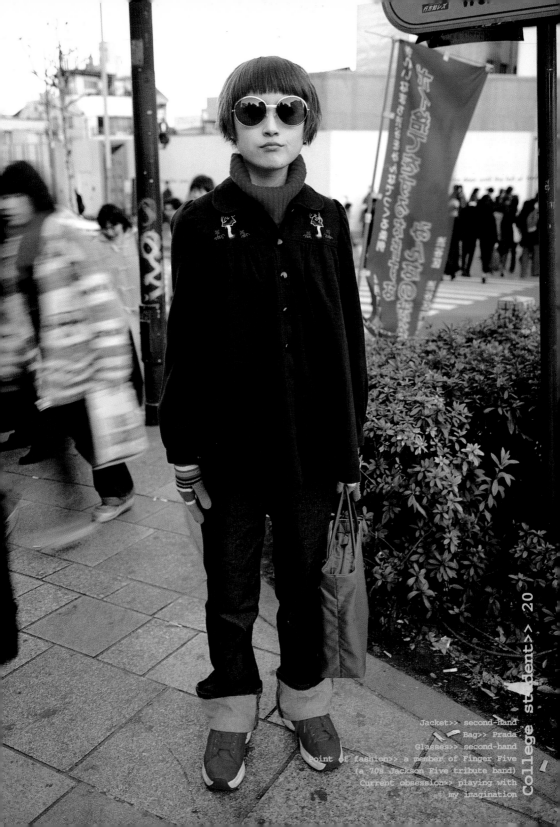

Jacket>> second-hand
Bag>> Prada
Glasses>> second-hand
Point of fashion>> a member of Finger Five
(a 70s Jackson Five tribute band)
Current obsession>> playing with
my imagination

College student>> 20

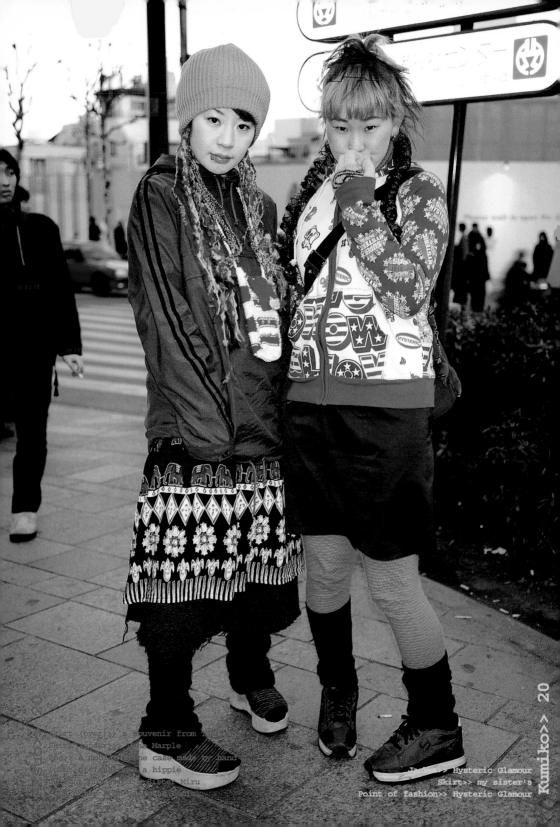

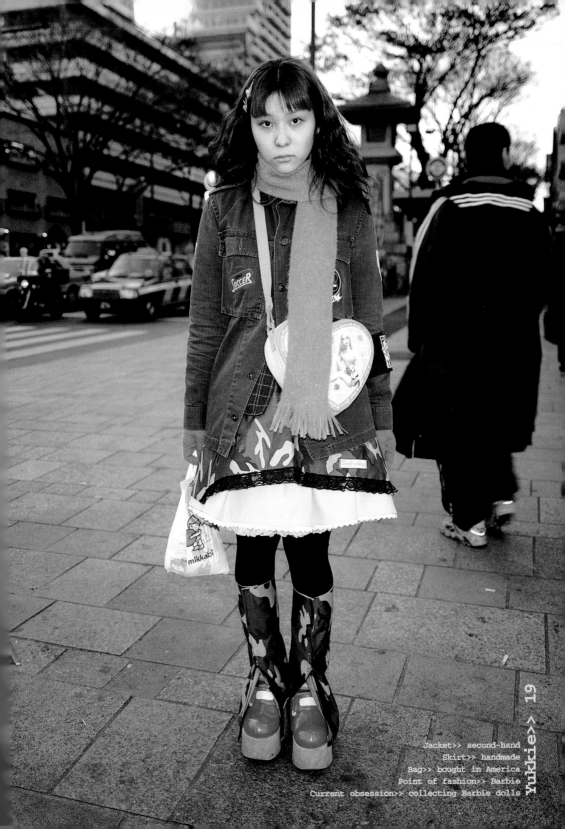

Jacket>> second-hand
Skirt>> handmade
Bag>> bought in America
Point of fashion>> Barbie
Current obsession>> collecting Barbie dolls

Yukkie>> 19

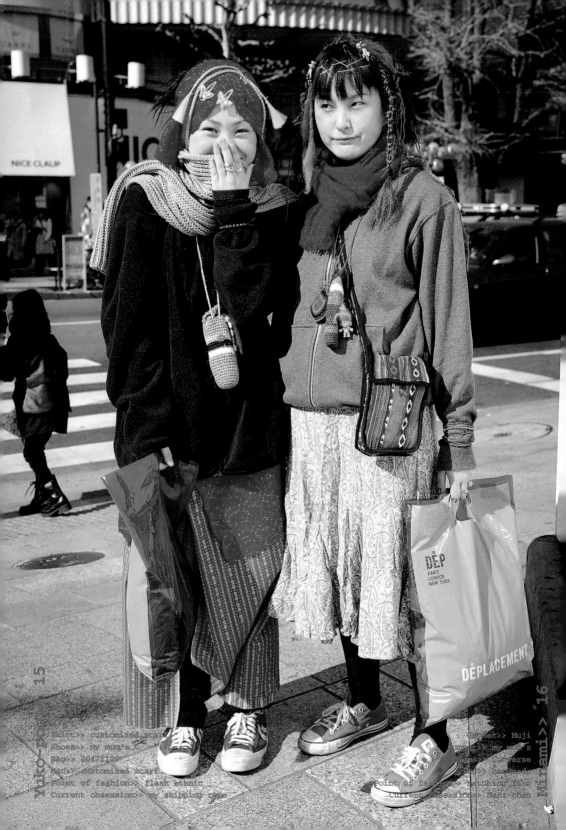

Shirt>> customized
Shoes>> my mum's
Bag>> 20471120
Hat>> customized scarf
Point of fashion>> flash ethnic
Current obsession>> my skipping rope

Jacket>> Muji
Shoes>> Converse
Point of fashion>> matching Yuko
Current obsession>> Maki-chan

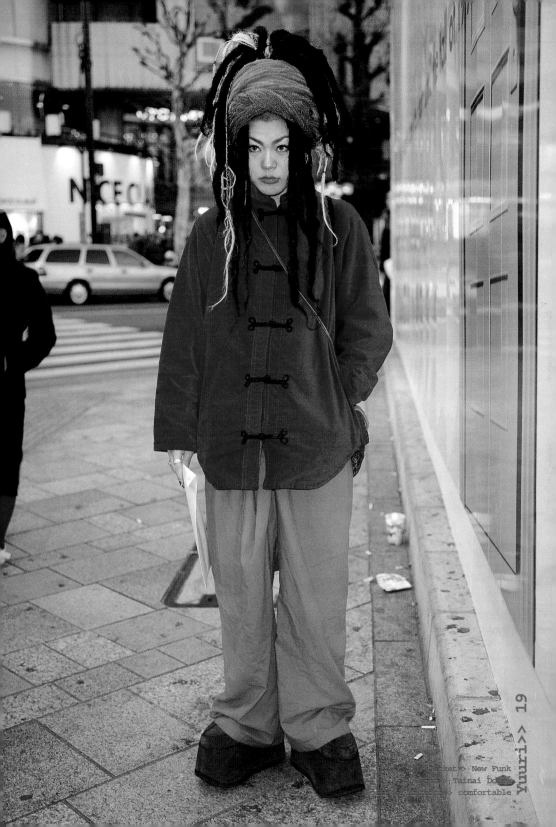

ket>> New Funk
Tainai Do
>> comfortable

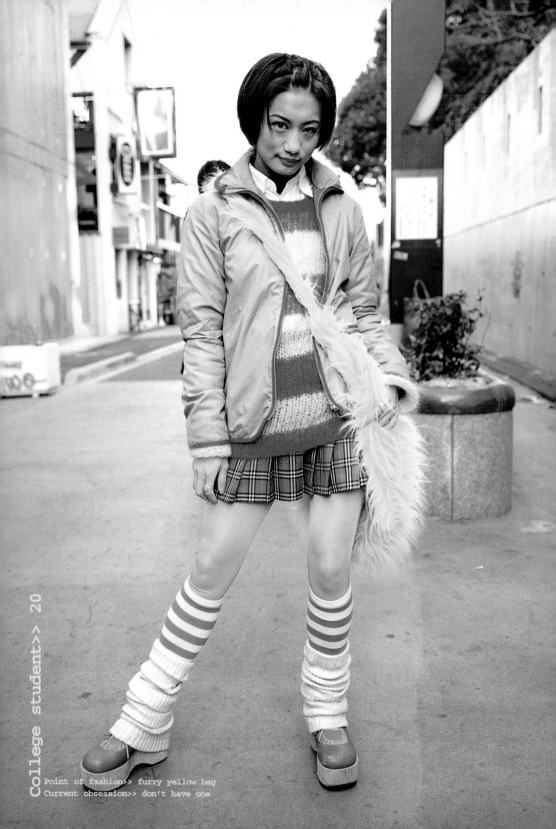

Point of fashion>> furry yellow bag
Current obsession>> don't have one

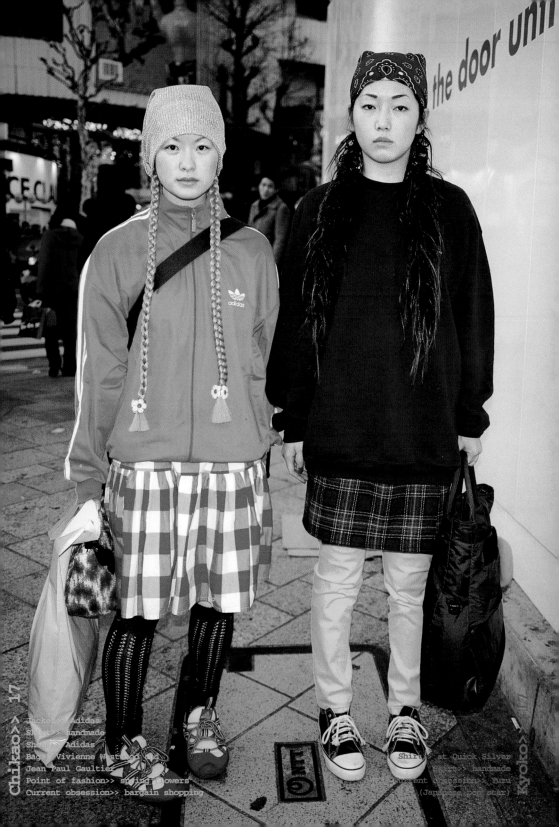

Chikao>> 17

Jacket>> Adidas
Shirt>> handmade
Shoes>> Adidas
Bag>> Vivienne Westwood and
Jean Paul Gaultier
Point of fashion>> spring flowers
Current obsession>> bargain shopping

Kyoko>> 17

Shirt>> at Quick Silver
Skirt>> handmade
Current obsession>> Puru
(Japanese pop star)

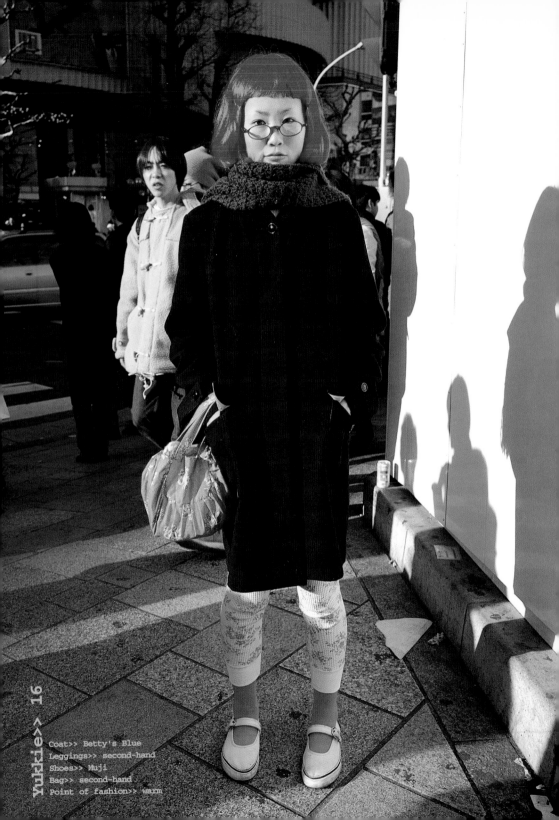

Coat>> Betty's Blue
Leggings>> second-hand
Shoes>> Muji
Bag>> second-hand
Point of fashion>> warm

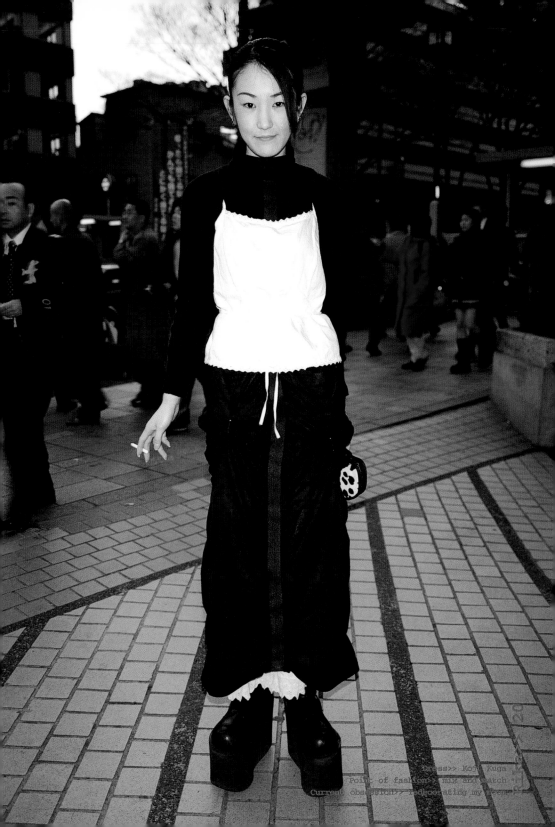

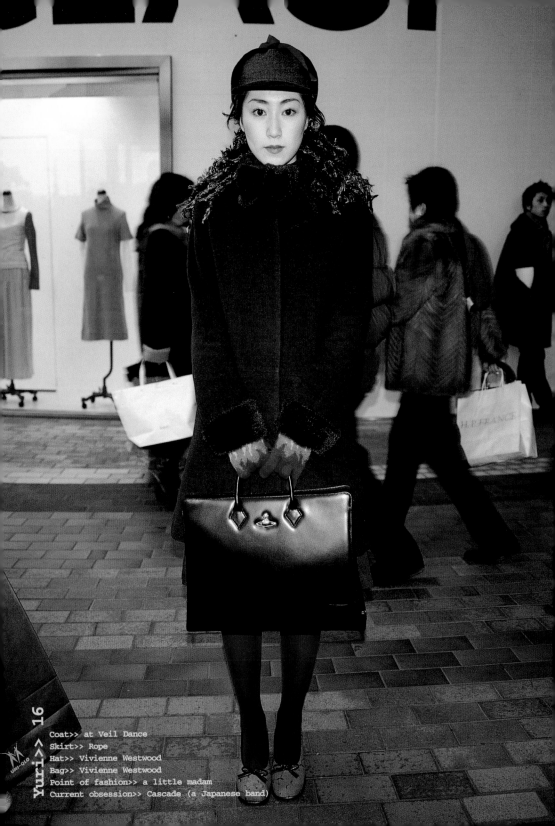

Yuri>> 16

Coat>> at Veil Dance
Skirt>> Rope
Hat>> Vivienne Westwood
Bag>> Vivienne Westwood
Point of fashion>> a little madam
Current obsession>> Cascade (a Japanese band)

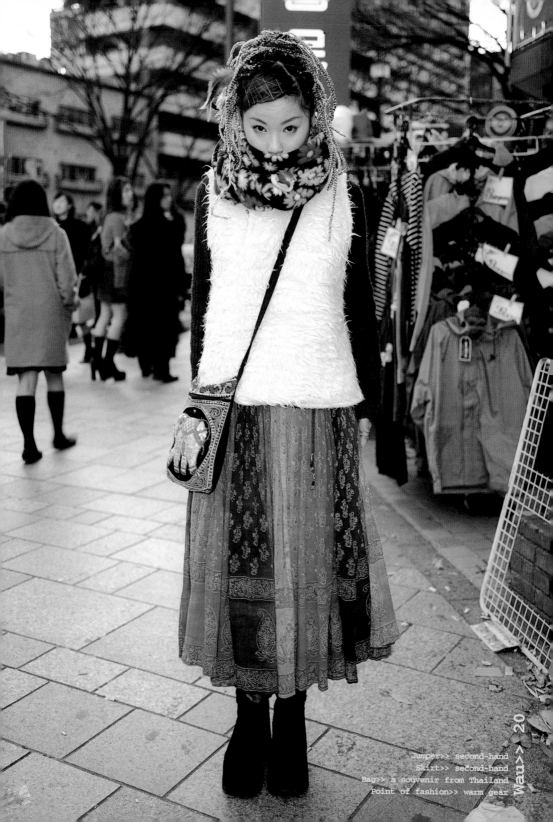

Jumper>> second-hand
Skirt>> second-hand
Bag>> a souvenir from Thailand
Point of fashion>> warm gear

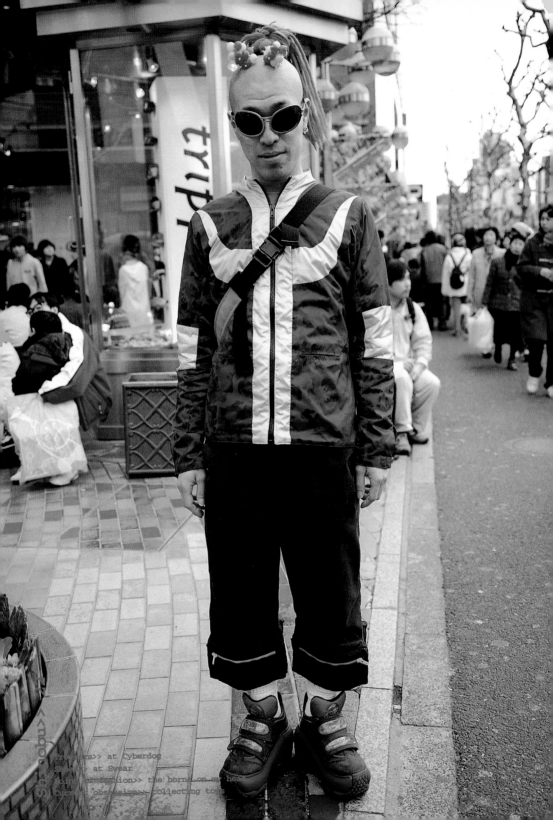

>> at Cyberdog
at Swear
the born on-
collecting to

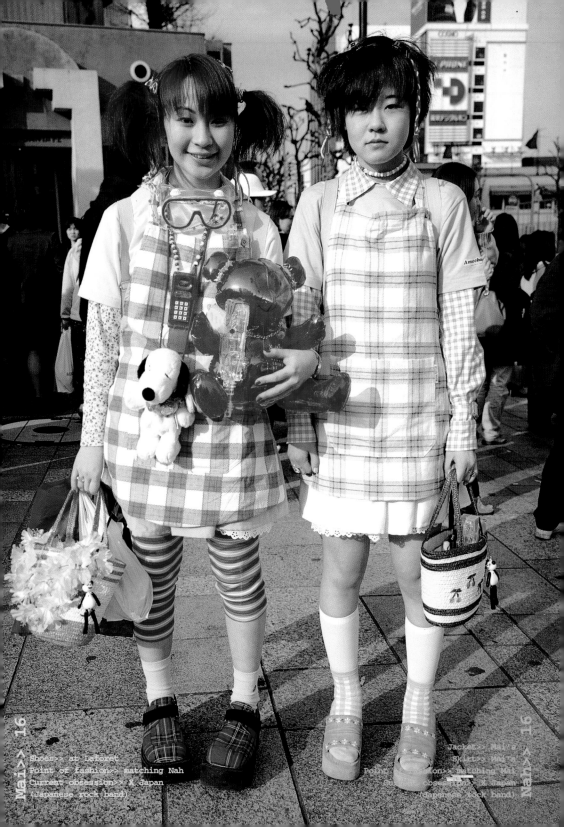

Shoes>> at Laforet
Point of fashion>> matching Nah
Current obsession>> X Japan
(Japanese rock band)

Jacket>> Mai's
Skirt>> Mai's
Point of fashion>> matching Mai
Current obsession>> X Japan
(Japanese rock band)

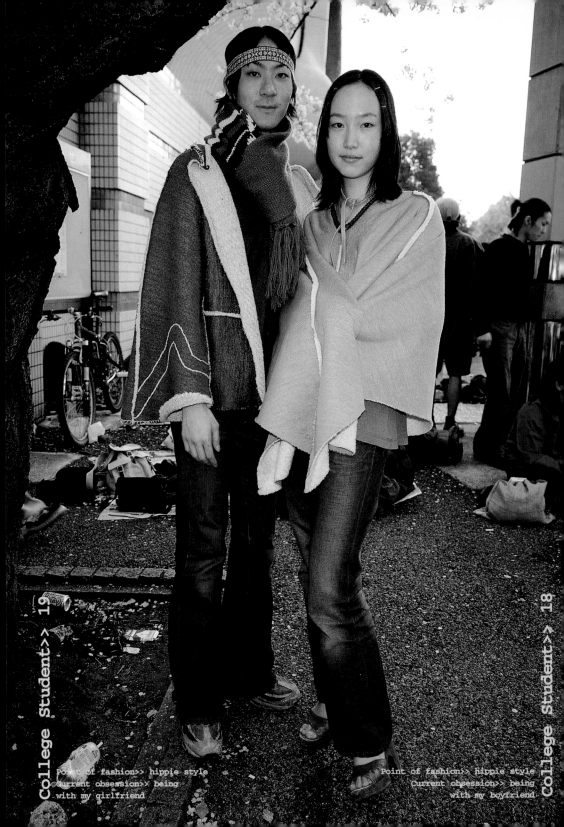

Point of fashion>> hippie style
Current obsession>> being
with my girlfriend

Point of fashion>> hippie style
Current obsession>> being
with my boyfriend

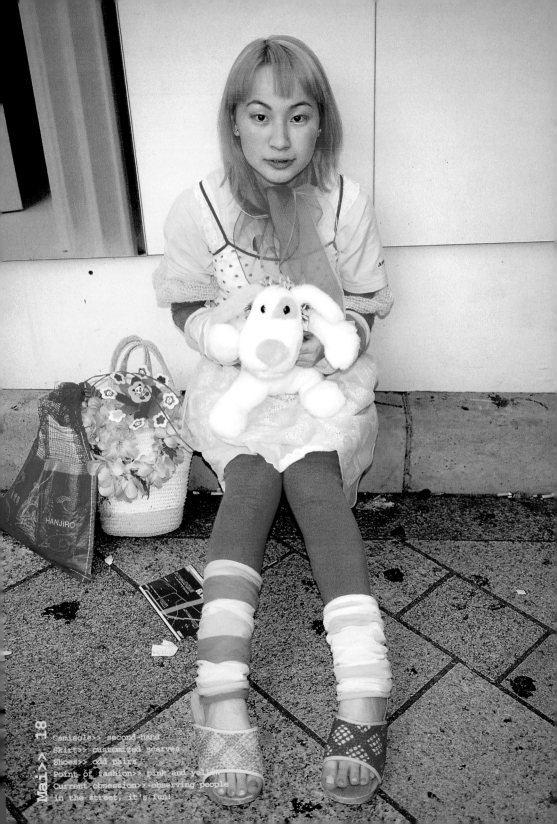

Mai>> 18

Camisole>> second-hand
Skirt>> customized scarves
Shoes>> odd pairs
Point of fashion>> pink and yellow
Current obsession>> observing people
in the street, it's fun!

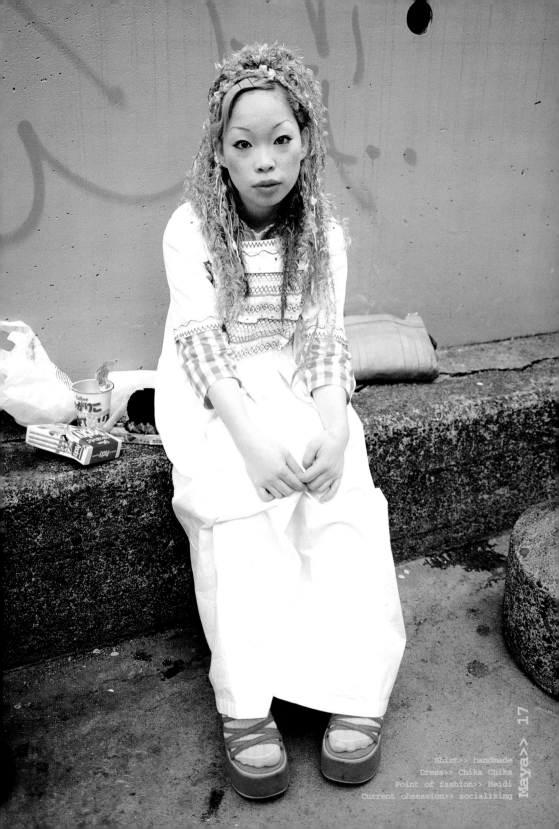

Shirt>> handmade
Dress>> Chika Chika
Point of fashion>> Heidi
Current obsession>> socializing

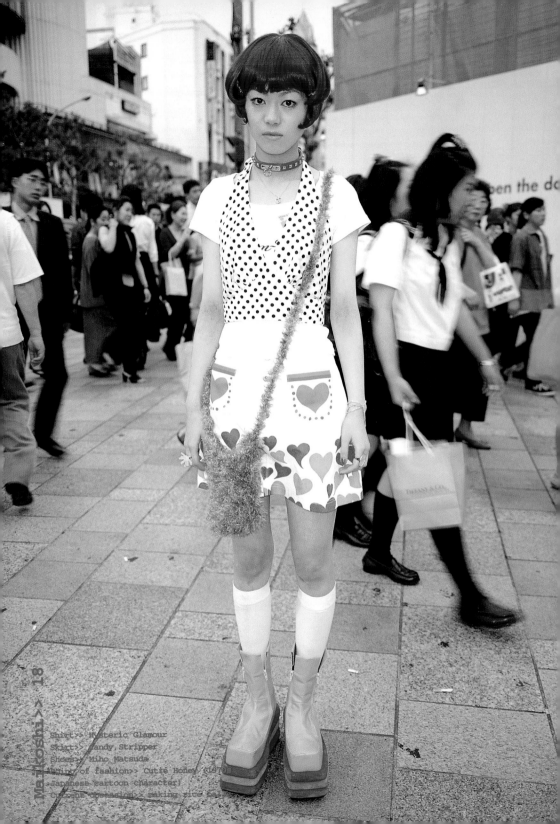

Shirt>> Hysteric Glamour
Skirt>> Candy Stripper
Shoes>> Miho Matsuda
Point of fashion>> Cutie Honey (1970
Japanese cartoon character)
Current obsession>> making rice balls

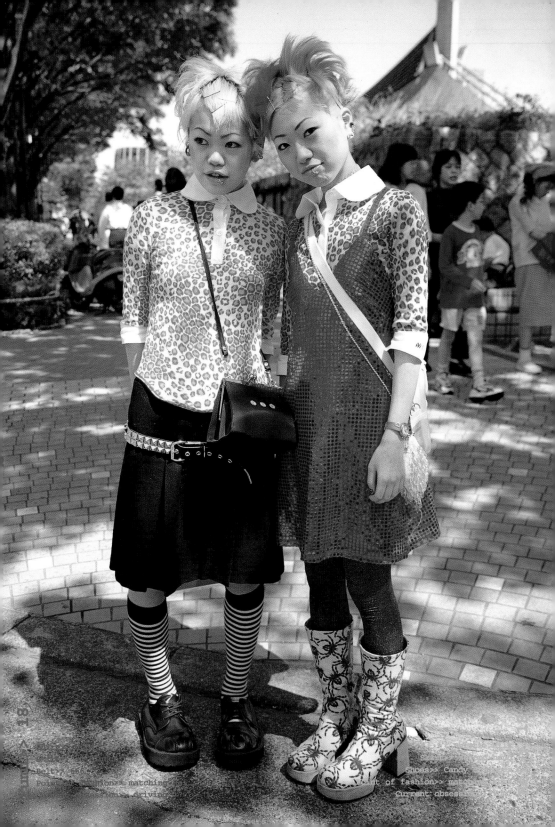

Point of fashion>> matching

shoes>> Candy

point of fashion>> matching

Current obsess

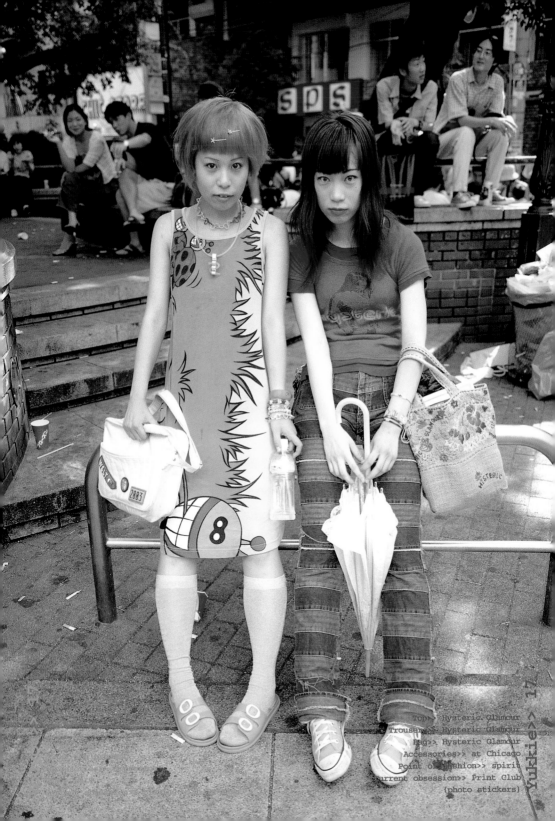

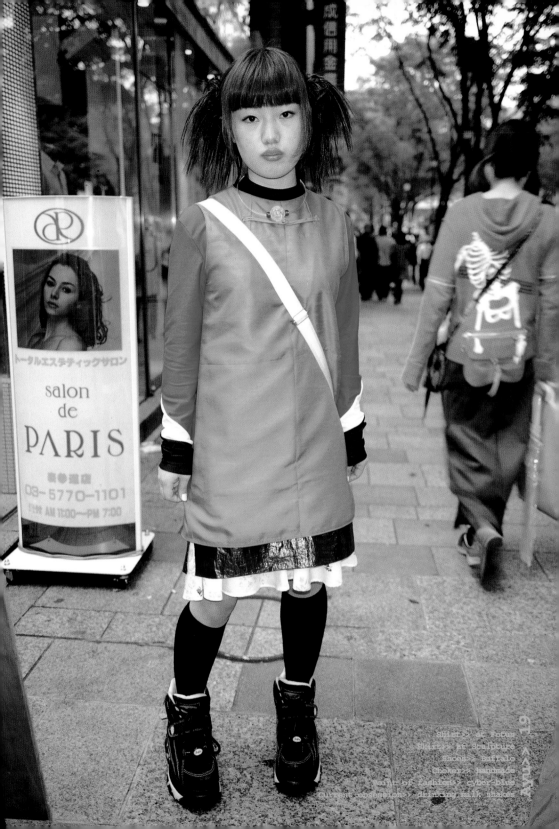

Shirt>> at FOCUS
Skirt>> at Sculpture
Shoes>> Buffalo
Choker>> handmade
Point of fashion>> cyber-blue
Current obsession>> drinking milk-shakes

Ayu >> 19

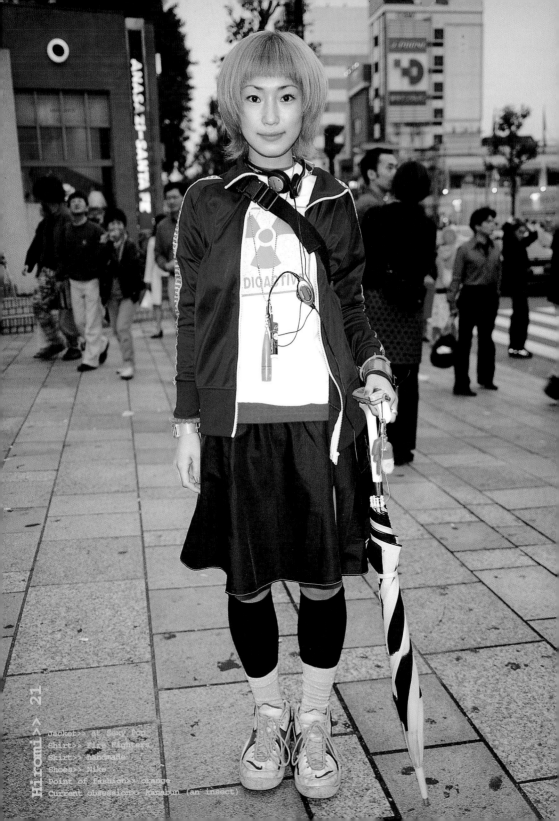

Hiromi >> 21

Jacket >> at Sexy Boy
Shirt >> Fire Fighters
Skirt >> handmade
Shoes >> Nike
Point of fashion >> orange
Current obsession >> Kanabun (an insect)

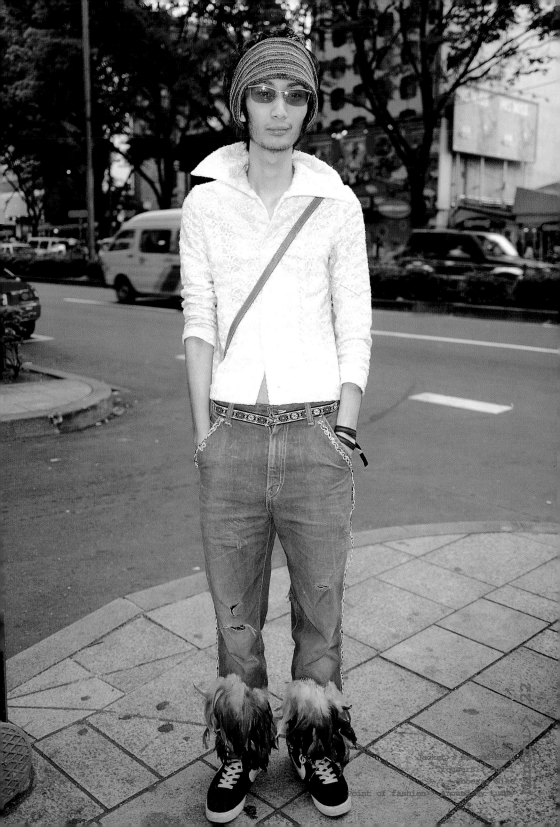

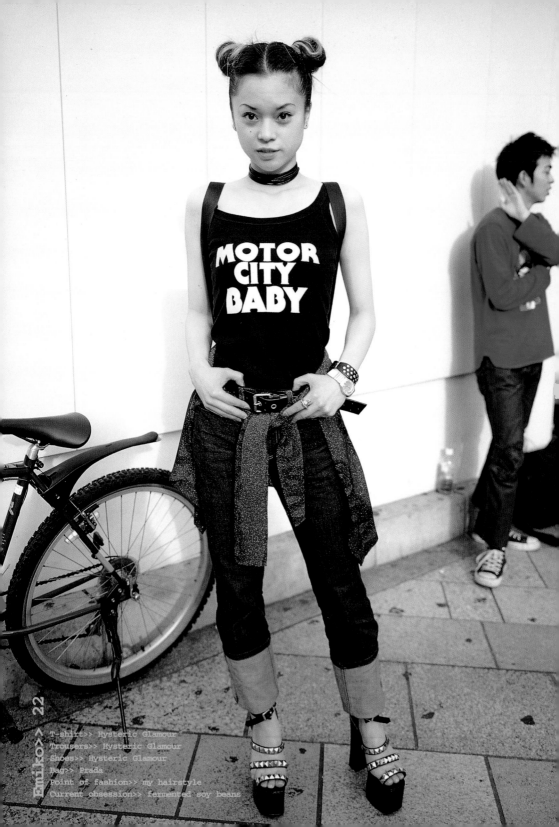

T-shirt>> Hysteric Glamour
Trousers>> Hysteric Glamour
Shoes>> Hysteric Glamour
Bag>> Prada
Point of fashion>> my hairstyle
Current obsession>> fermented soy beans

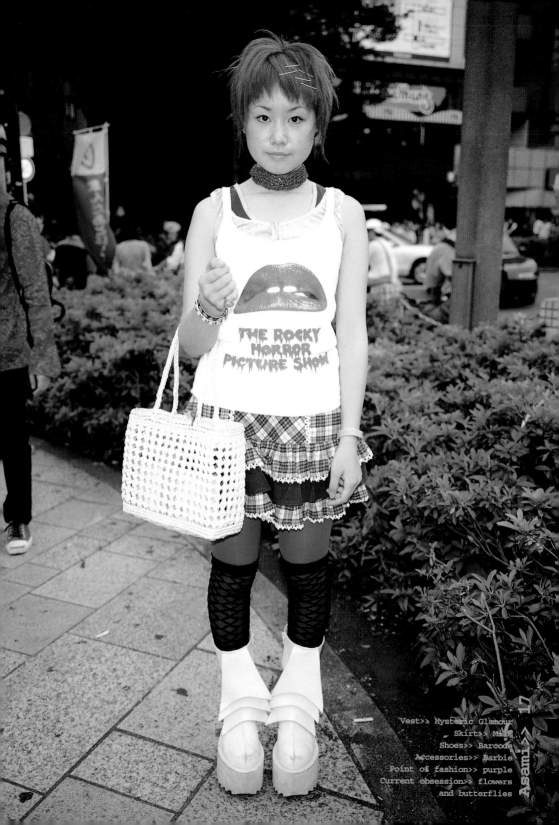

Vest>> Hysteric Glamour
Skirt>> Milk
Shoes>> Barcode
Accessories>> Barbie
Point of fashion>> purple
Current obsession>> flowers
and butterflies

Asami>> 17

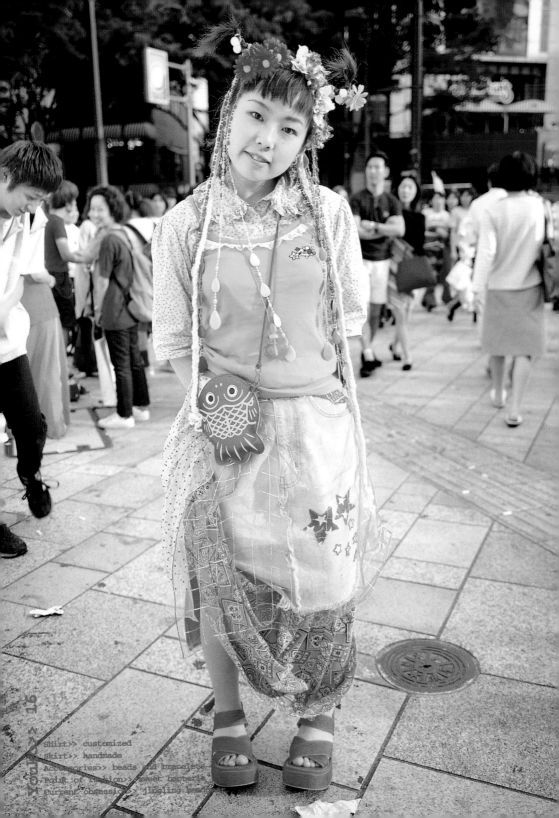

Shirt>> customized
Skirt>> handmade
Accessories>> beads and bracelets
Point of fashion>> sweet natured
Current obsession>> jingling bells

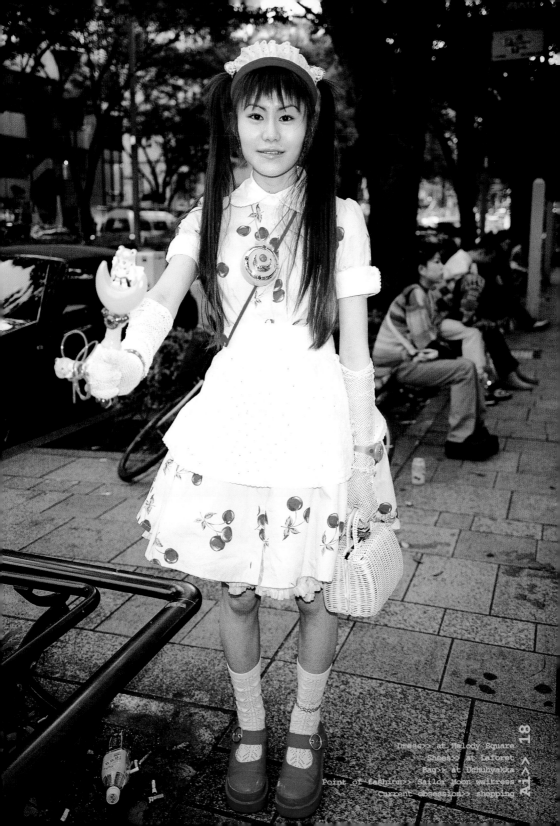

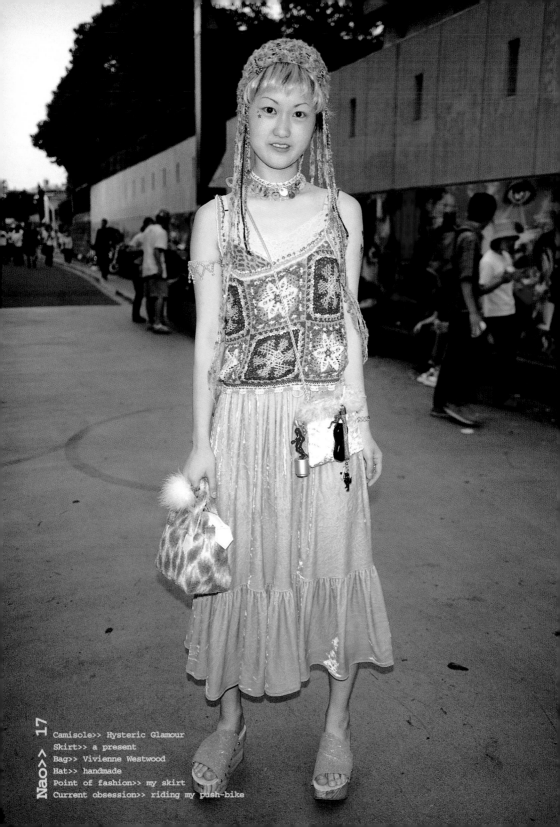

Camisole>> Hysteric Glamour
Skirt>> a present
Bag>> Vivienne Westwood
Hat>> handmade
Point of fashion>> my skirt
Current obsession>> riding my push-bike

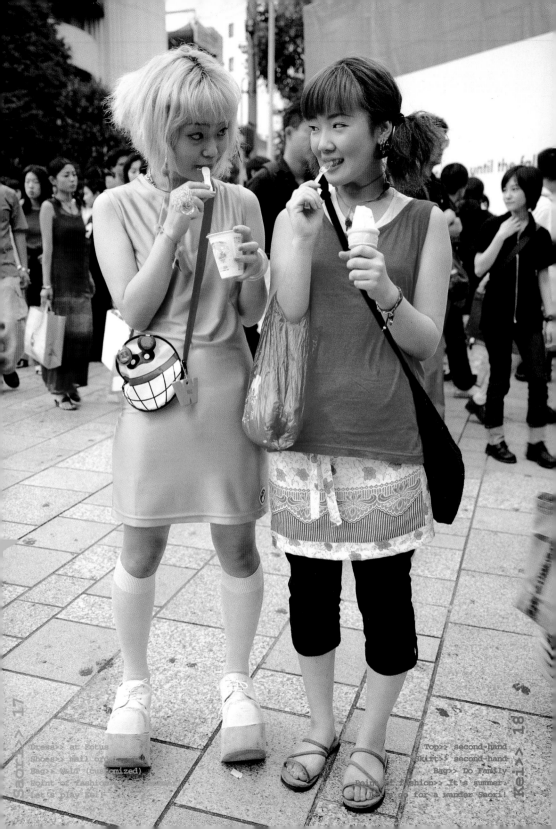

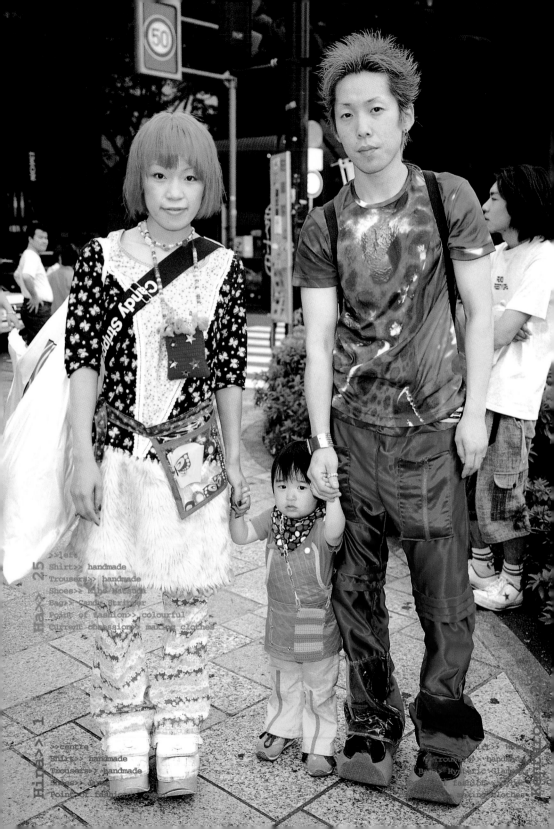

>>left
Shirt>> handmade
Trousers>> handmade
Shoes>> Miho Matsuda
Bag>> Candy Stripper
Point of fashion>> colourful
Current obsession>> making clothes

>>centre
Shirt>> handmade
Trousers>> handmade
Shoes>>
Point of fashion>>

Trousers>> handmade
Shop>> Hysteric Glam
fashion>>
making clothes

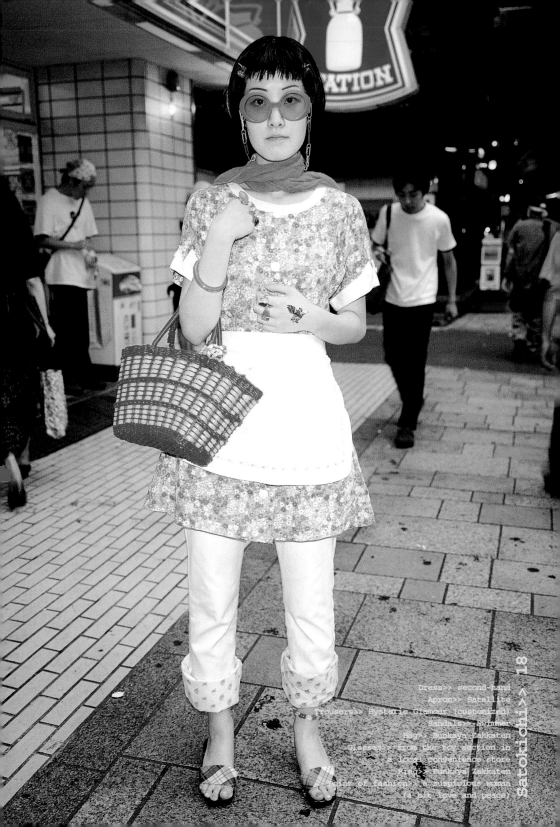

Dress>> second-hand
Apron>> Satellite
Trousers>> Hysteric Glamour (customized)
Sandals>> Swimmer
Bag>> Bunkaya Zakkaten
Glasses>> from the toy section in
a local convenience store
Rings>> Bunkaya Zakkaten
Point of fashion>> a suspicious woman
(a bit love and peace)

Satokichi>> 18

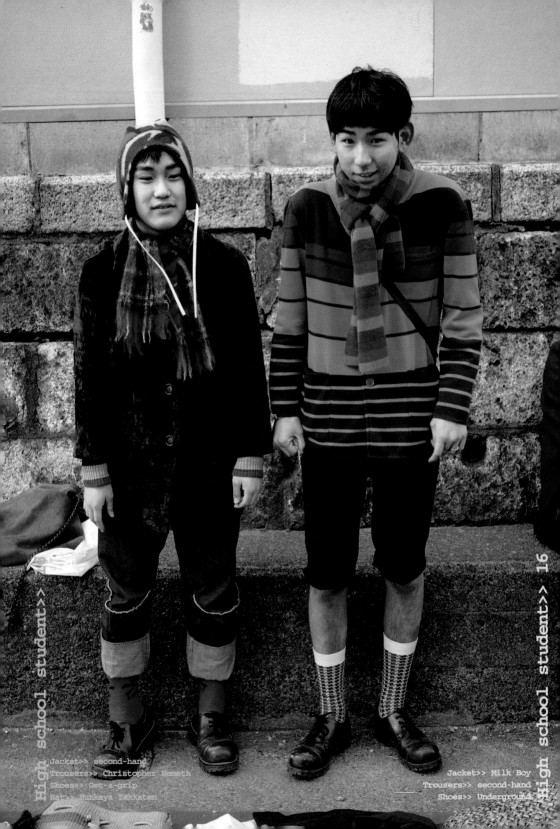

Jacket>> second-hand
Trousers>> Christopher Nemeth
Shoes>> Get-a-grip
Hat>> Bunkaya Zakkaten

Jacket>> Milk Boy
Trousers>> second-hand
Shoes>> Underground

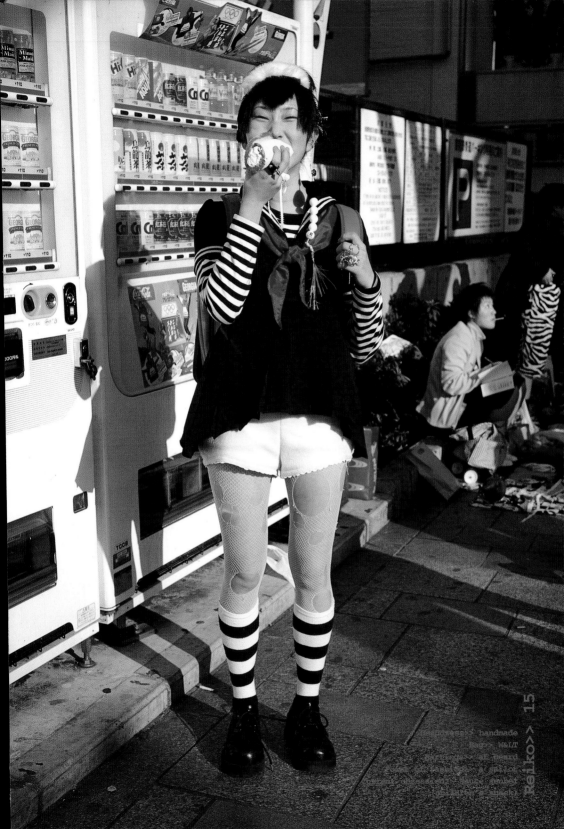

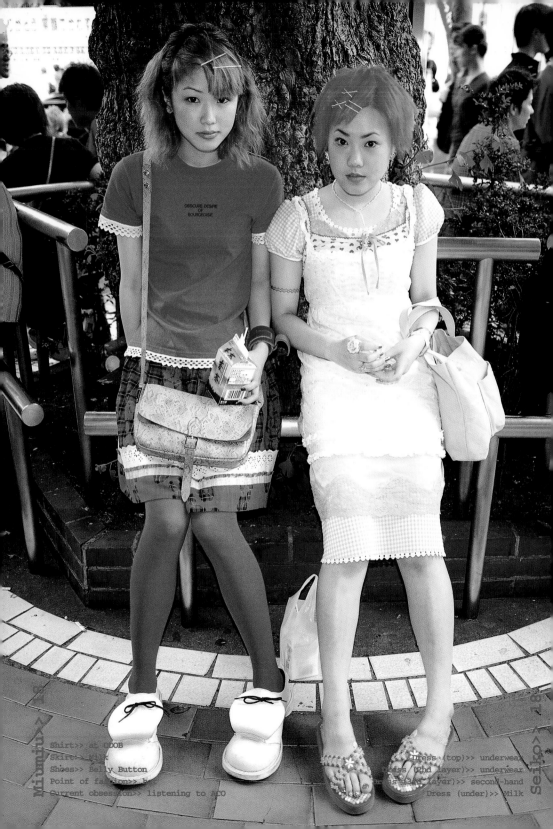

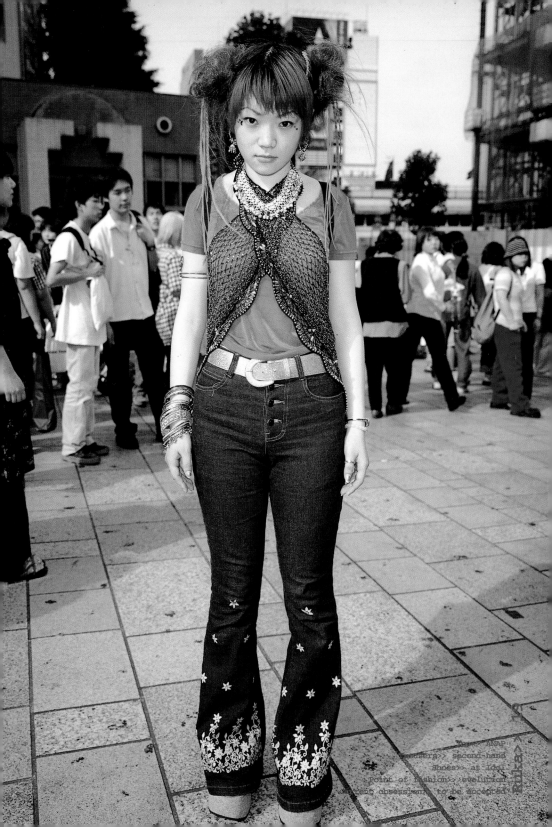

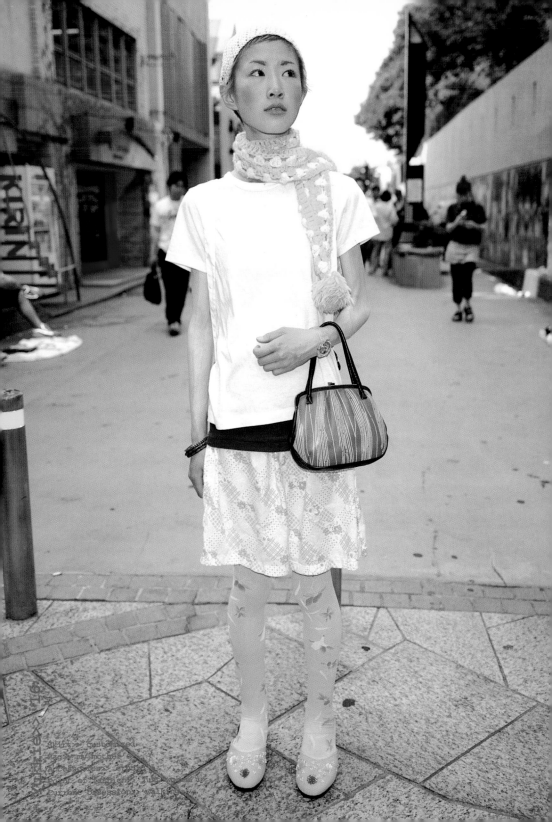

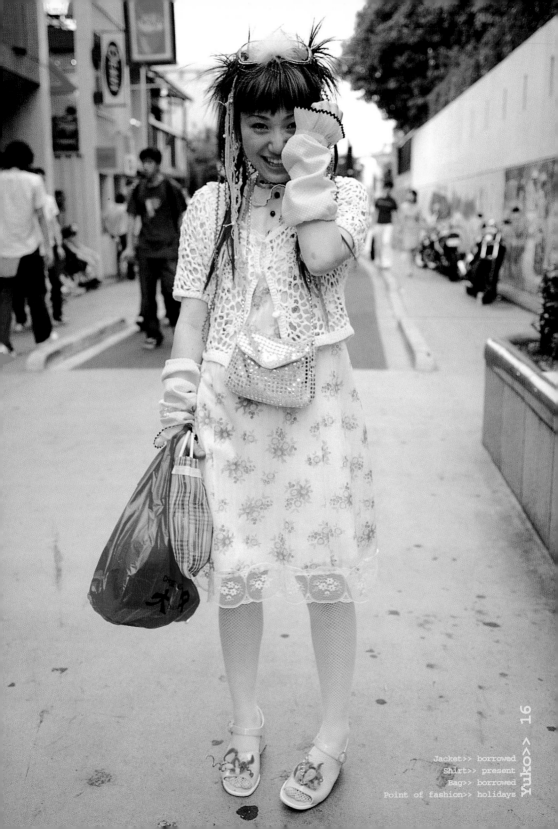

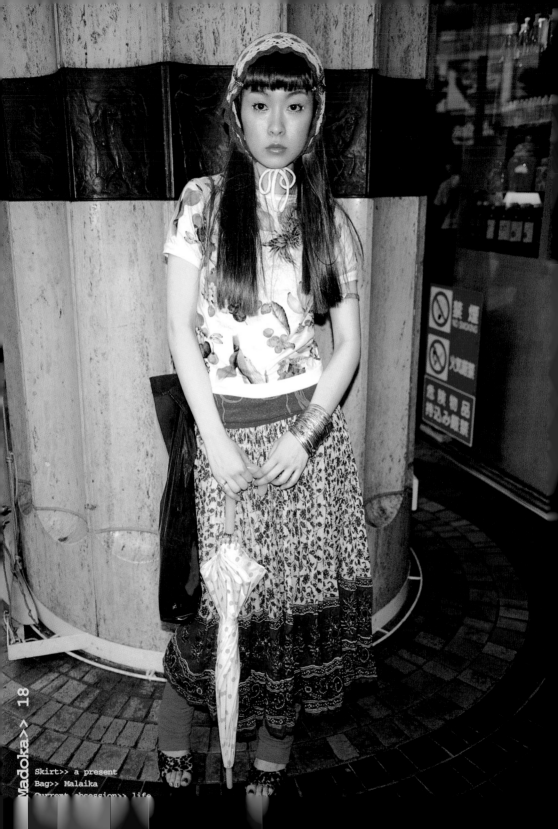

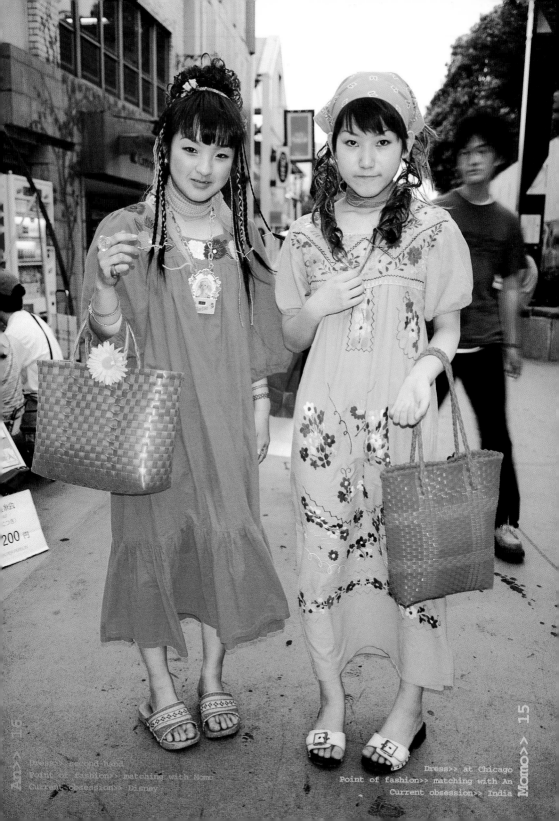

Dress>> second-hand
Point of fashion>> matching with Momo
Current obsession>> Disney

Dress>> at Chicago
Point of fashion>> matching with An
Current obsession>> India

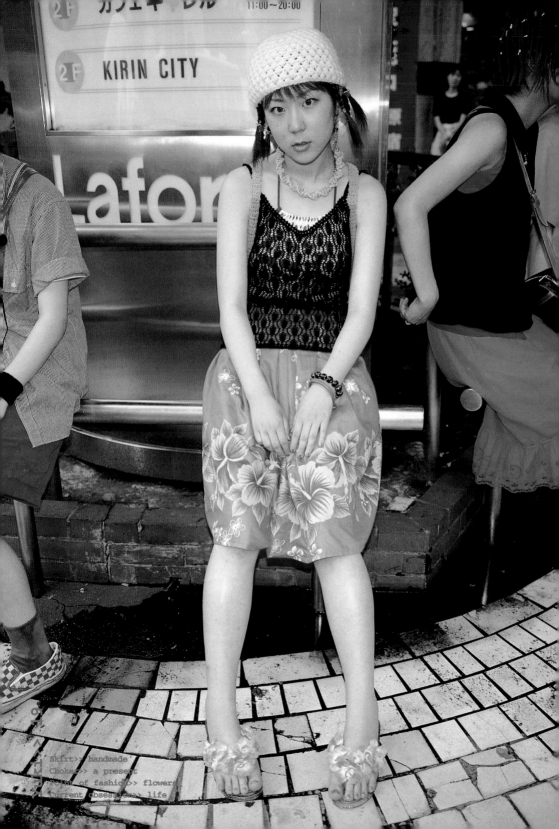

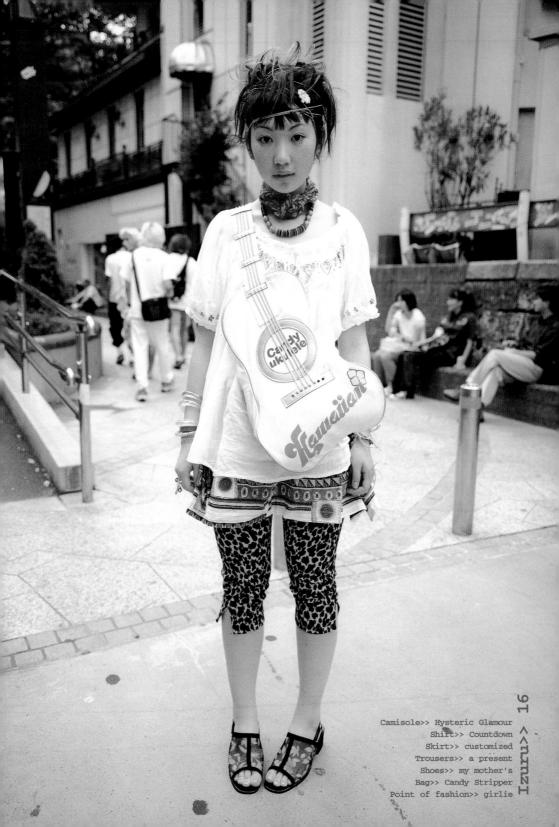

Camisole>> Hysteric Glamour
Shirt>> Countdown
Skirt>> customized
Trousers>> a present
Shoes>> my mother's
Bag>> Candy Stripper
Point of fashion>> girlie

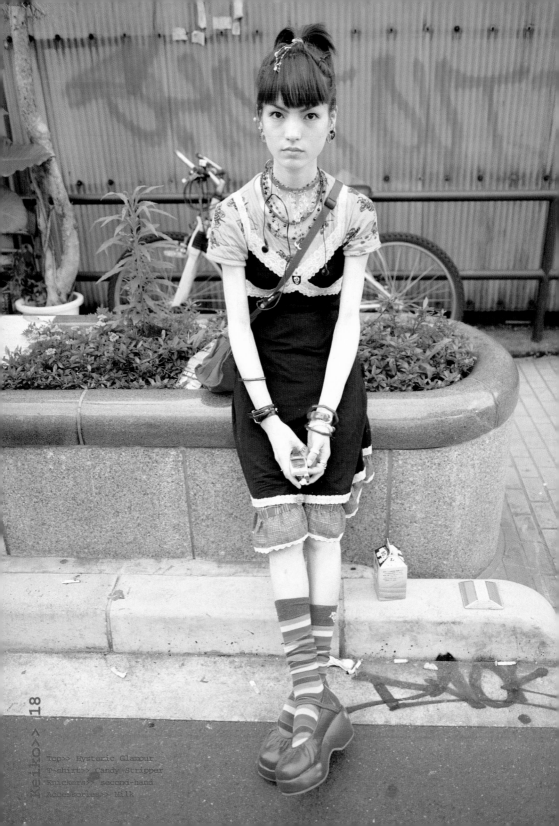

Top>> Hysteric Glamour
T-shirt>> Candy Stripper
Knickers>> second-hand
Accessories>> Milk

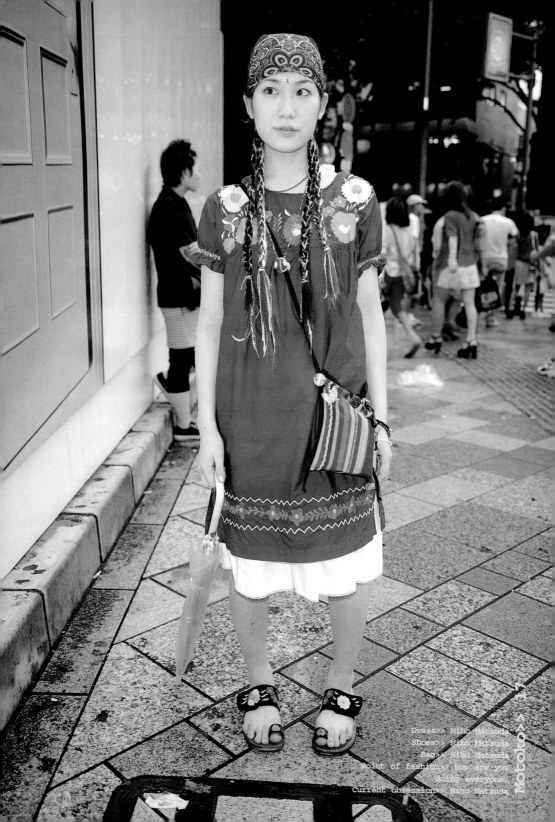

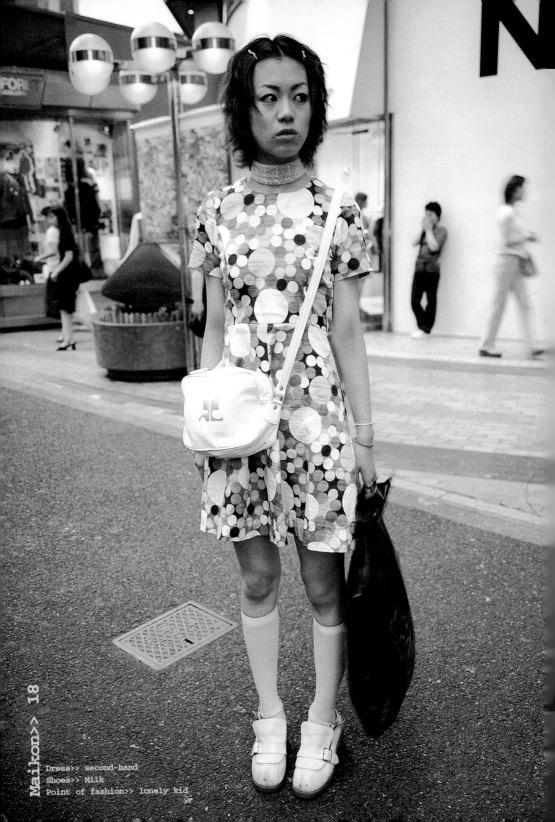

Dress>> second-hand
Shoes>> Milk
Point of fashion>> lonely kid

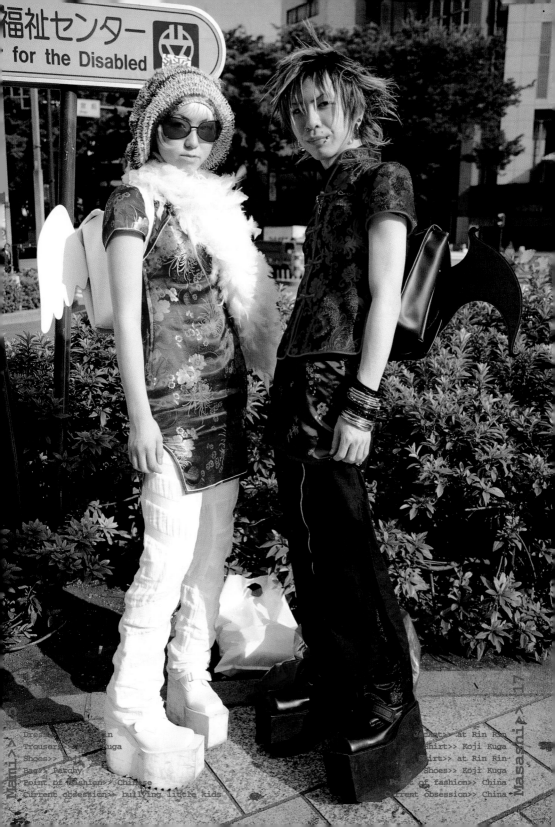

福祉センター
for the Disabled

Mami>>16

Dress>> at Rin Rin
Trouser>> Koji Kuga
Shoes>> Rodeo
Bag>> Peachy
Point of fashion>> Chinese
Current obsession>> bullying little kids

Jacket>> at Rin Rin
T-shirt>> Koji Kuga
Shirt>> at Rin Rin
Shoes>> Koji Kuga
Point of fashion>> China
Current obsession>> China

Masashi>>17

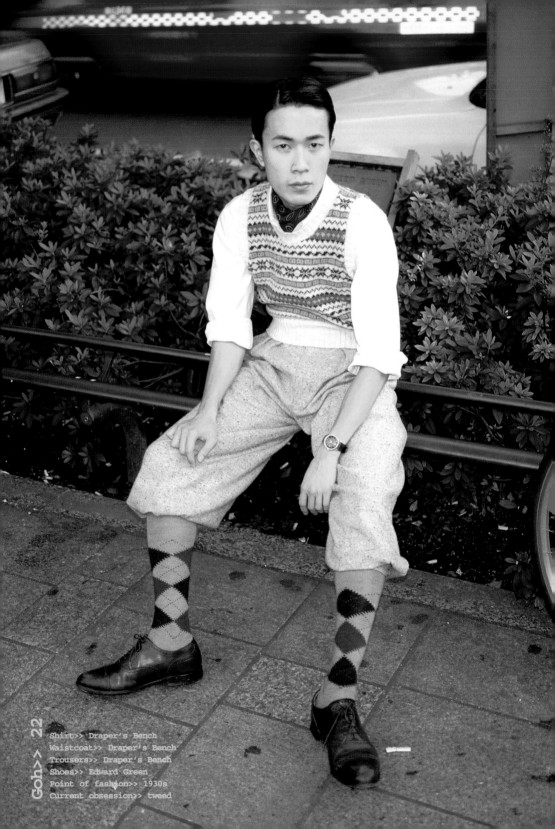

Shirt>> Draper's Bench
Waistcoat>> Draper's Bench
Trousers>> Draper's Bench
Shoes>> Edward Green
Point of fashion>> 1930s
Current obsession>> tweed

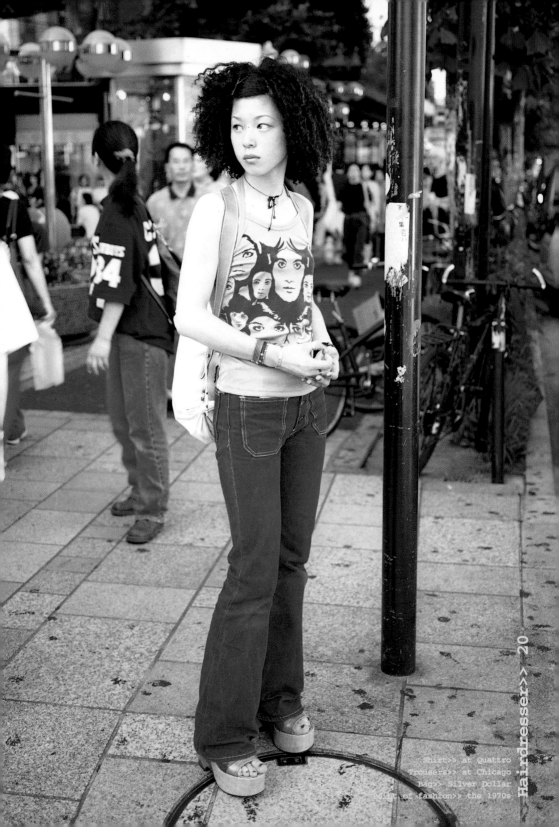

Shirt>> at Quattro
Trousers>> at Chicago
Bag>> Silver Dollar
Point of fashion>> the 1970s

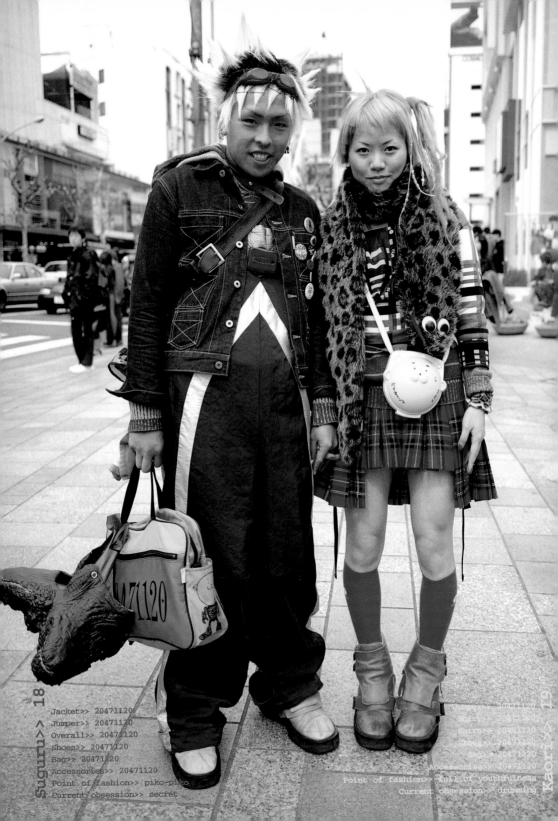

Jacket>> 20471120
Jumper>> 20471120
Overall>> 20471120
Shoes>> 20471120
Bag>> 20471120
Accessories>> 20471120
Point of fashion>> piko-piko
Current obsession>> secret

Jacket>> 20471120
Jumper>> 20471120
Shoes>> 20471120
Bag>> 20471120
Accessories>> 20471120
Point of fashion>> full of youthfulness
Current obsession>> drumming

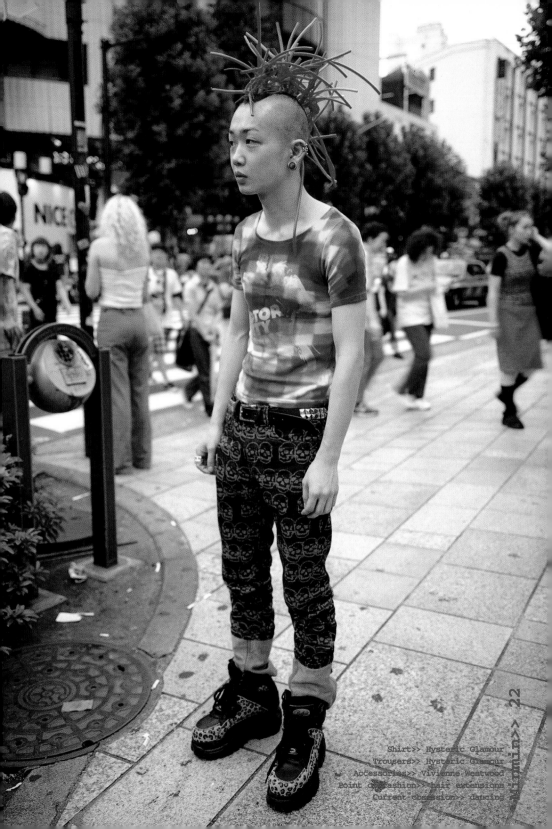

Shirt>> Hysteric Glamour
Trousers>> Hysteric Glamour
Accessories>> Vivienne Westwood
Point of fashion>> hair extensions
Current obsession>> dancing

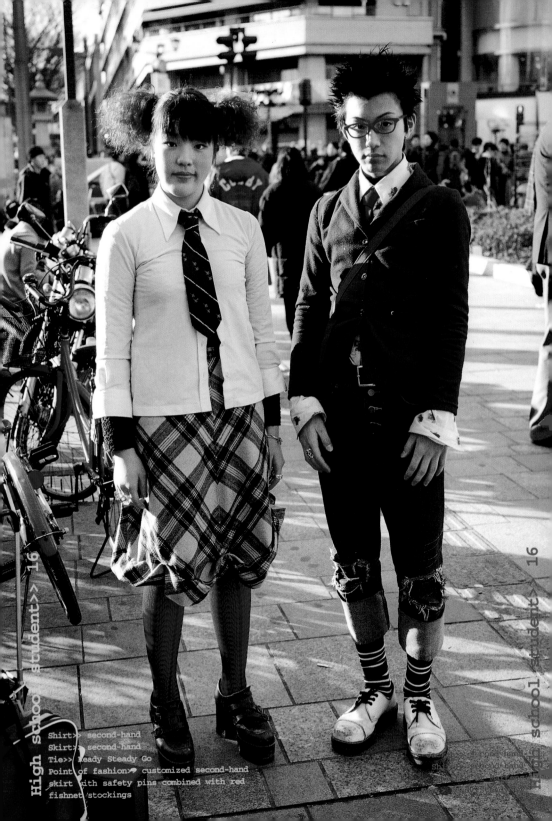

Shirt>> second-hand
Skirt>> second-hand
Tie>> Ready Steady Go
Point of fashion>> customized second-hand
skirt with safety pins combined with red
fishnet stockings

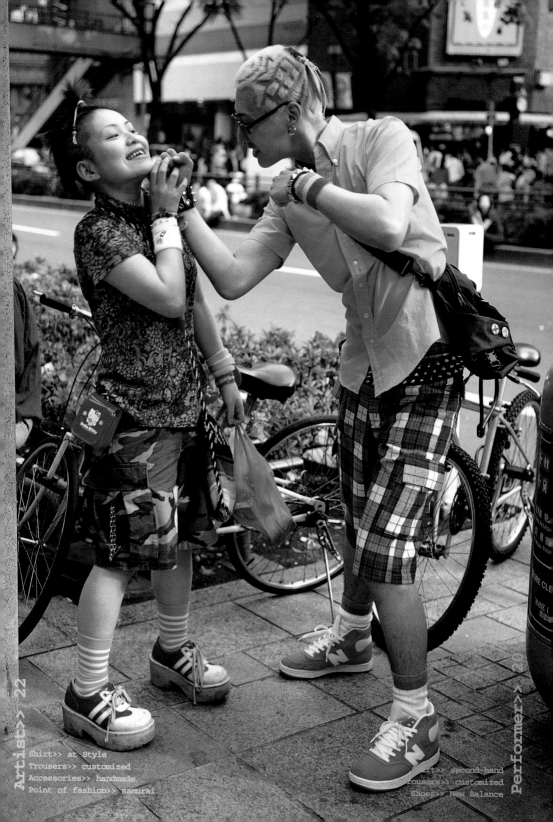

Shirt>> at Style
Trousers>> customized
Accessories>> handmade
Point of fashion>> samurai

rt>> second-hand
rousers>> customized
Shoes>> New Balance

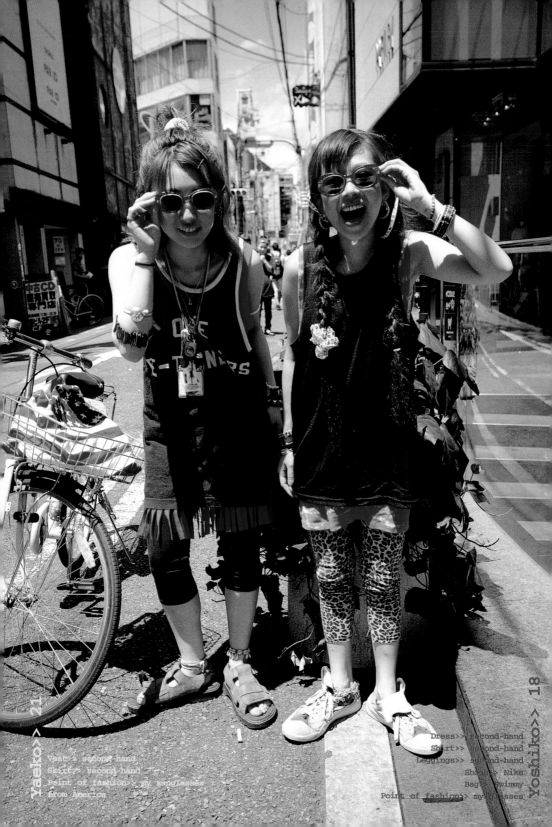

Vest>> second-hand
Skirt>> second-hand
Point of fashion>> my sunglasses :
from America

Dress>> second-hand
Shirt>> second-hand
Leggings>> second-hand
Shoes>> Nike
Bag>> Swimmy
Point of fashion>> my glasses

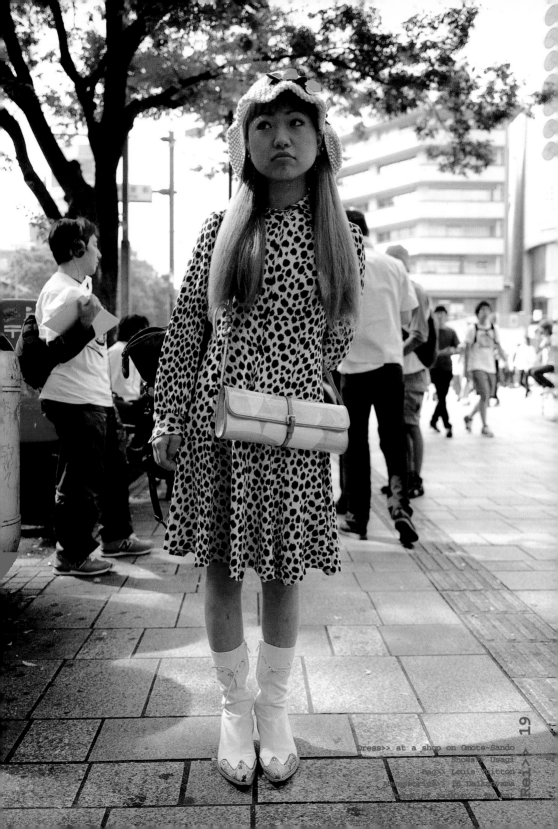

Dress>> at a shop on Omote-Sando
Shoes>> Usagi
Bag>> Louis Vuitton
Earrings>> at a shop in Harajuku

Rei>>

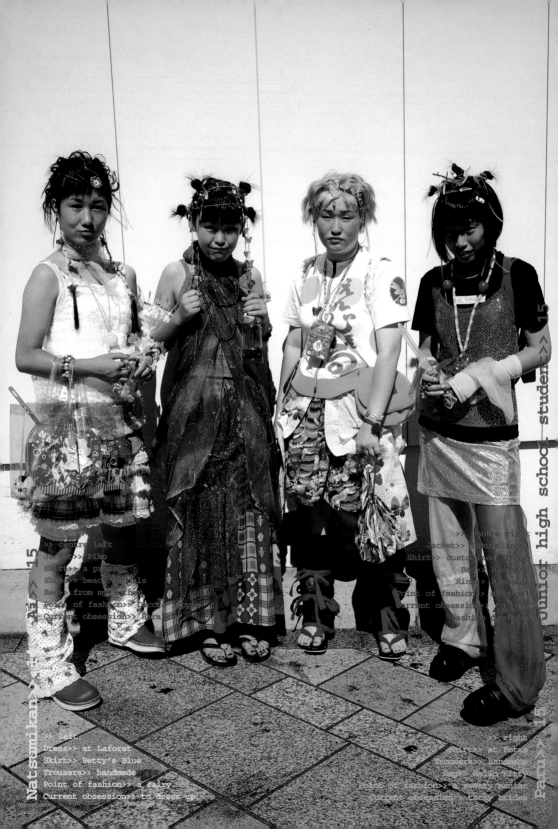

>> centre left
Jacket>> Piko
Skirt>> a present
Shoes>> beach sandals
Bag>> from my mother
Point of fashion>> accessories
Current obsession>> characters

>> centre right
Jacket>> Takuya Angel
Skirt>> customized kimono
Bag>> handmade
Ring>> handmade
Point of fashion>> an angel
Current obsession>> to be a fashion designer

>> left
Dress>> at Laforet
Skirt>> Betty's Blue
Trousers>> handmade
Point of fashion>> a fairy
Current obsession>> to dress up

>> right
at Fotus
Trousers>> handmade
Bag>> Hello Kitty
Point of fashion>> sweaty maniac
Current obsession>> tacky brides

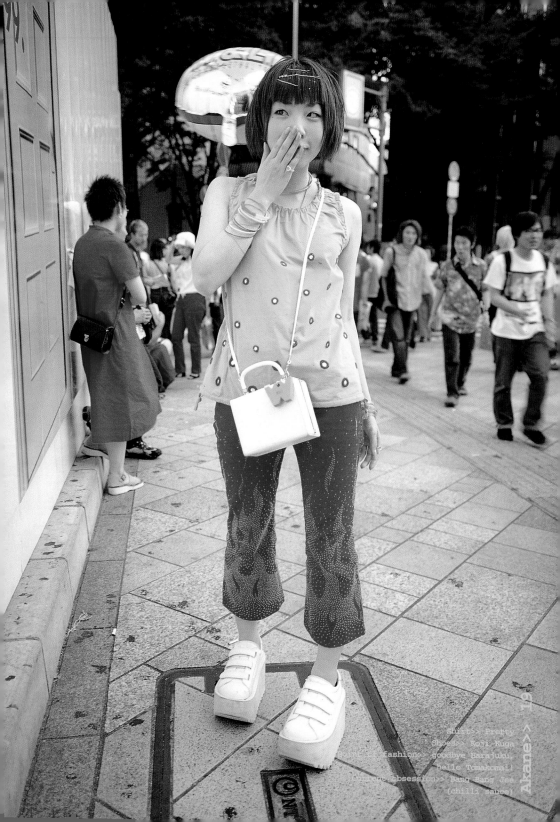

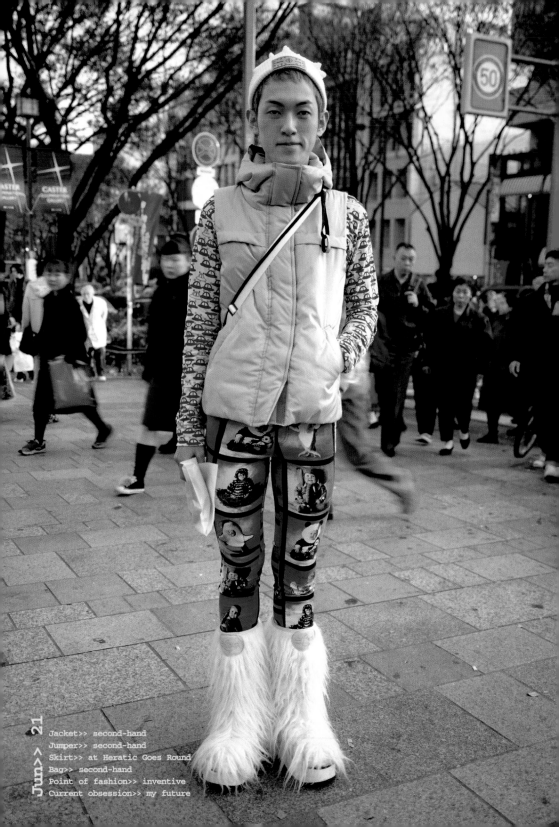

Jacket>> second-hand
Jumper>> second-hand
Skirt>> at Heratic Goes Round
Bag>> second-hand
Point of fashion>> inventive
Current obsession>> my future

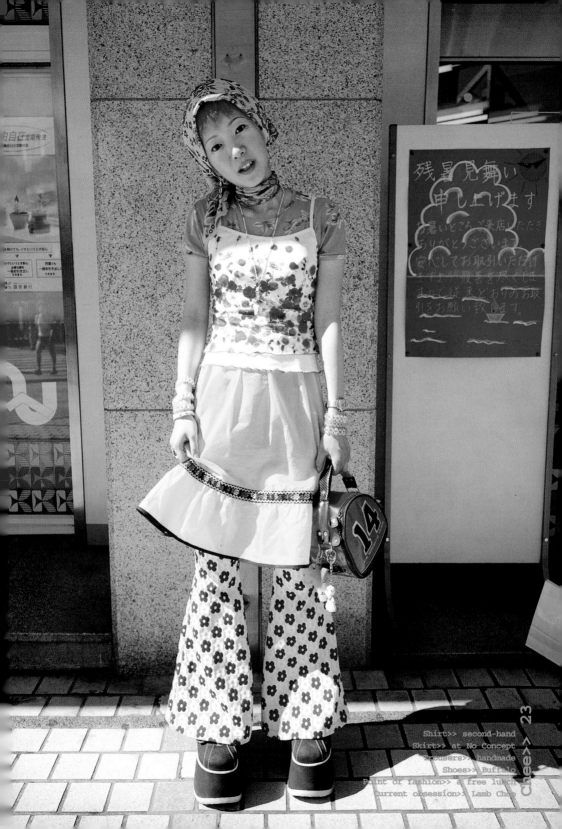

Shirt>> second-hand
Skirt>> at No Concept
Trousers>> handmade
Shoes>> Buffalo
Point of fashion>> a free lunch
Current obsession>> Lamb Chop

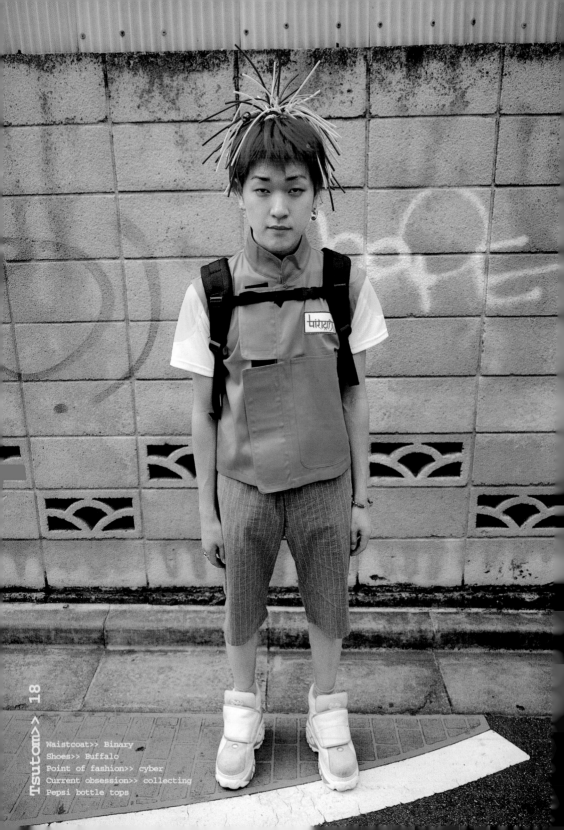

Waistcoat>> Binary
Shoes>> Buffalo
Point of fashion>> cyber
Current obsession>> collecting
Pepsi bottle tops

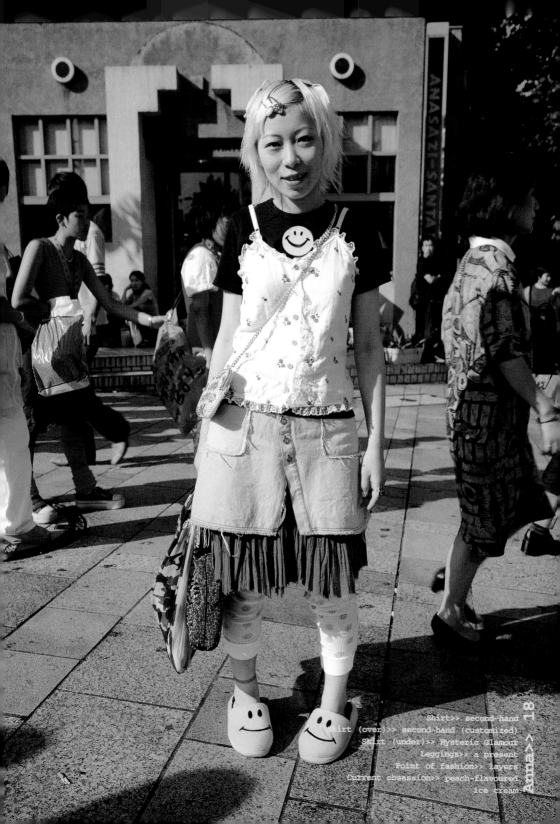

Shirt>> second-hand
Skirt (over)>> second-hand (customized)
Skirt (under)>> Hysteric Glamour
Leggings>> a present
Point of fashion>> layers
Current obsession>> peach-flavoured
ice cream

Anna>> 18

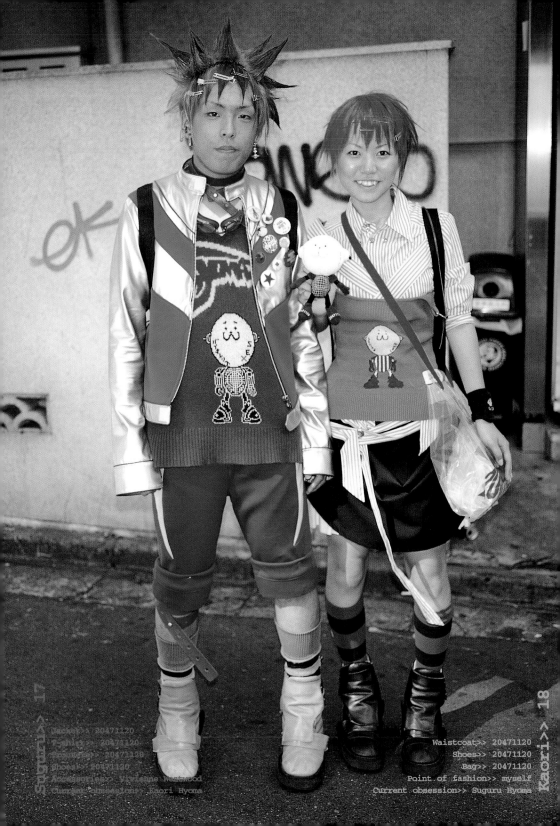

Jacket>> 20471120
T-shirt>> 20471120
Trousers>> 20471120
Shoes>> 20471120
Accessories>> Vivienne Westwood
Current obsession>> Kaori Hyoma

Waistcoat>> 20471120
Shoes>> 20471120
Bag>> 20471120
Point of fashion>> myself
Current obsession>> Suguru Hyoma

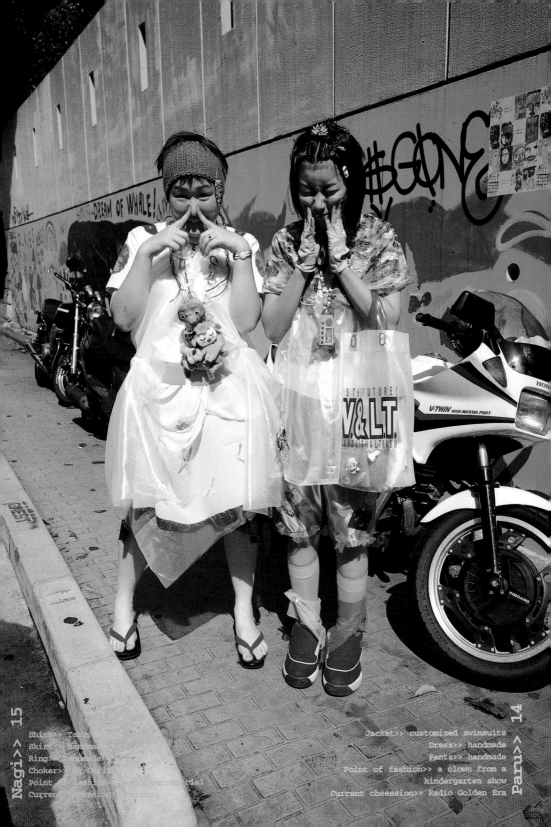

Shirt>> Takuy[...]
Skirt>> handmad[...]
Ring>> handmade[...]
Choker>> self-D[...]
Point [...]fashion[...]
Current [...]

Jacket>> customized swimsuits
Dress>> handmade
Pants>> handmade
Point of fashion>> a clown from a
kindergarten show
Current obsession>> Radio Golden Era

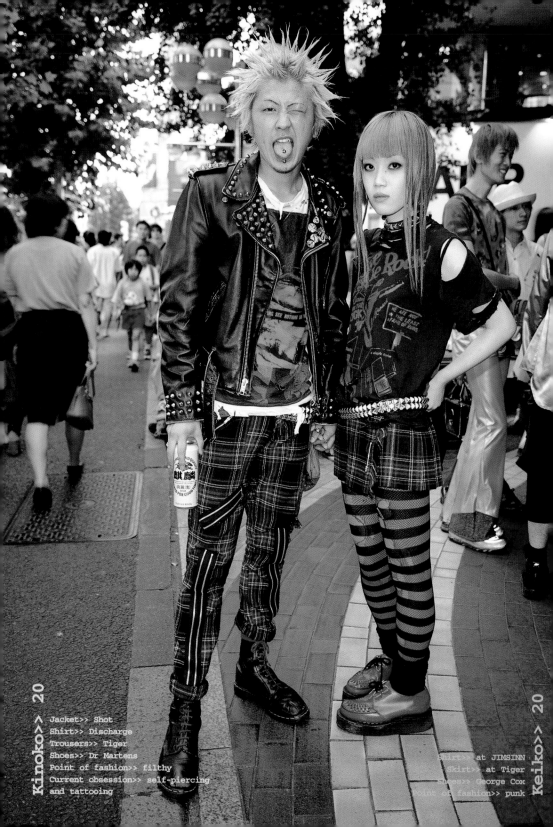

Jacket>> Shot
Shirt>> Discharge
Trousers>> Tiger
Shoes>> Dr Martens
Point of fashion>> filthy
Current obsession>> self-piercing
and tattooing

Shirt>> at JIMSINN
Skirt>> at Tiger
Shoes>> George Cox
Point of fashion>> punk

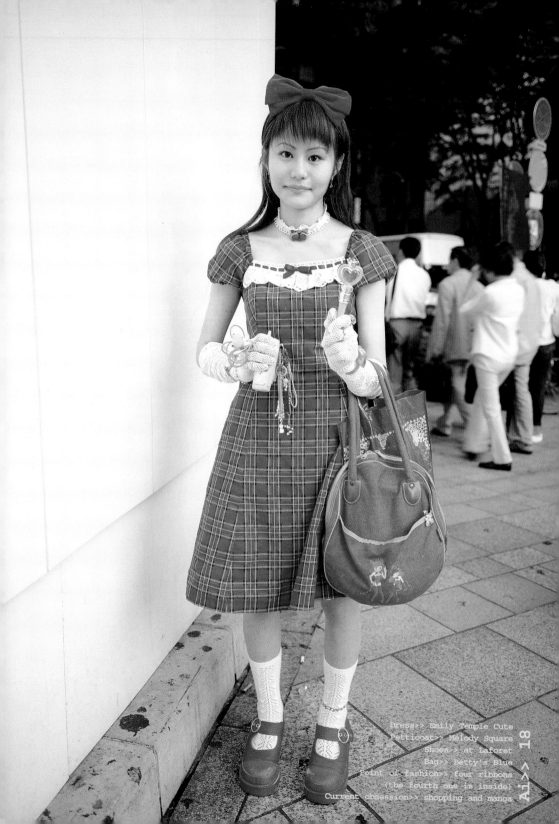

Dress>> Emily Temple Cute
Petticoat>> Melody Square
Shoes>> at Laforet
Bag>> Betty's Blue
Point of fashion>> four ribbons
(the fourth one is inside)
Current obsession>> shopping and manga

Ai >> 18

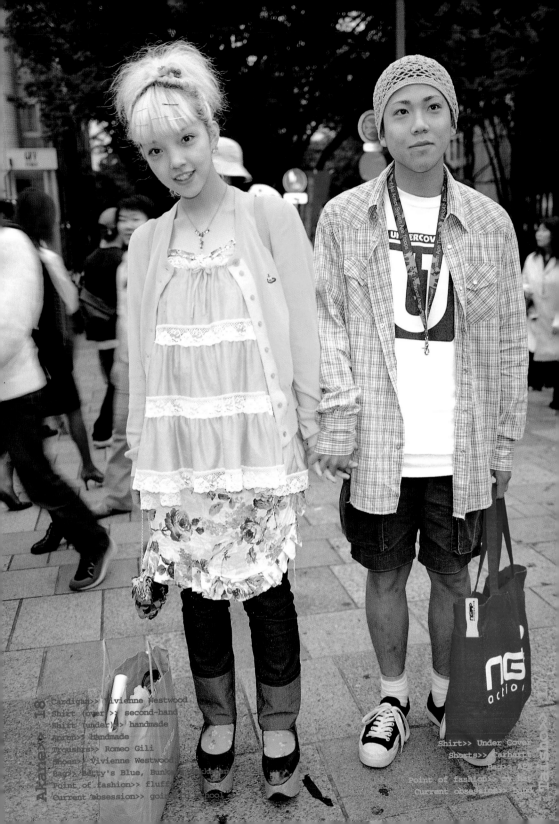

Akane>> 18

Cardigan>> Vivienne Westwood
Shirt (over)>> second-hand
Shirt (under)>> handmade
Apron>> handmade
Trousers>> Romeo Gili
Shoes>> Vivienne Westwood
Bag>> Betty's Blue, Bunkamura-do
Point of fashion>> fluff
Current obsession>> going to school

Shirt>> Under Cover
Shorts>> Carhartt
Point of fashion>> my scarf
Current obsession>> band

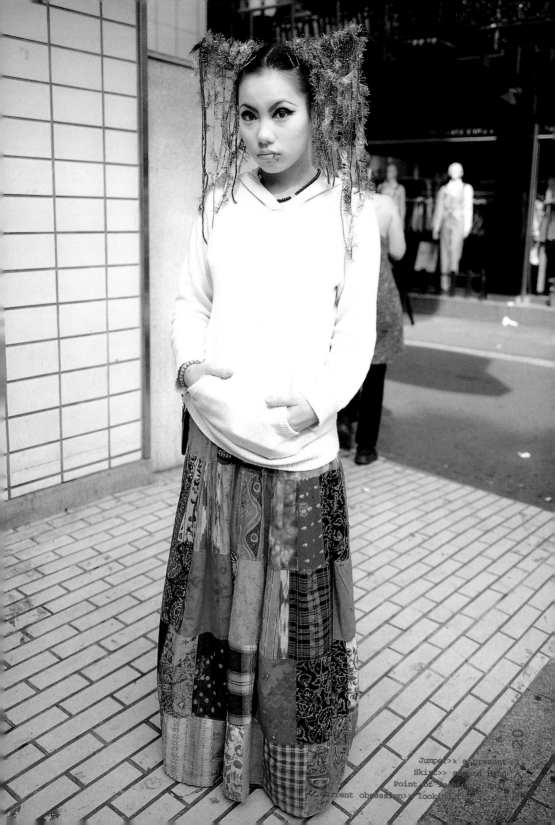

Jumper>> a present
Skirt>> second hand
Point of fashion>>
Current obsession>> looking for

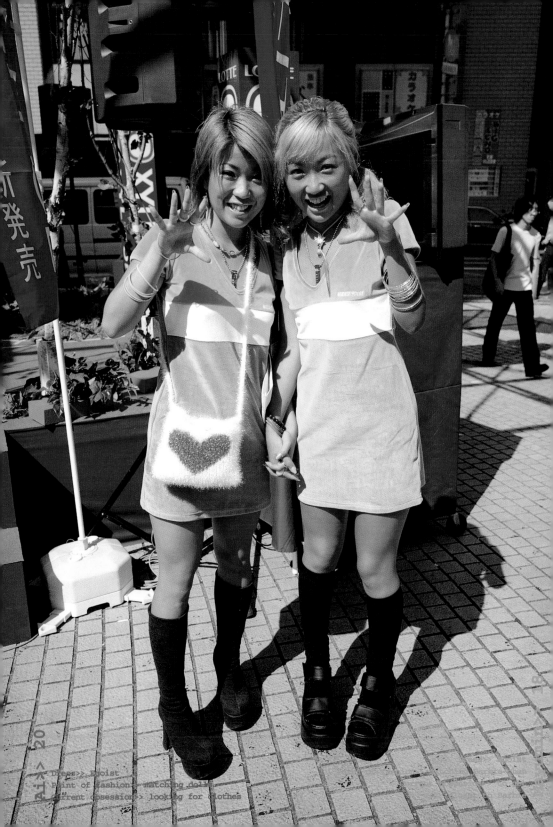

Dress >> Egoist
Point of fashion > matching dolls
Current obsession > looking for clothes

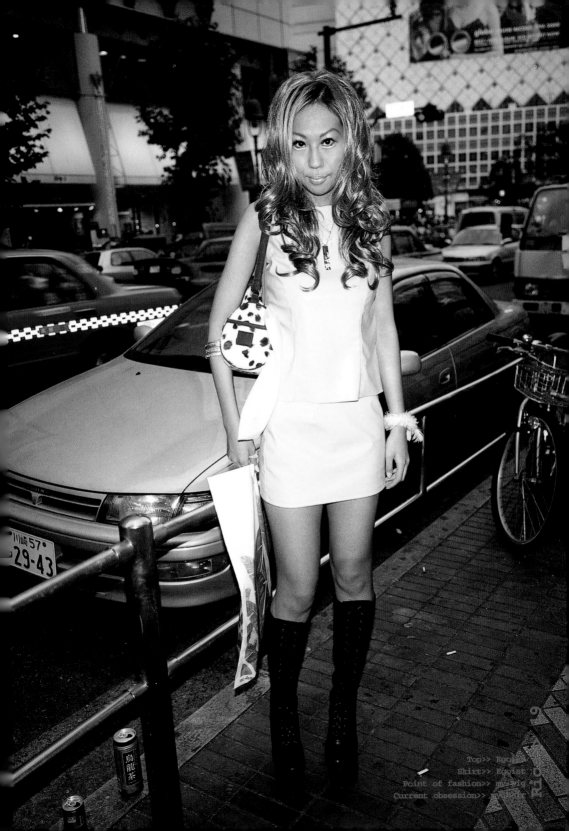

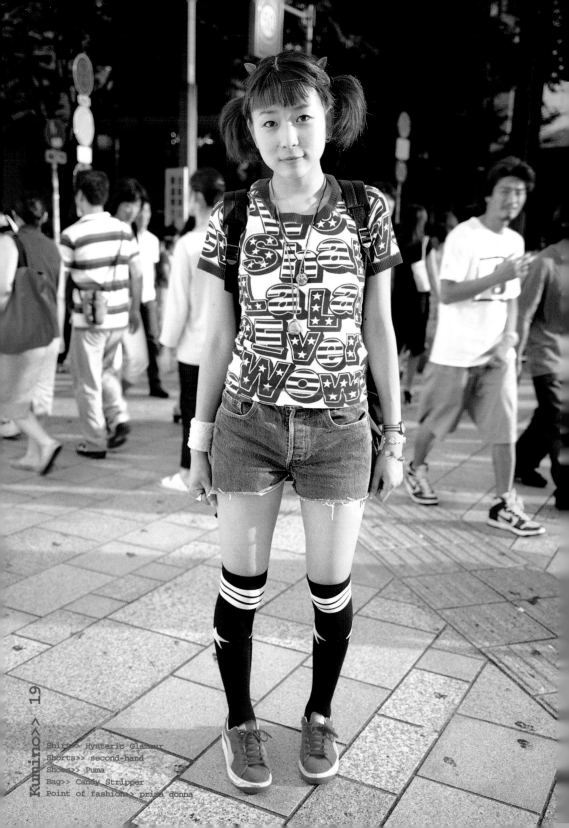

Shirt>> Hysteric Glamour
Shorts>> second-hand
Shoes>> Puma
Bag>> Candy Stripper
Point of fashion>> prima donna

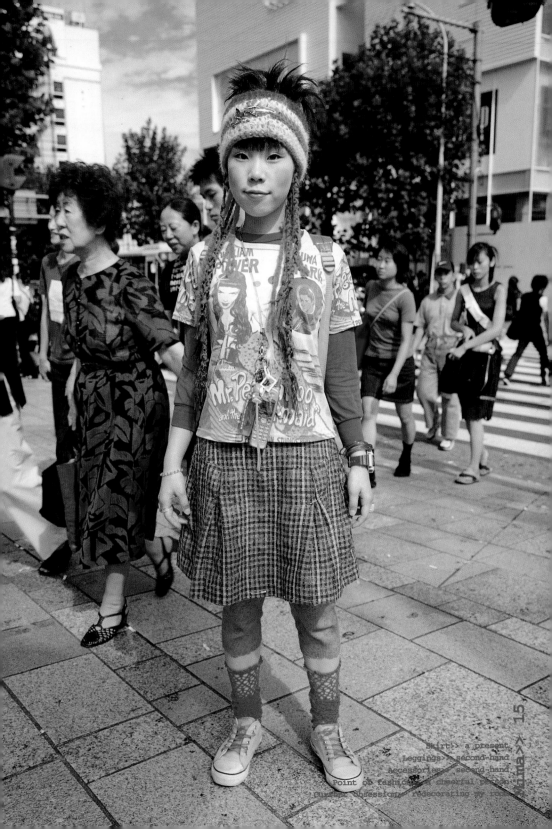

Skirt>> a present.
Leggings>> second-hand.
Accessories>> second-hand.
Point of fashion>> a cheerful person.
Current obsession>> redecorating my room.

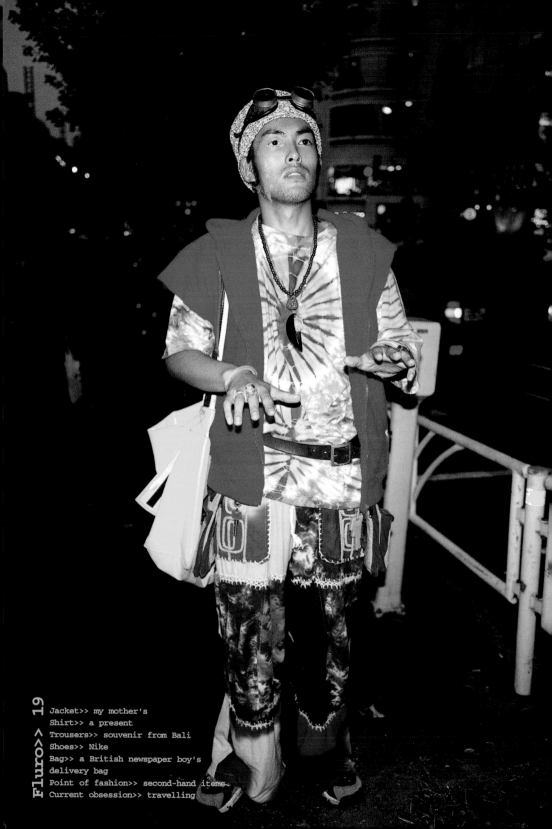

Jacket>> my mother's
Shirt>> a present
Trousers>> souvenir from Bali
Shoes>> Nike
Bag>> a British newspaper boy's
delivery bag
Point of fashion>> second-hand items
Current obsession>> travelling

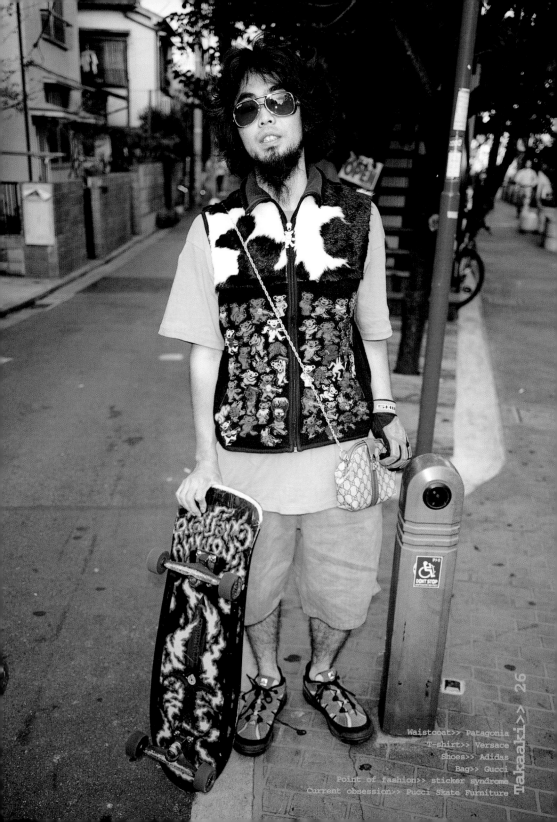

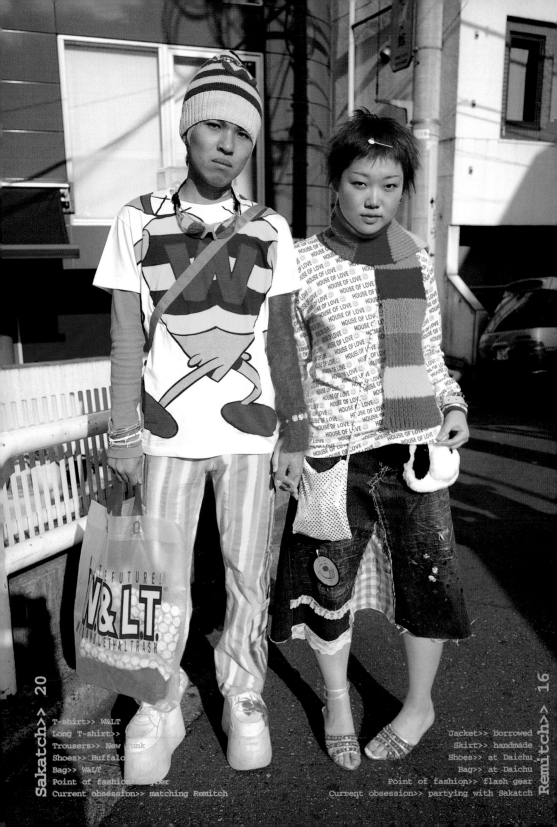

T-shirt>> W<
Long T-shirt>> W<
Trousers>> New Punk
Shoes>> Buffalo
Bag>> W<
Point of fashion>> hair
Current obsession>> matching Remitch

Jacket>> Borrowed
Skirt>> handmade
Shoes>> at Daichu
Bag>> at Daichu
Point of fashion>> flash gear
Current obsession>> partying with Sakatch

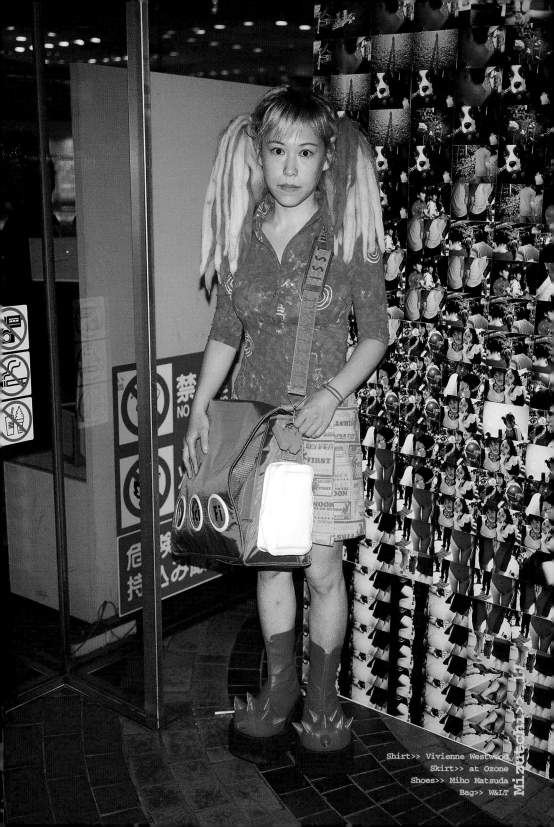

Shirt>> Vivienne Westwood
Skirt>> at Ozone
Shoes>> Miho Matsuda
Bag>> W<

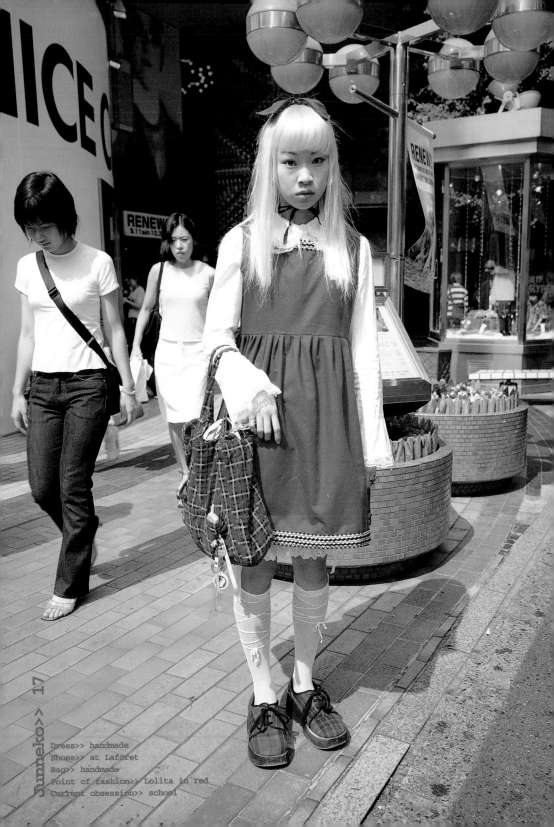

Dress>> handmade
Shoes>> at Laforet
Bag>> handmade
Point of fashion>> Lolita in red
Current obsession>> school

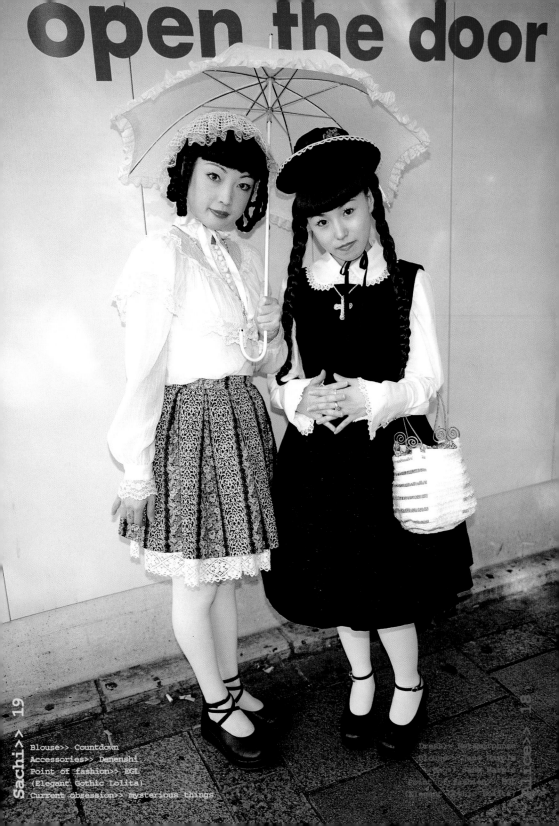

open the door

Blouse>> Countdown
Accessories>> Denenshi
Point of fashion>> EGL
(Elegant Gothic Lolita)
Current obsession>> mysterious things

Dress>> Metamorphose
Blouse>> Metamorphose
Accessories>> Denenshi
Point of fashion>> EGL
(Elegant Gothic Lolita)

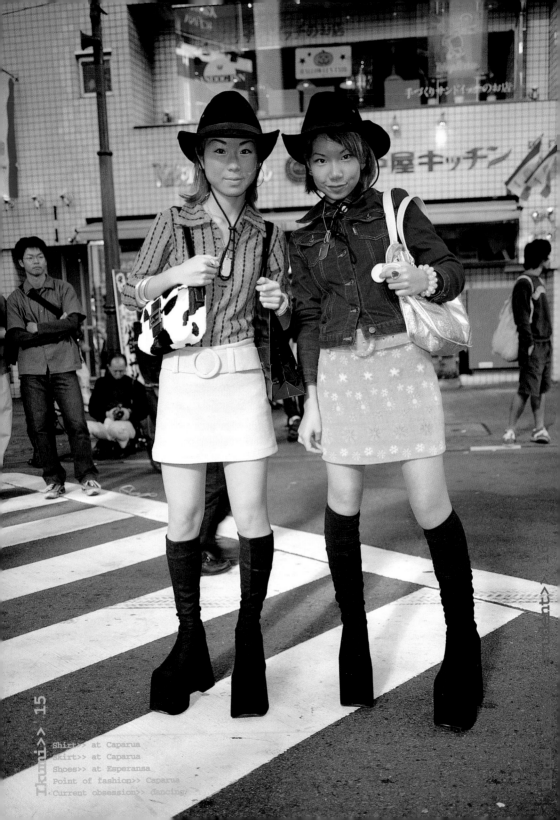

Shirt>> at Caparua
Skirt>> at Caparua
Shoes>> at Esperansa
Point of fashion>> Caparua
<Current obsession>>

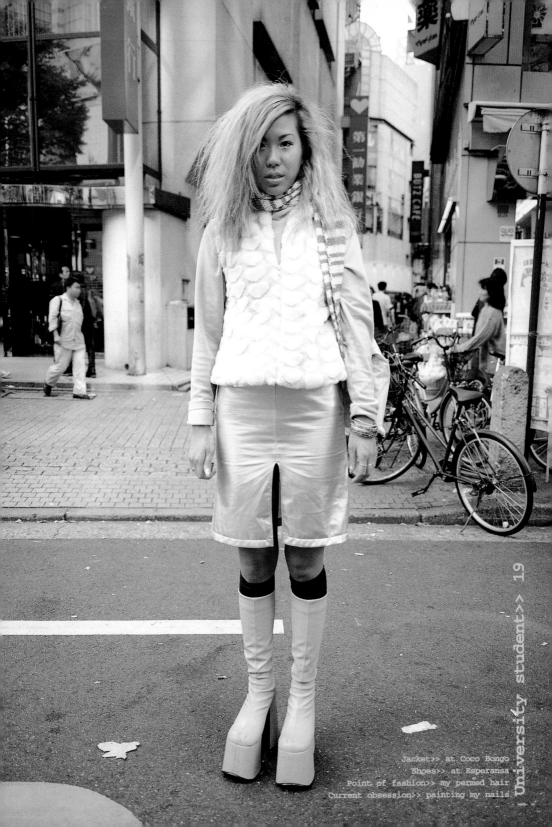

Jacket>> at Coco Bongo
Shoes>> at Esperansa
Point of fashion>> my permed hair
Current obsession>> painting my nails

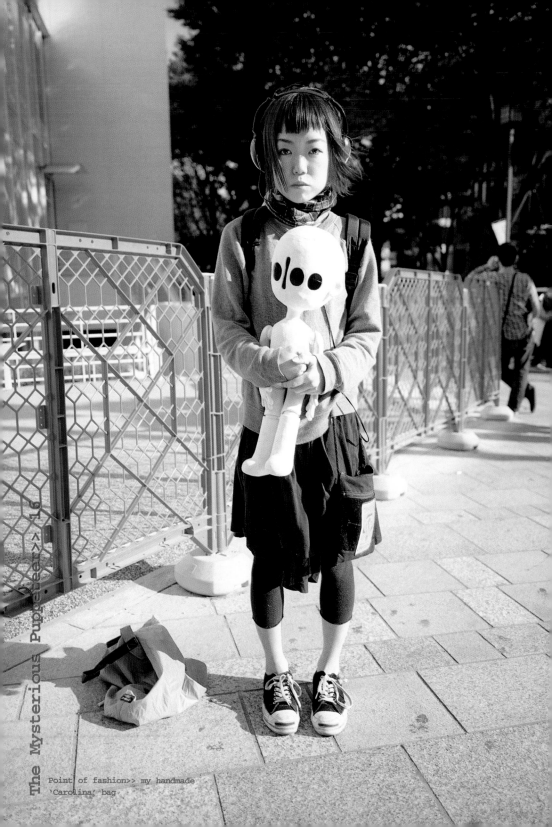

Point of fashion>> my handmade
'Carolina' bag

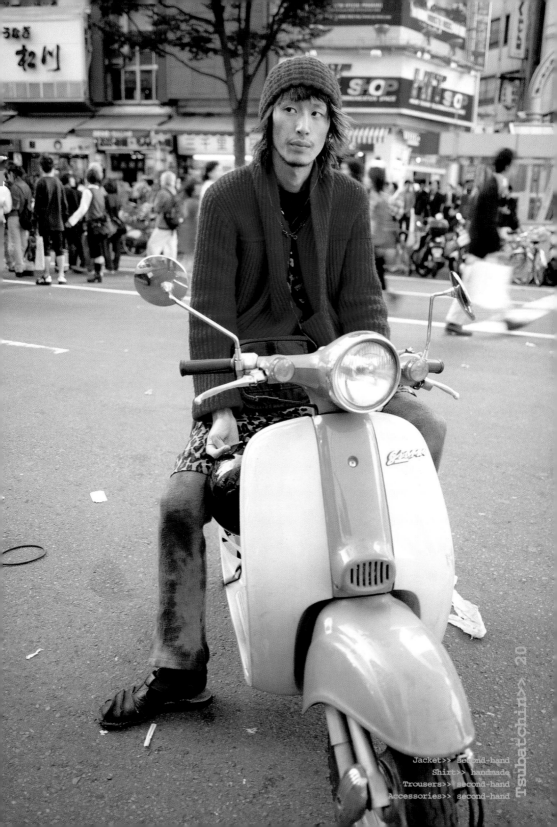

Tsubatchin>> 20

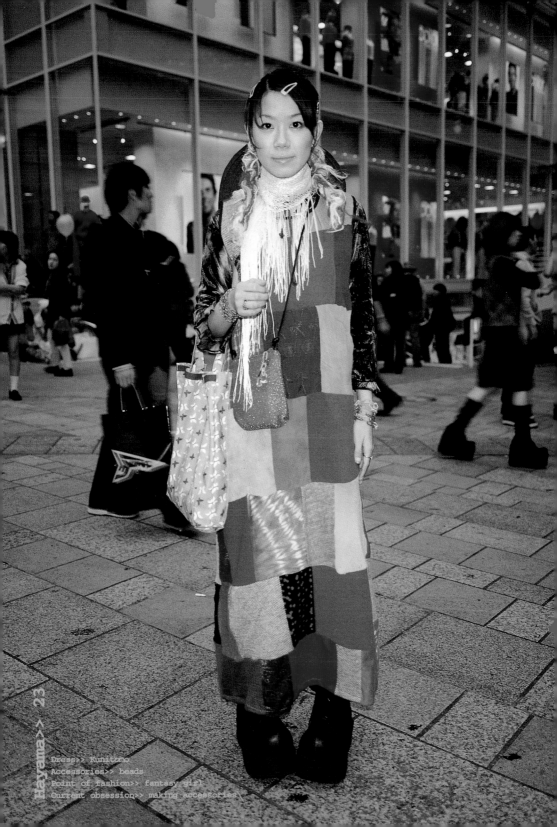

Dress>> Kunitomo
Accessories>> beads
Point of fashion>> fantasy girl
Current obsession>> making accessories\

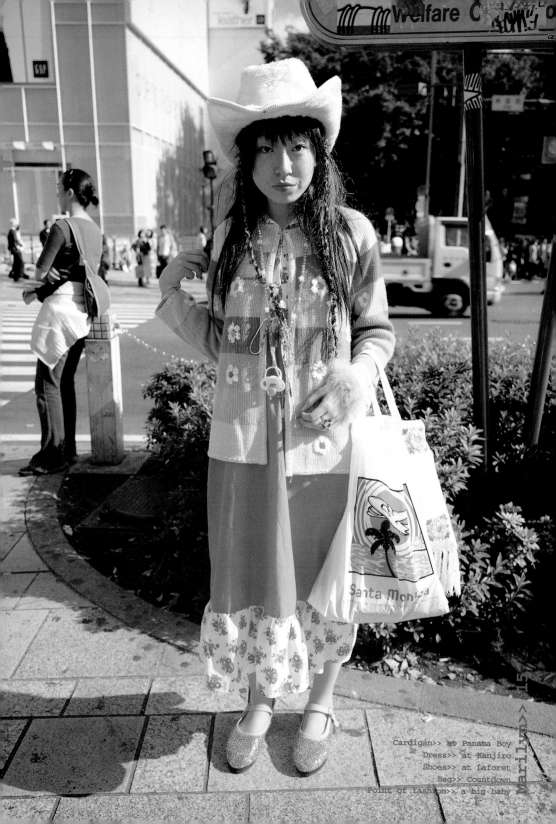

Cardigan>> at Panama Boy
Dress>> at Nanjiro
Shoes>> at Laforet
Bag>> Countdown
Point of fashion>> a big baby

Marilyn>>

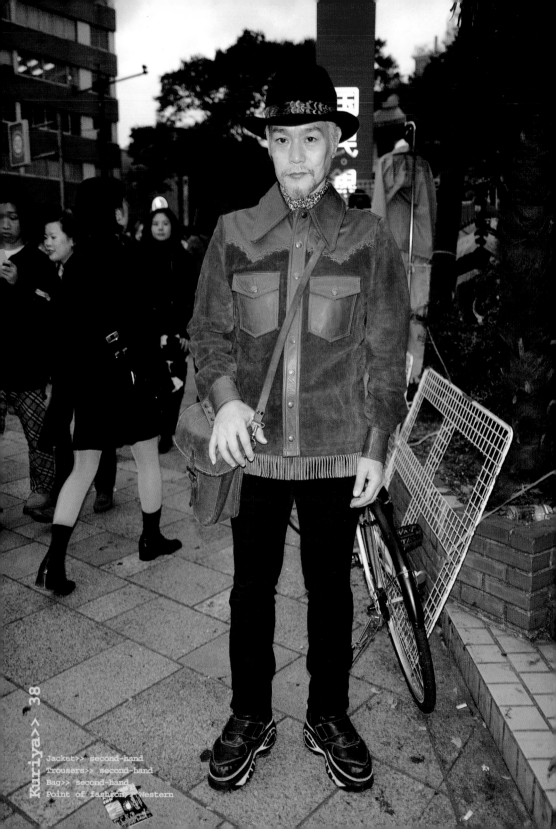

Jacket>> second-hand
Trousers>> second-hand
Bag>> second-hand
Point of fashion>> Western

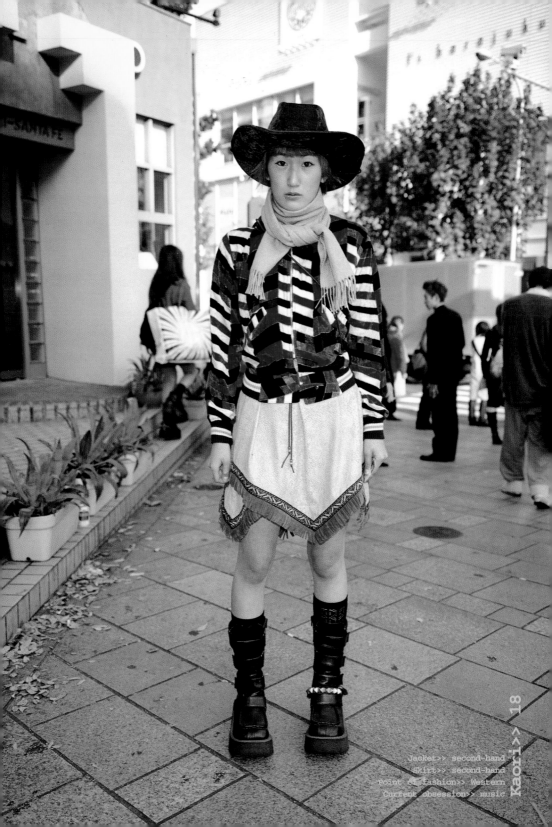

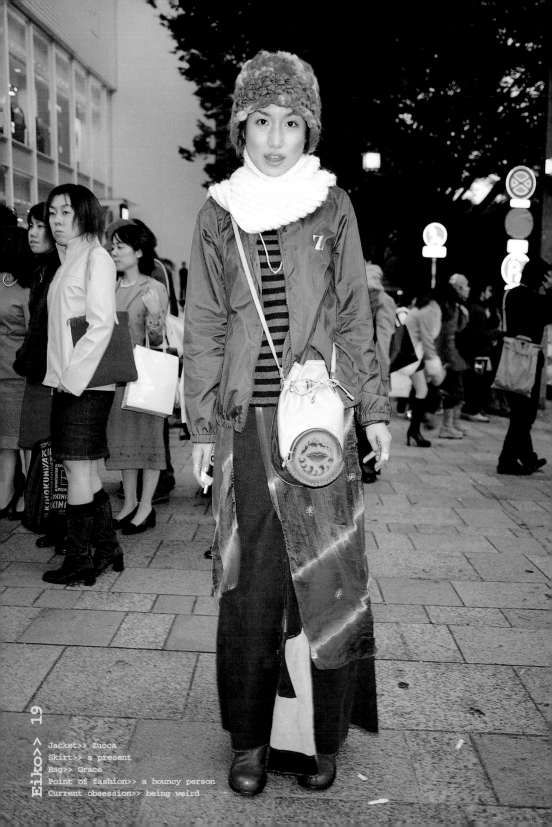

Jacket>> Zucca
Skirt>> a present
Bag>> Grace
Point of fashion>> a bouncy person
Current obsession>> being weird

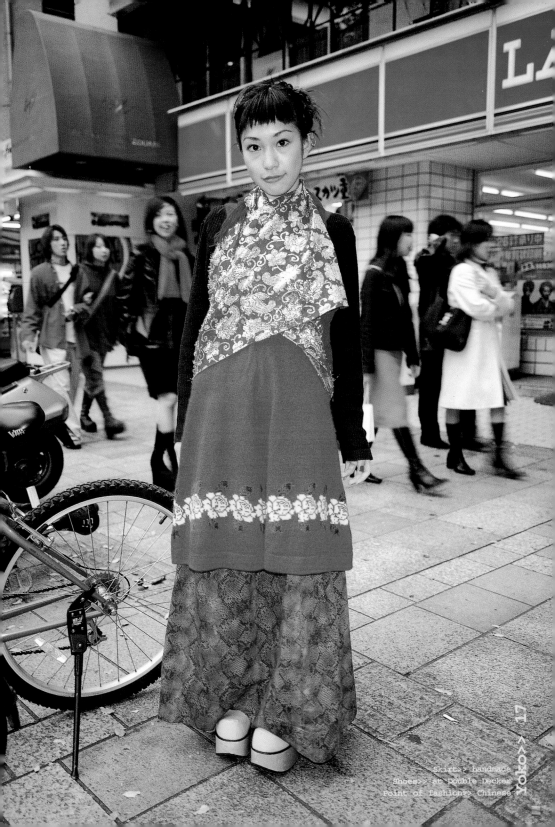

Skirt>> handmade
Shoes>> at Double Decker
Point of fashion>> Chinese

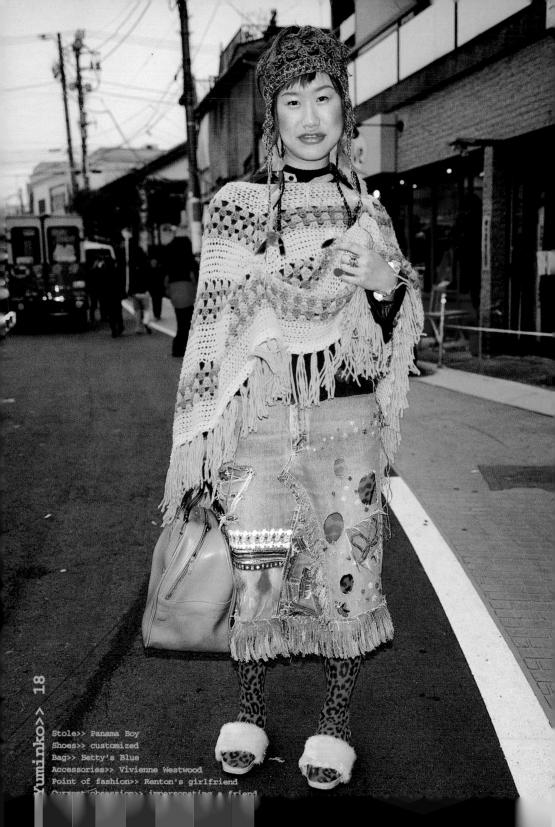

Stole>> Panama Boy
Shoes>> customized
Bag>> Betty's Blue
Accessories>> Vivienne Westwood
Point of fashion>> Renton's girlfriend
Current obsession>> impersonating a friend

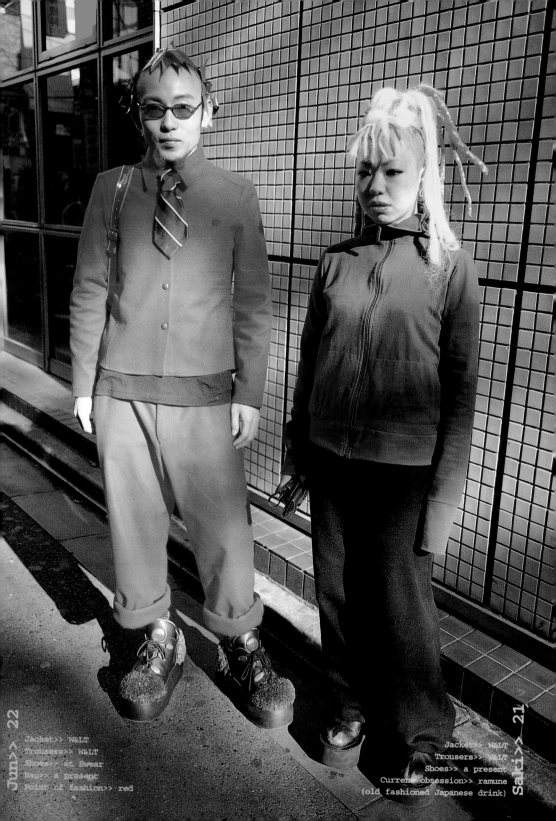

Jacket>> W<
Trousers>> W<
Shoes>> at Swear
Bag>> a present
Point of fashion>> red

Jacket>> W<
Trousers>> W<
Shoes>> a present
Current obsession>> ramune
(old fashioned Japanese drink)

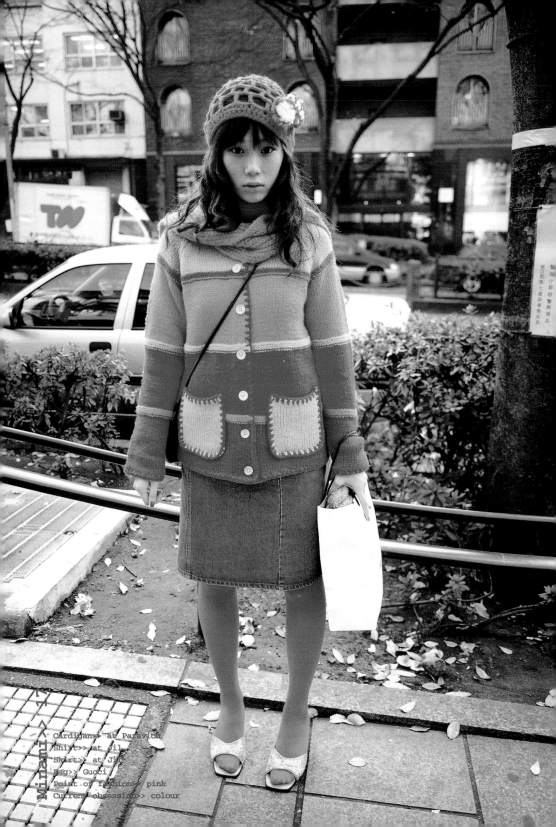

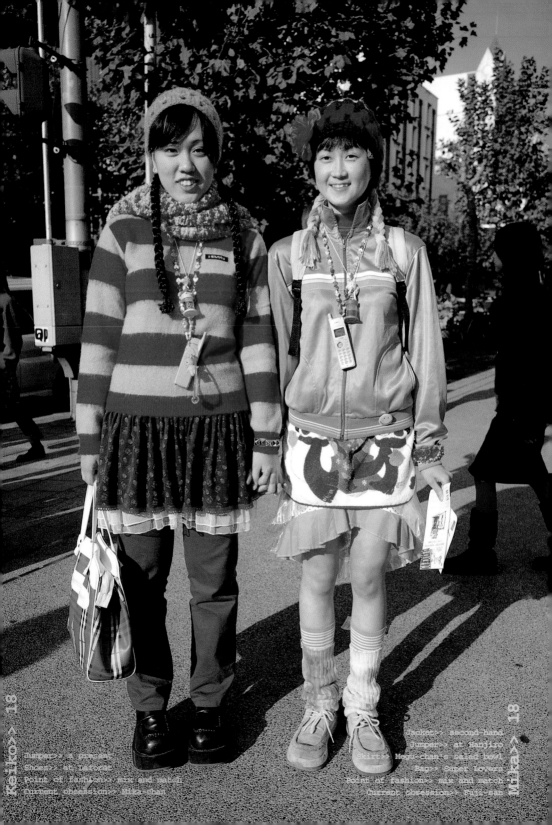

Jumper>> a present
Shoes>> at Laforet
Point of fashion>> mix and match
Current obsession>> Mika-chan

Jacket>> second-hand
Jumper>> at Hanjiro
Skirt>> Megu-chan's salad bowl
Bag>> Super lovers
Point of fashion>> mix and match
Current obsession>> Yuji-san

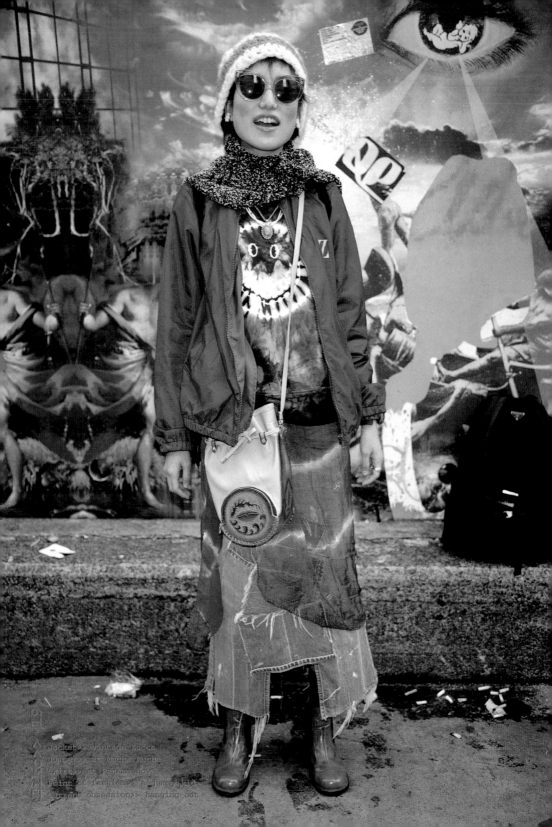

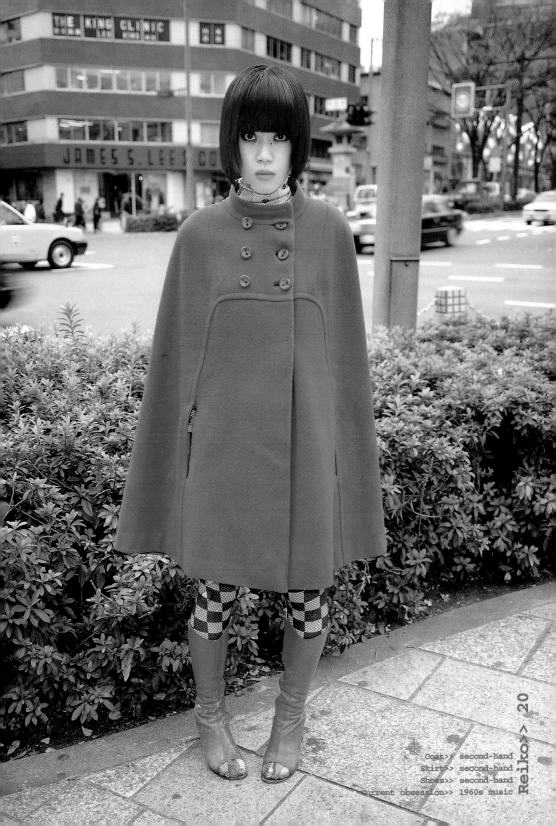

Reiko>> 20

Coat>> second-hand
Skirt>> second-hand
Shoes>> second-hand
Current obsession>> 1960s music

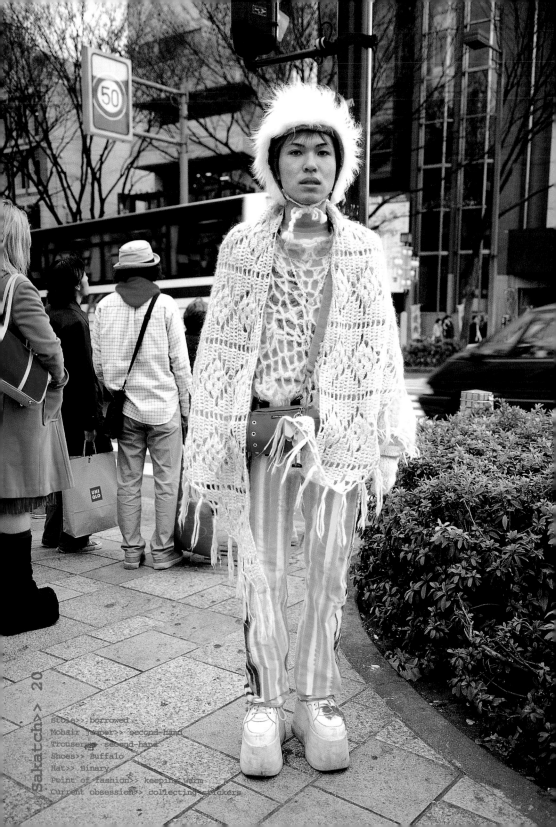

Stole>> borrowed
Mohair jumper>> second-hand
Trousers>> second-hand
Shoes>> Buffalo
Hat>> Sinary
Point of fashion>> keeping warm
Current obsession>> collecting stickers

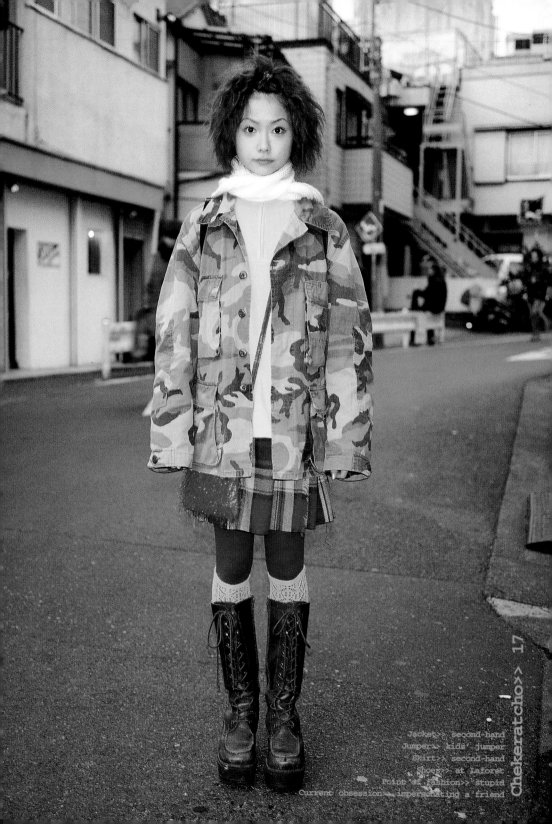

Jacket>> second-hand
Jumper>> kids' jumper
Skirt>> second-hand
Shoes>> at Laforet
Point of fashion>> stupid
Current obsession>> impersonating a friend

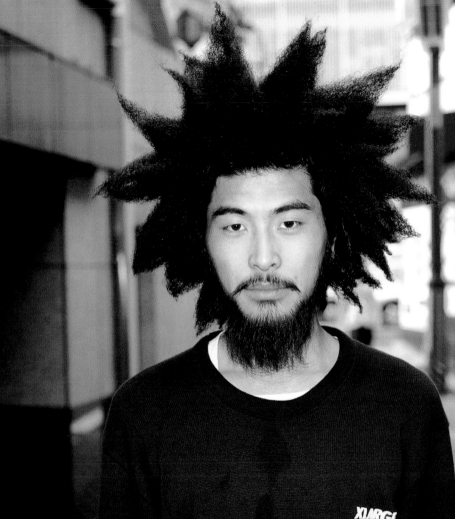

>> I came from Gunma. Is hair
like this unusual around here?

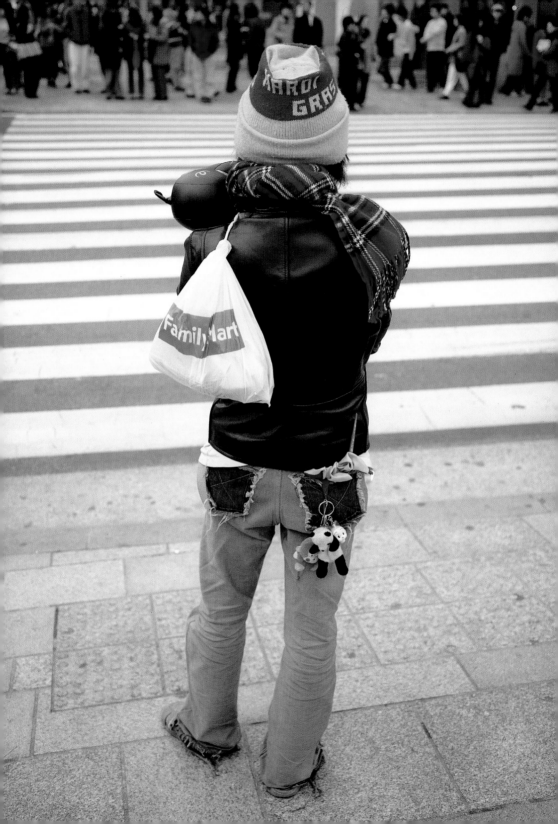

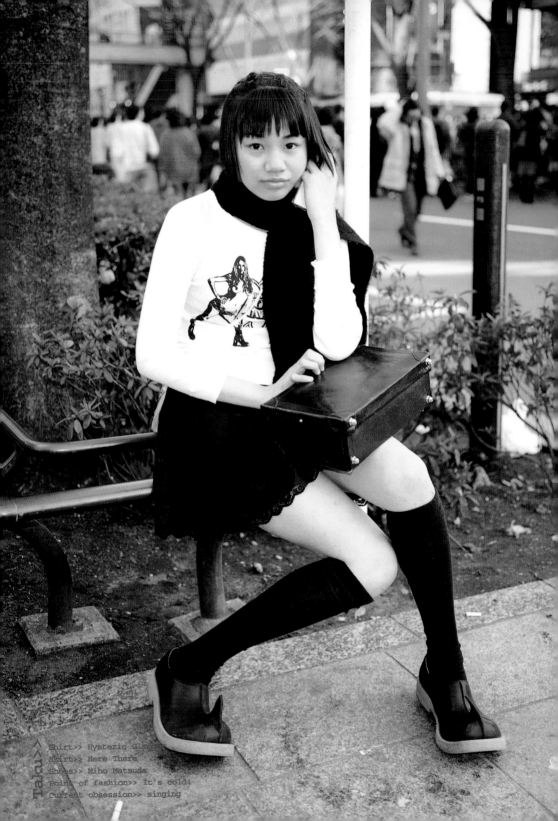

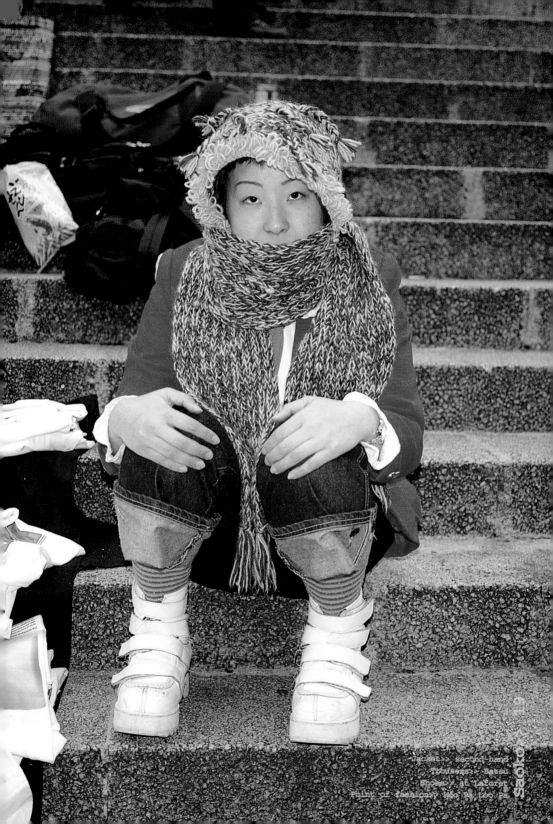

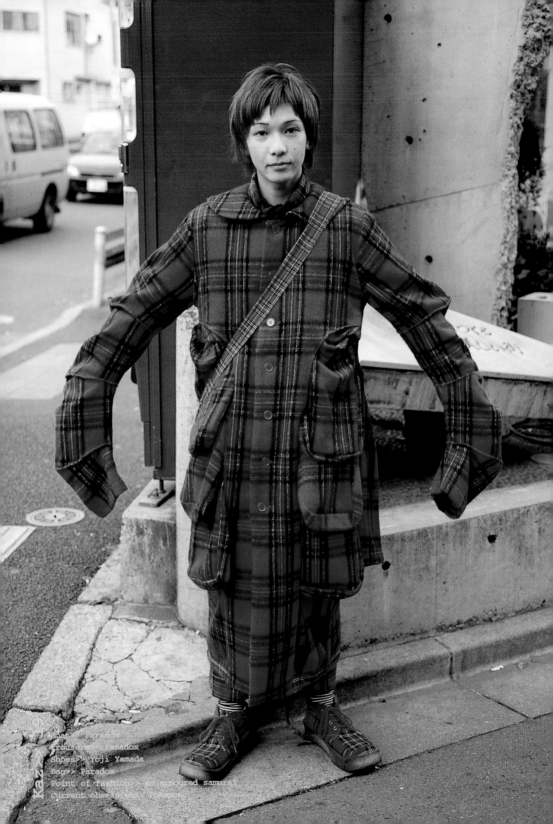

Kazu >> Paradox
Trousers >> Paradox
Shoes >> Yoji Yamada
Bag >> Paradox
Point of fashion >> an armoured samurai
Current obsession >> Pokemon

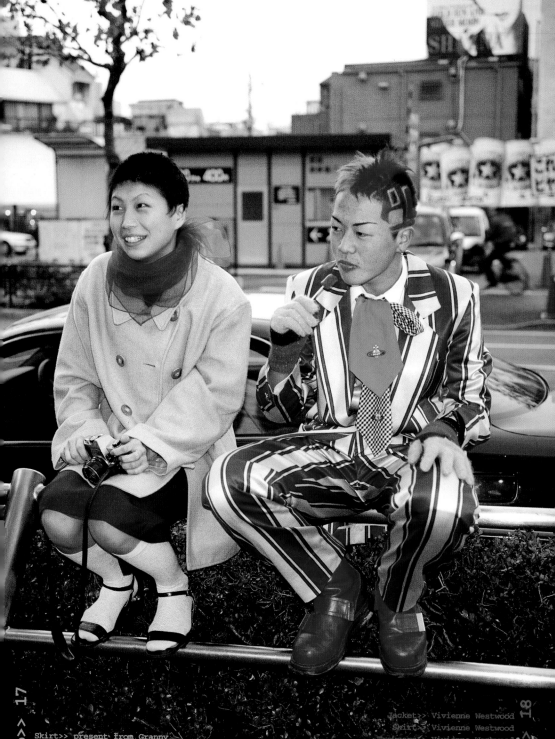

Skirt>> present from Granny
Shoes>> my sister's
Current obsession>> konnyaku
(an edible delicacy made from
the starch of the devil's tongue)

Jacket>> Vivienne Westwood
Skirt>> Vivienne Westwood
Trousers>> Vivienne Westwood
Shoes>> Dirk Bikkenberg
Bag>> Comme des Garçons
Point of fashion>> Vivienne Westwood
Current obsession>> Drijvere

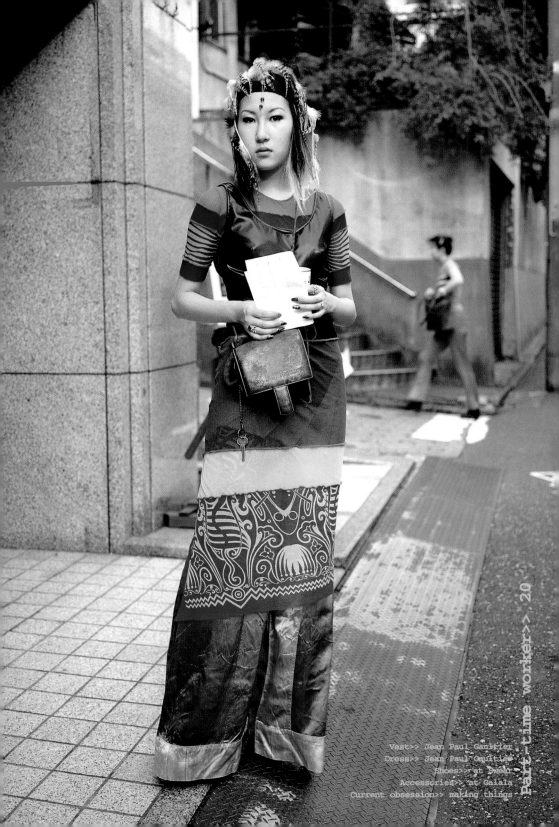

Vest>> Jean Paul Gaultier
Dress>> Jean Paul Gaultier
Shoes>> at Swear
Accessories>> at Galala
Current obsession>> making things

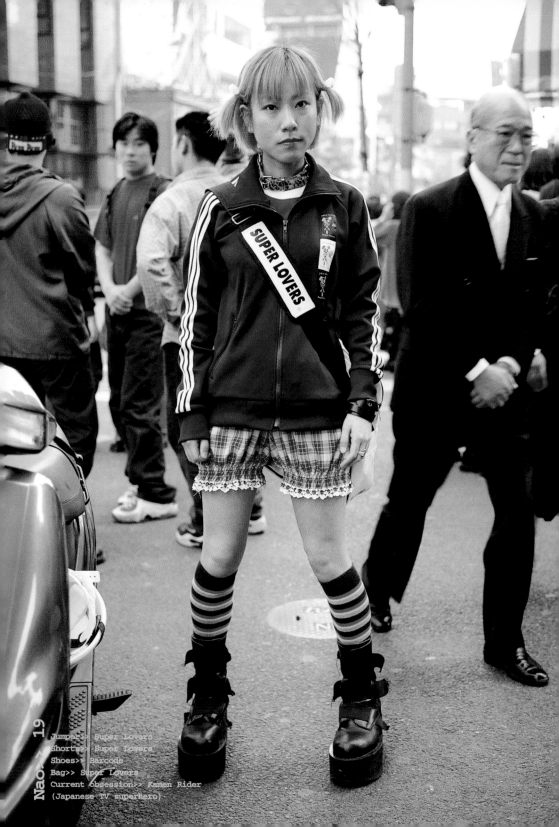

Jumper>> Super Lovers
Shorts>> Super Lovers
Shoes>> Barcode
Bag>> Super Lovers
Current Obsession>> Kamen Rider
(Japanese TV superhero)

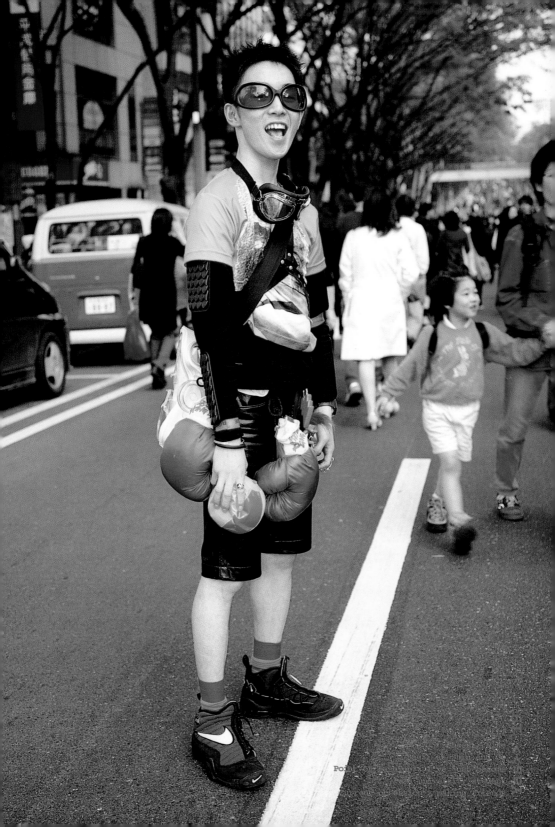

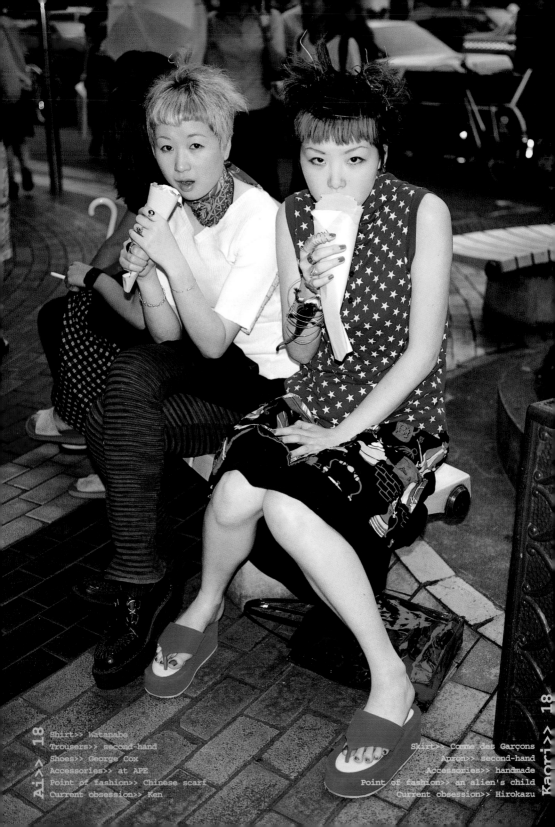

Shirt>> Watanabe
Trousers>> second-hand
Shoes>> George Cox
Accessories>> at APE
Point of fashion>> Chinese scarf
Current obsession>> Ken

Skirt>> Comme des Garçons
Apron>> second-hand
Accessories>> handmade
Point of fashion>> an alien's child
Current obsession>> Hirokazu

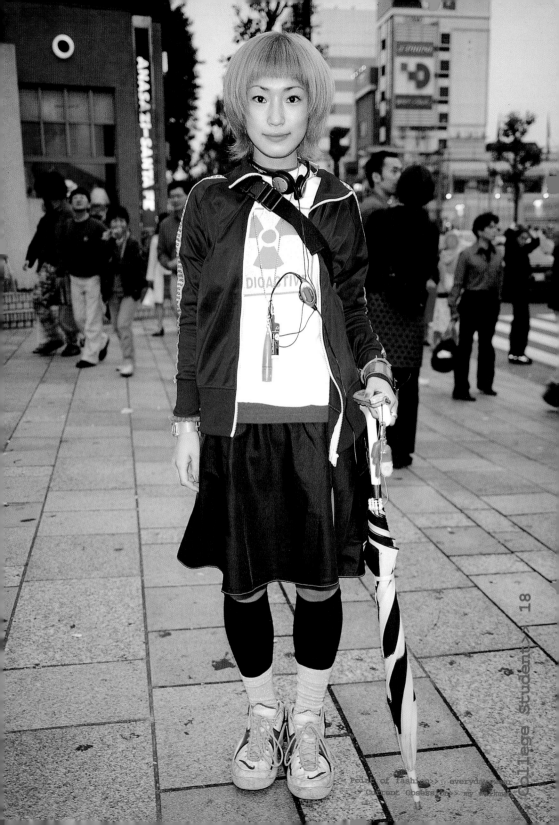

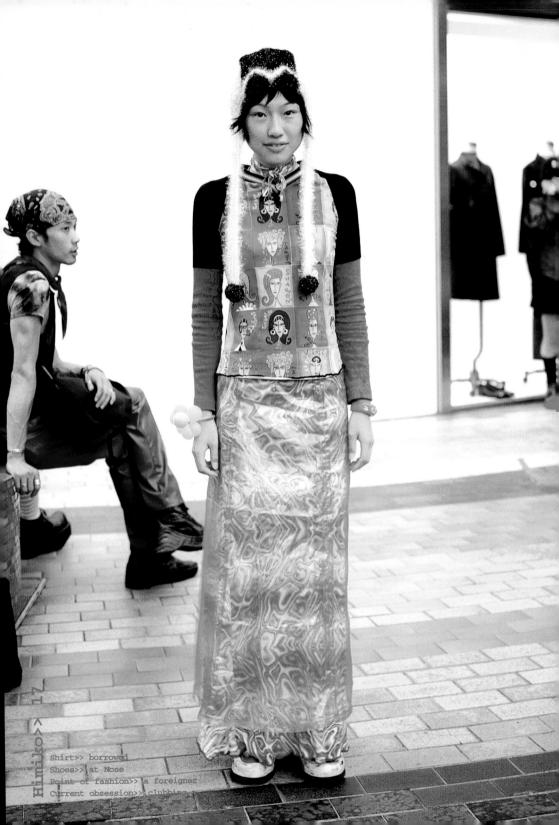

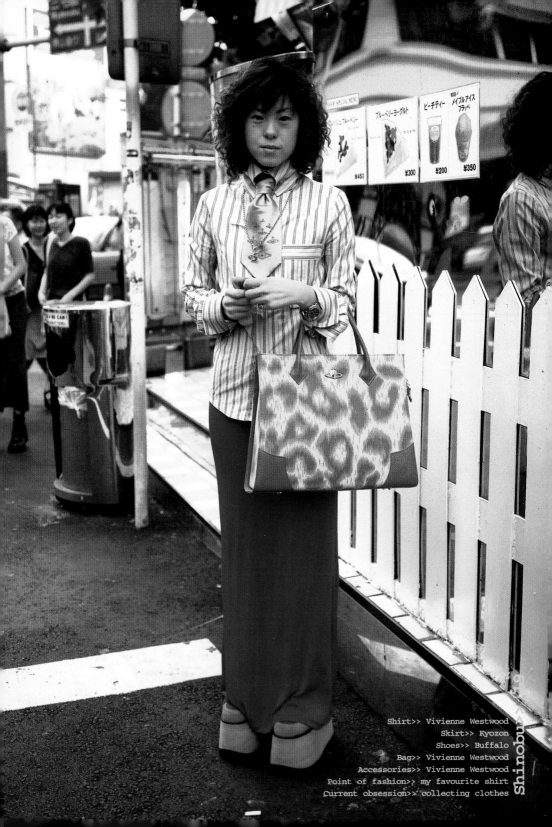

Shirt>> Vivienne Westwood
Skirt>> Kyozon
Shoes>> Buffalo
Bag>> Vivienne Westwood
Accessories>> Vivienne Westwood
Point of fashion>> my favourite shirt
Current obsession>> collecting clothes

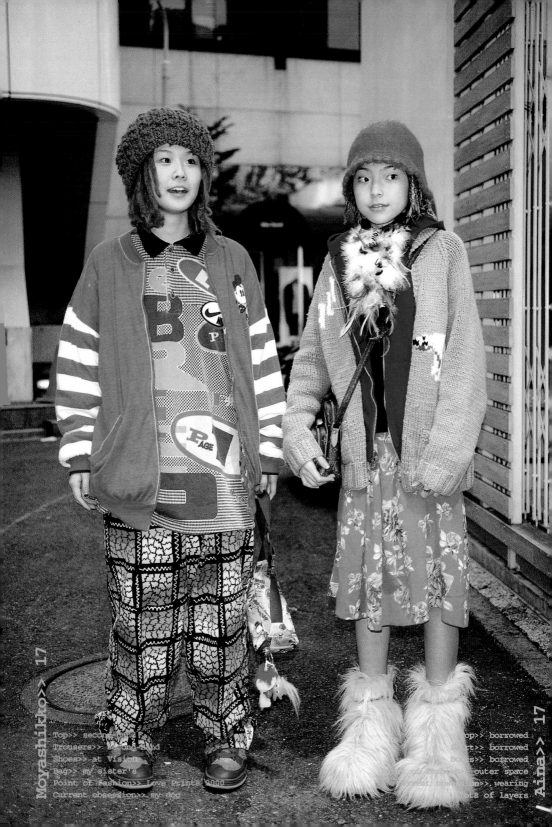

Top>> secon...
Trousers>> ...and
Shoes>> at Vision
Bag>> my sister's
Point of fashion>> Love Prints 2000
Current obsession>> my dog

op>> borrowed
rt>> borrowed
s>> borrowed
outer space
ion>>, wearing
ts of layers

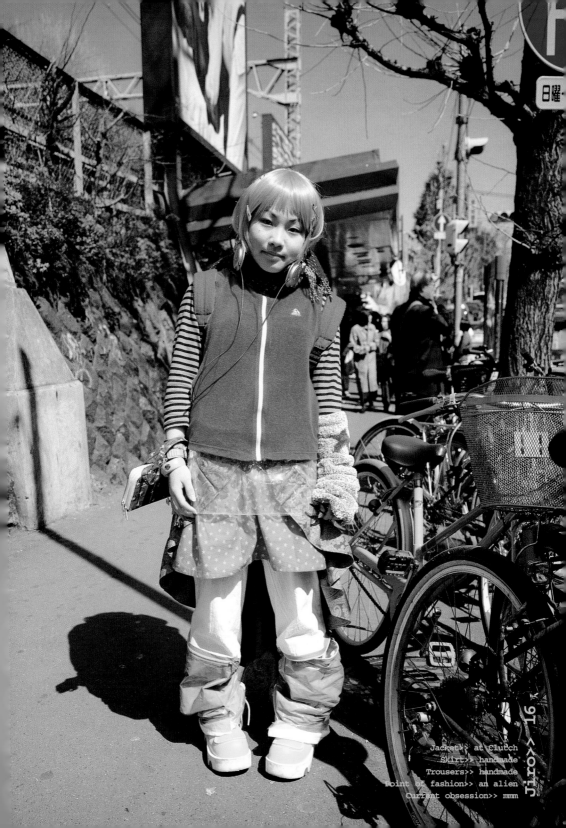

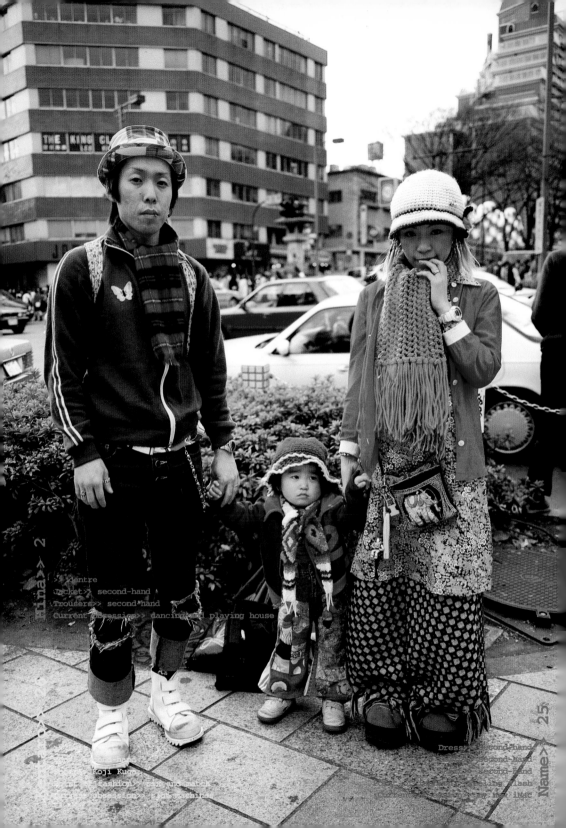

>> Centre
Jacket>> second-hand
Trousers>> second-hand
Current obsession>> dancing and playing house

Koji Kuga
Dress fashion>> mix and match
Current obsession>> slot machines

25

Dress>> second-hand
second-hand
second-hand
like Flash
my new iMac

Name>>

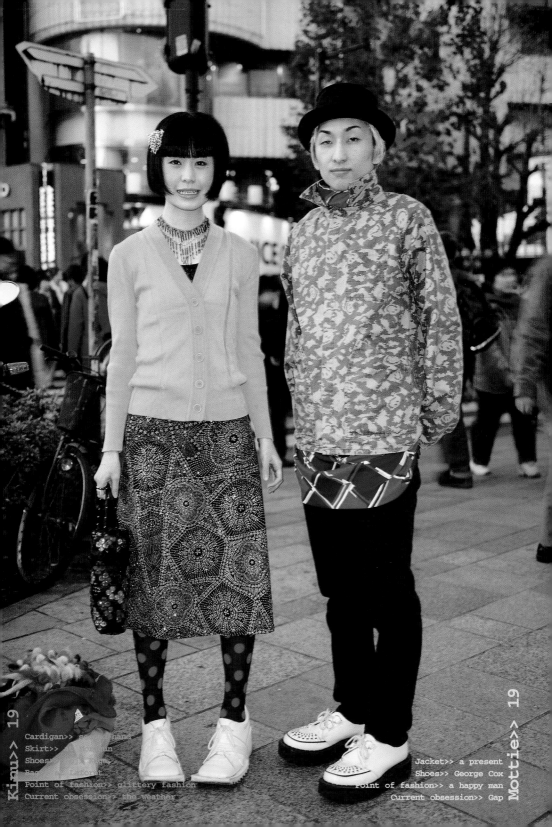

Cardigan>> second hand
Skirt>> second hand
Shoes>> ____
Bag>> a present
Point of fashion>> glittery fashion
Current obsession>> the weather

Jacket>> a present
Shoes>> George Cox
Point of fashion>> a happy man
Current obsession>> Gap

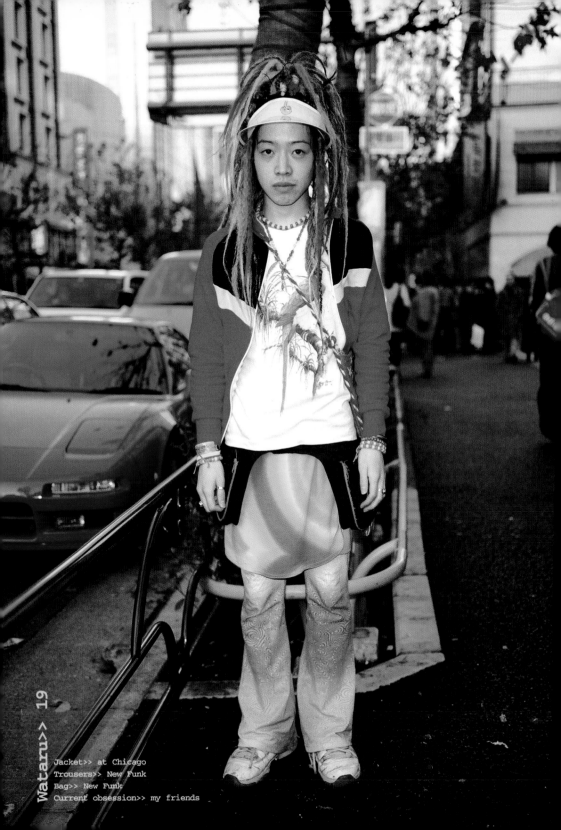

Jacket>> at Chicago
Trousers>> New Funk
Bag>> New Funk
Current obsession>> my friends

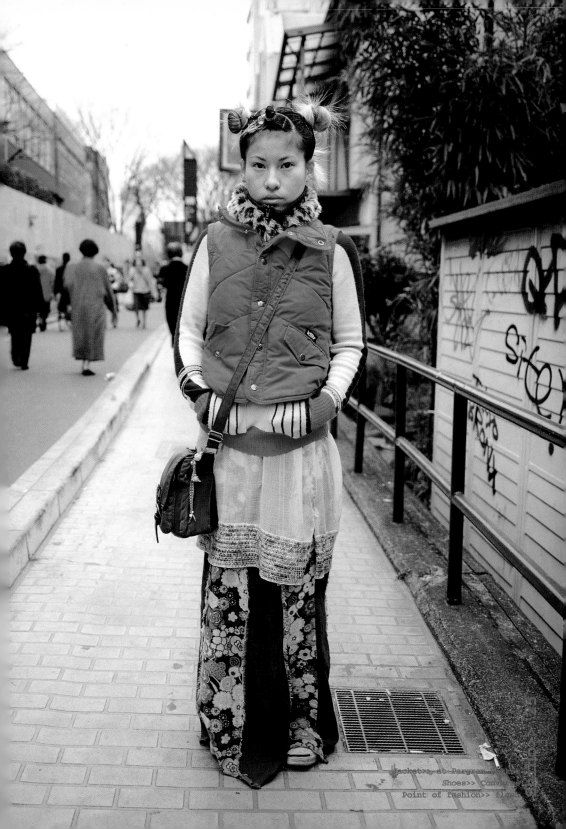

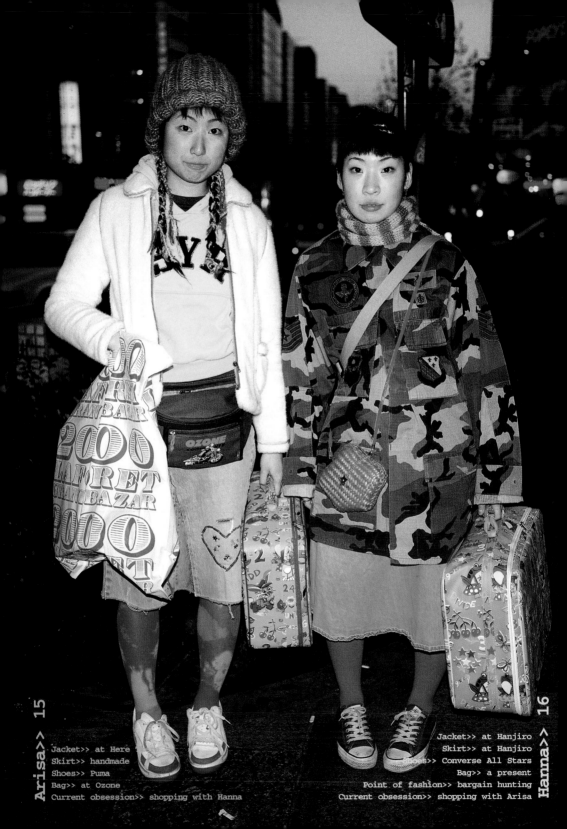

Jacket>> at Here
Skirt>> handmade
Shoes>> Puma
Bag>> at Ozone
Current obsession>> shopping with Hanna

Jacket>> at Hanjiro
Skirt>> at Hanjiro
Shoes>> Converse All Stars
Bag>> a present
Point of fashion>> bargain hunting
Current obsession>> shopping with Arisa

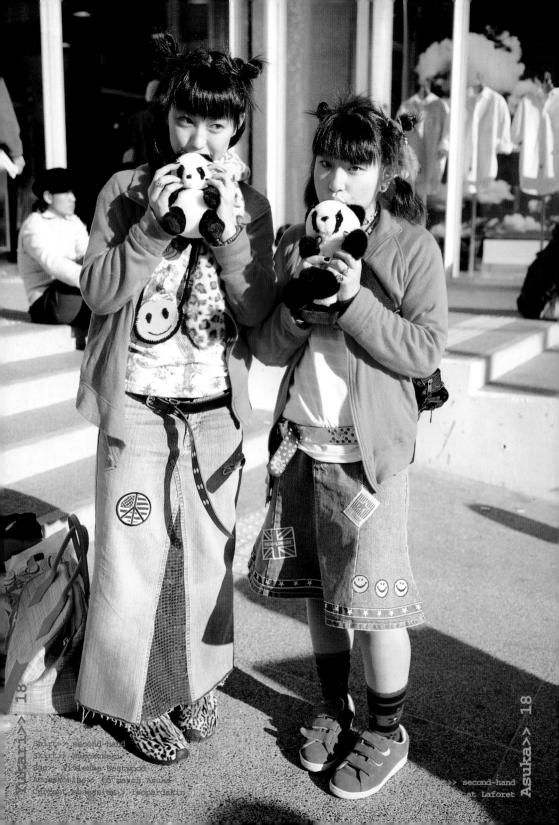

Shirt >> second-hand
Skirt >> (custom-made)
Bag >> Vivienne Westwood
Accessories >> (of vegen, Asuka)
(Right Cheogaesang / leopardskin)

>> second-hand
at Laforet

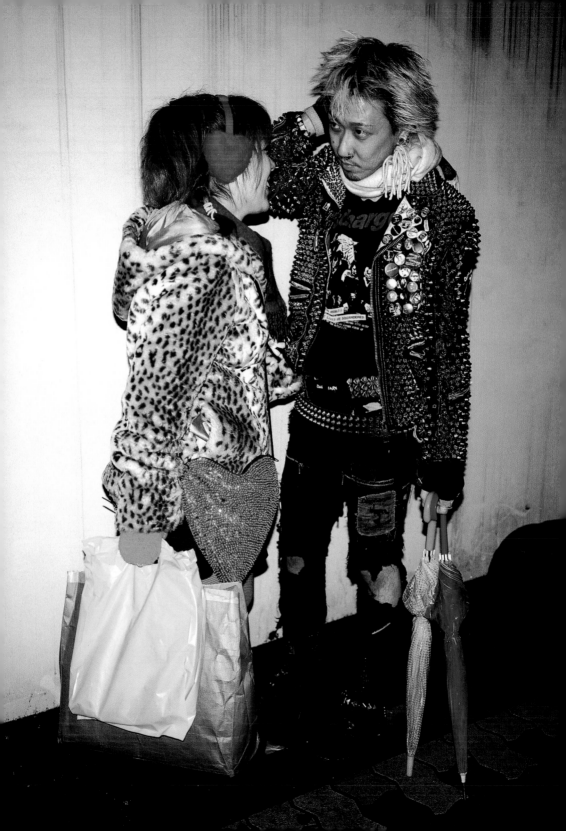

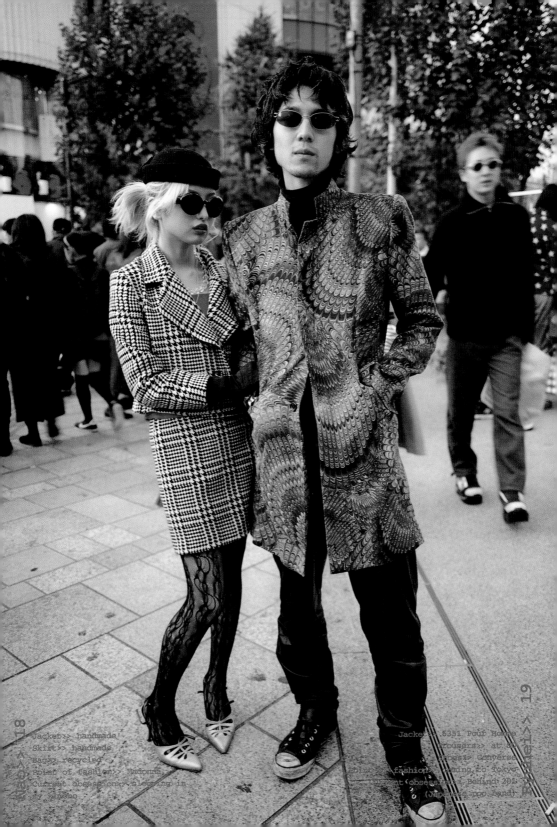

Jacket>> handmade
Skirt>> handmade
Bag>> recycled
Point of fashion>> Madonna
Current obsession>> sleeping in
my kimono

Jacket>> 5351 Pour Homme
Trousers>> at
Shoes>> Converse
Point of fashion>> coming to Tokyo
Current obsession>> Belinda 291
(Japanese pop band)

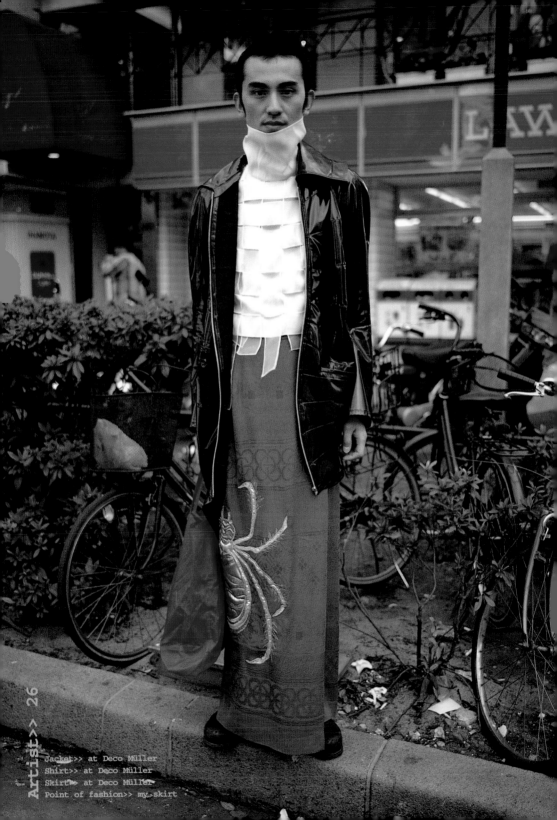

Jacket>> at Deco Müller
Shirt>> at Deco Müller
Skirt>> at Deco Müller
Point of fashion>> my skirt

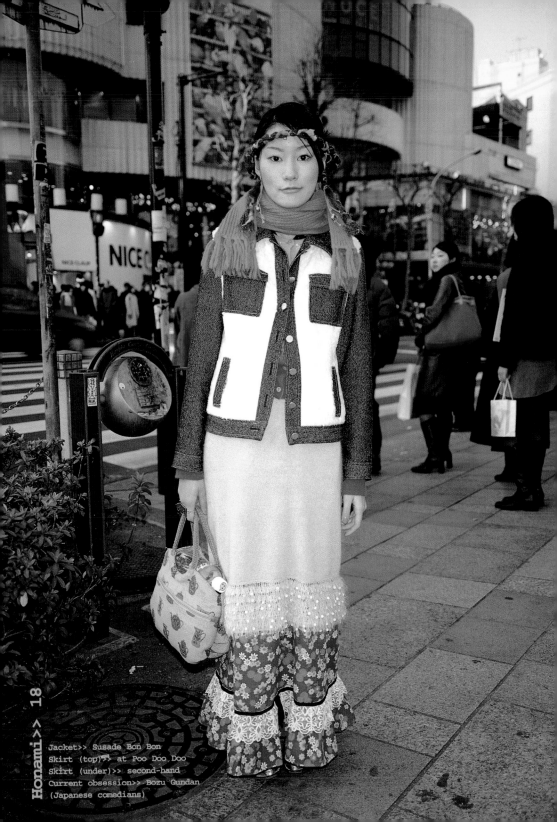

Jacket>> Susade Bon Bon
Skirt (top)>> at Poo Doo Doo
Skirt (under)>> second-hand
Current obsession>> Bozu Gundan
(Japanese comedians)

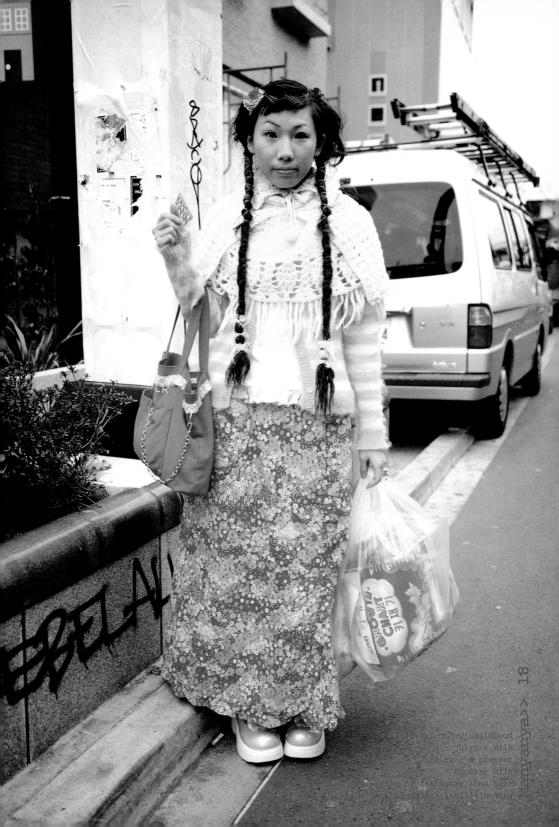

Colin >> from my childhood
Shirt>> Milk
Skirt>> a present
Shoes>> Milk
Point of fashion>> long hair
Current obsession>> stylish looking

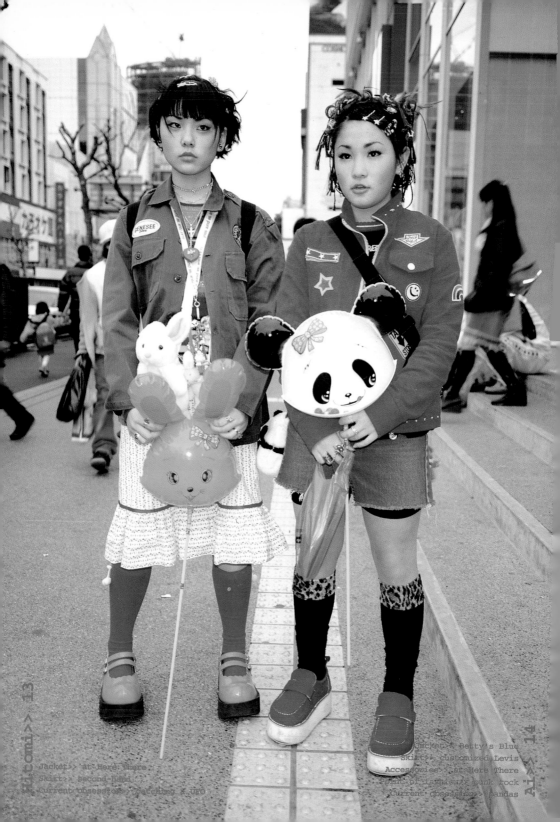

Jacket>> at Here There
Skirt>> Second-hand
Current obsession>> Tetsuko Kuroyanagi

Jacket>> Betty's Blue
Skirt>> customized Levi's
Accessories>> at Here There
Point of fashion>> punk rock
Current obsession>> pandas

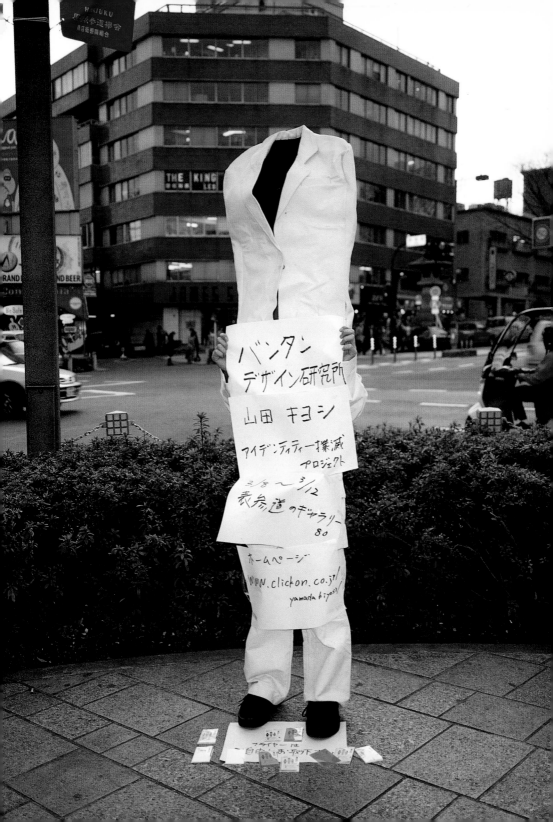

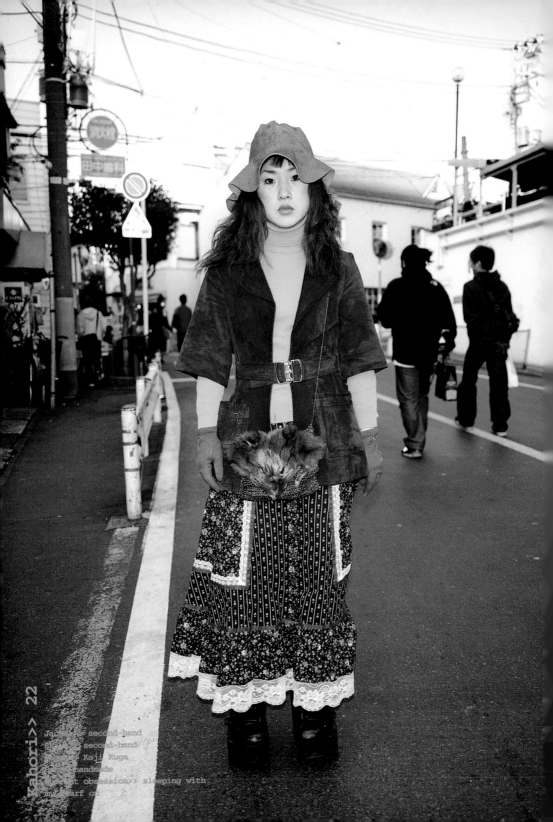

Jacket>> second-hand
second-hand
Koji Kuga
handmade
t obsession>> sleeping with
my scarf on

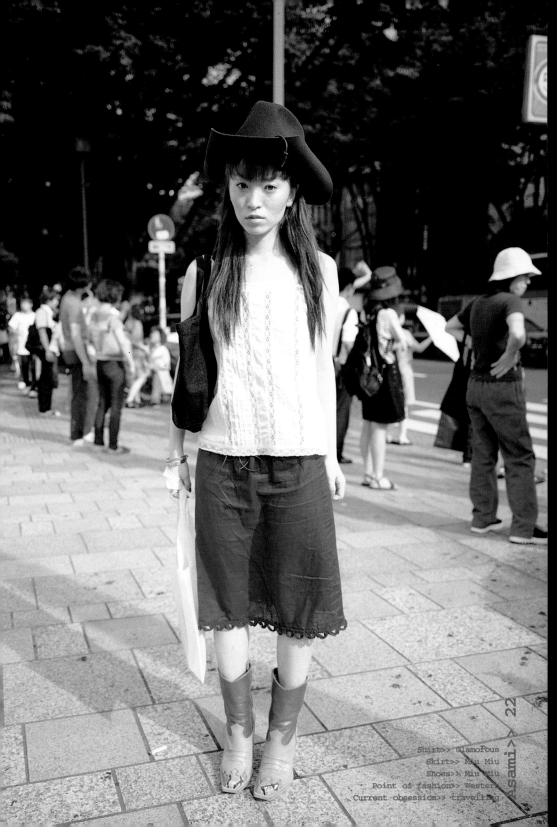

Shirt>> Glamorous
Skirt>> Miu Miu
Shoes>> Miu Miu
Point of fashion>> Western
Current obsession>> travelling

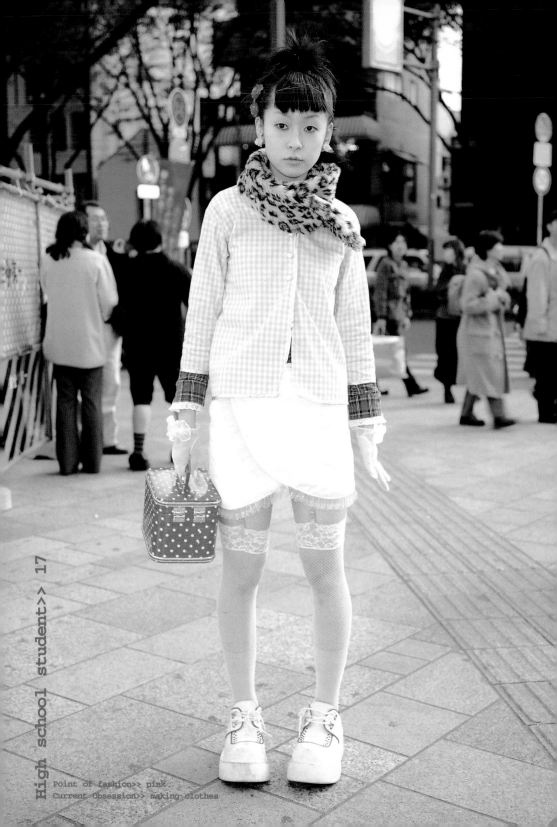

Point of fashion>> pink.
Current Obsession>> making clothes

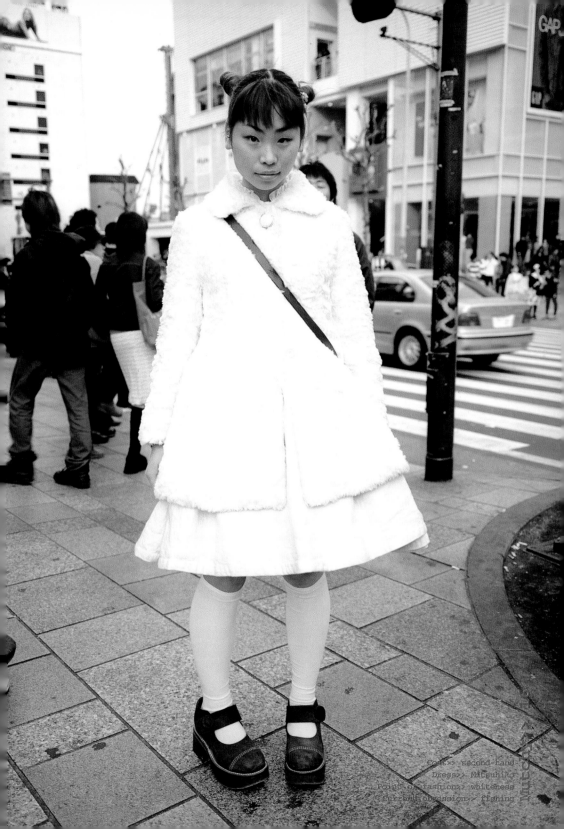

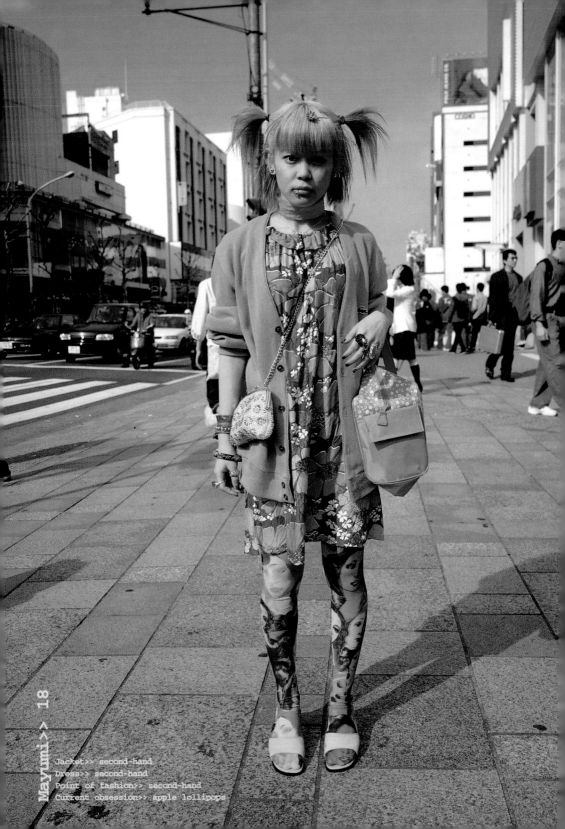

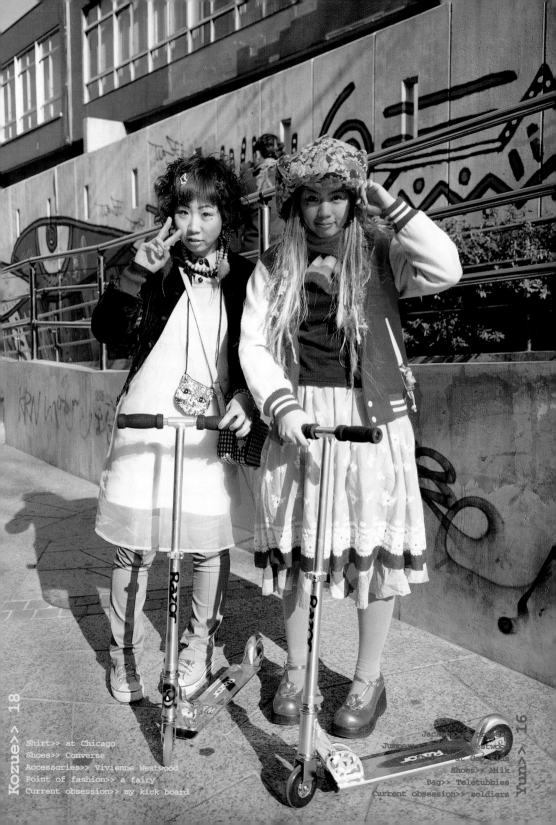

Shirt>> at Chicago
Shoes>> Converse
Accessories>> Vivienne Westwood
Point of fashion>> a fairy
Current obsession>> my kick board

Jacket>> from a friend
Jumper>> Vivienne Westwood
at Gap>> us
Shoes>> Milk
Bag>> Teletubbies
Current obsession>> soldiers

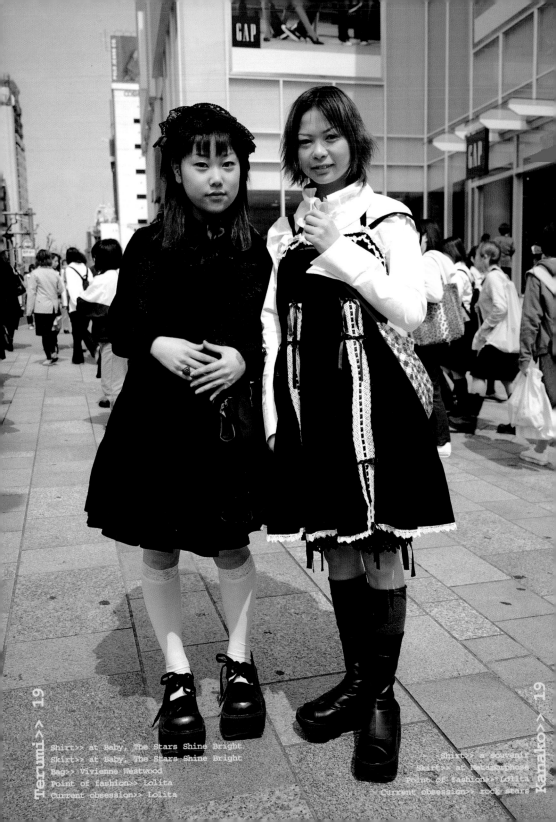

Terumi>> 19

Shirt>> at Baby, The Stars Shine Bright
Skirt>> at Baby, The Stars Shine Bright
Bag>> Vivienne Westwood
Point of fashion>> Lolita
Current obsession>> Lolita

Kanako>> 19

Shirt>> a souvenir
Skirt>> at Metamorphose
Point of fashion>> Lolita
Current obsession>> rock stars

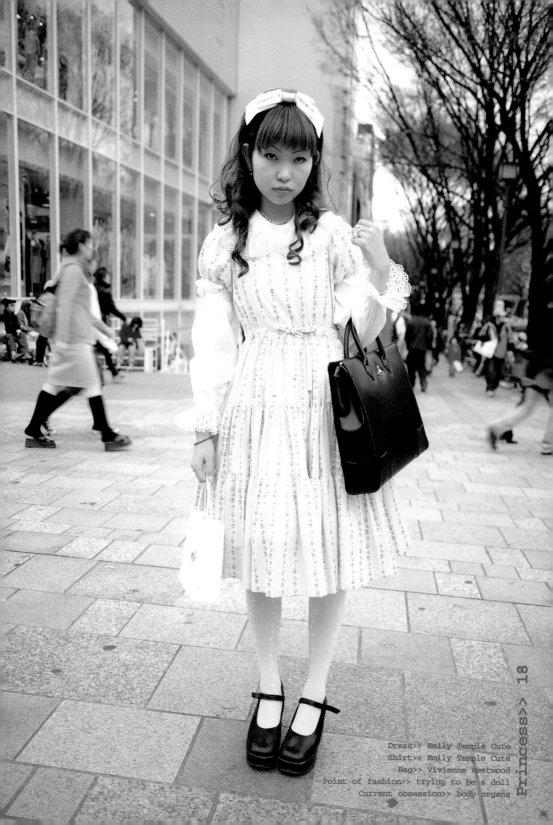

Dress>> Emily Temple Cute
Shirt>> Emily Temple Cute
Bag>> Vivienne Westwood
Point of fashion>> trying to be a doll
Current obsession>> body organs

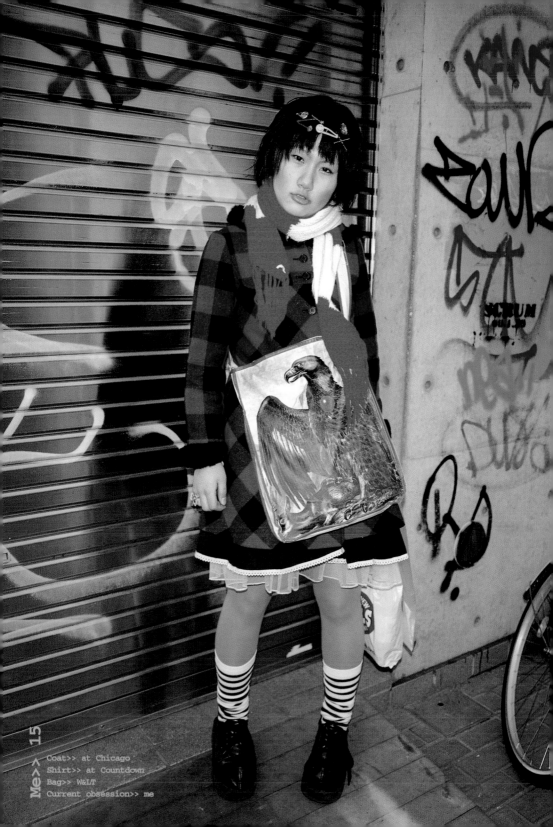

>> Coat>> at Chicago
Shirt>> at Countdown
Bag>> W<
Current obsession>> me

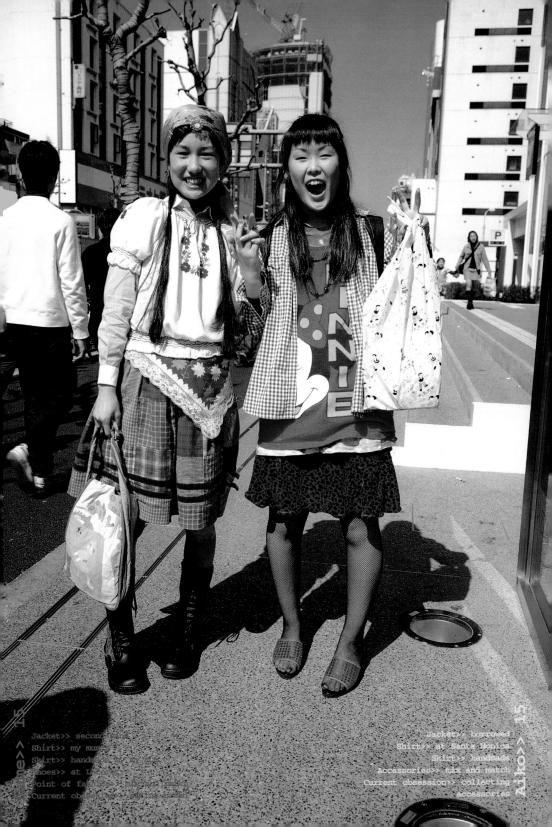

Jacket>> second
Shirt>> my mum
Skirt>> hand
hoes>> at L
oint of fa
Current ob

Jacket>> borrowed
Shirt>> at Santa Monica
Skirt>> handmade
Accessories>> mix and match
Current obsession>> collecting
accessories

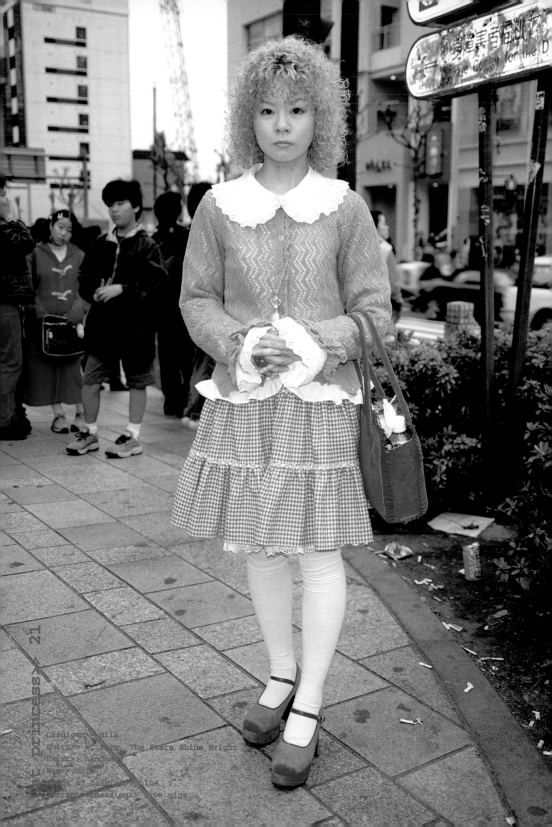

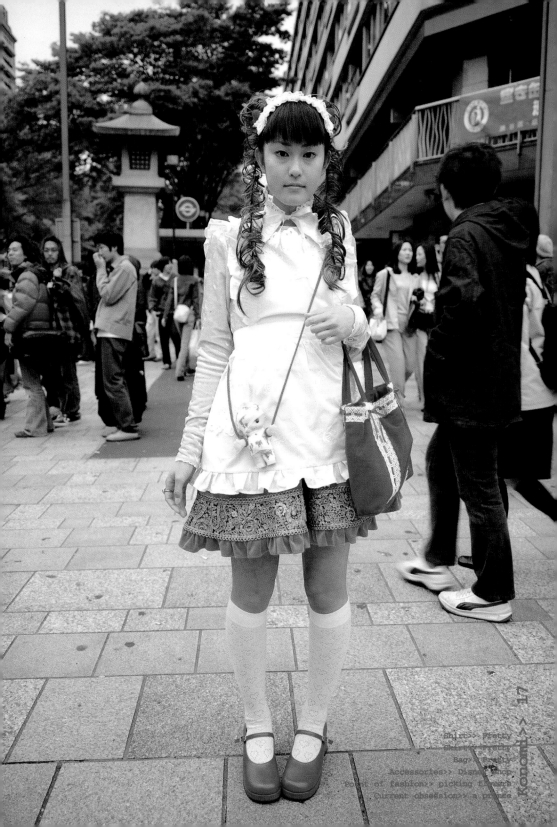

Shirt>> Pretty
Skirt>> Pretty
Bag>> Pretty
Accessories>> Disney Shop
Point of fashion>> picking flowers
Current obsession>> a prince

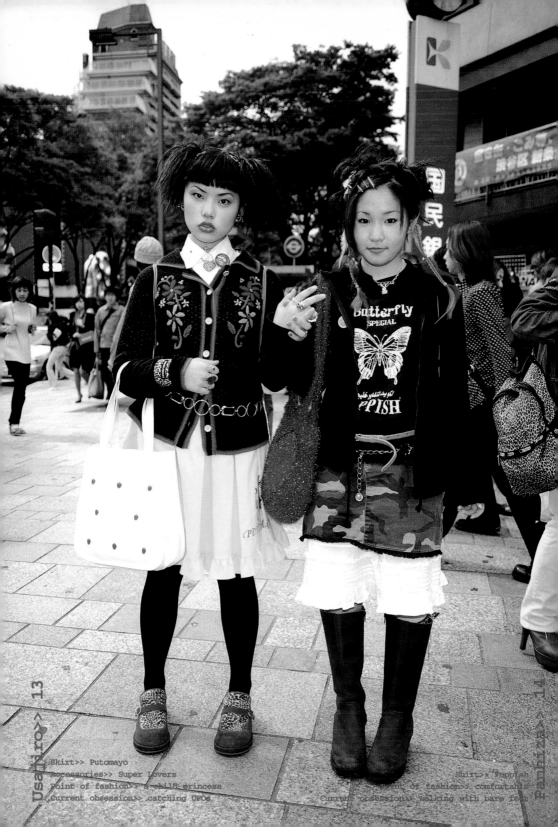

Skirt>> Putomayo
Accessories>> Super Lovers
Point of fashion>> a chilly princess
Current obsession>> catching UFOs

Shirt>> Toppish
Point of fashion>> comfortable
Current obsession>> walking with bare feet

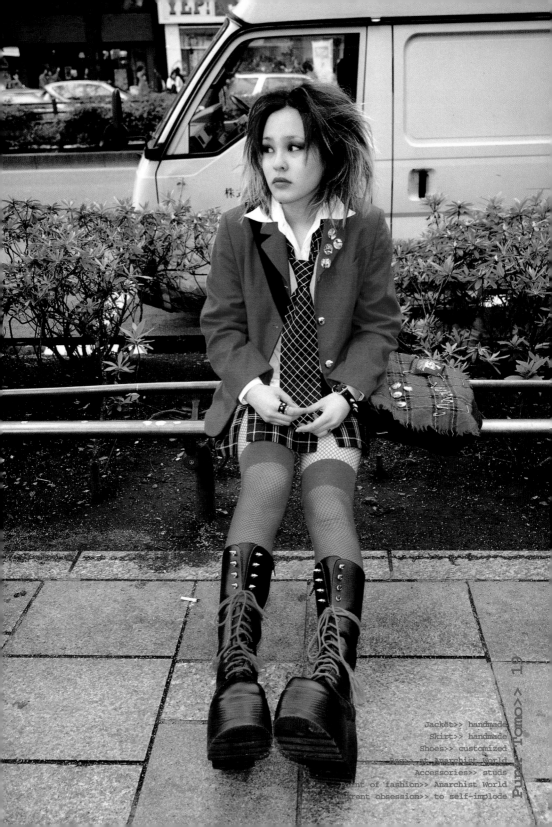

Jacket>> handmade
Skirt>> handmade
Shoes>> customized
Bag>> Anarchist World
Accessories>> studs
point of fashion>> Anarchist World
current obsession>> to self-implode

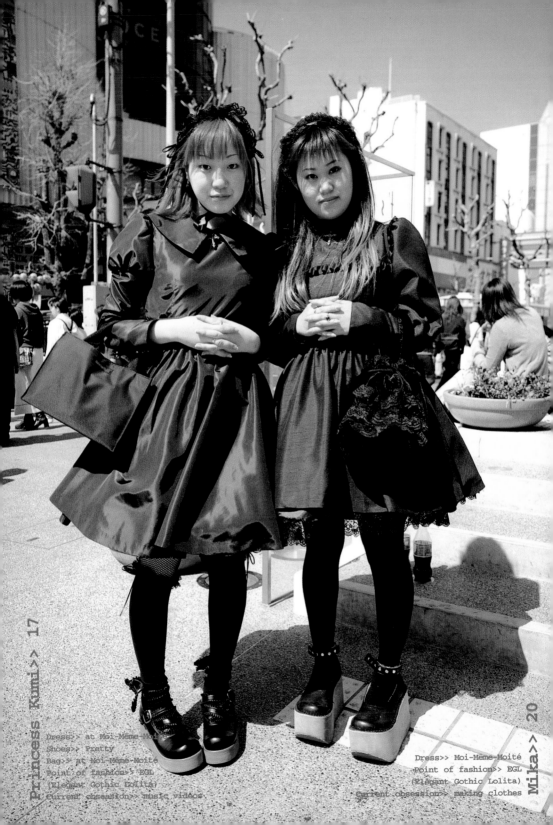

Dress>> at Moi-Même-Moité
Shoes>> Pretty
Bag>> at Moi-Même-Moité
Point of fashion>> EGL
(Elegant Gothic Lolita)
Current obsession>> music videos

Dress>> Moi-Même-Moité
Point of fashion>> EGL
(Elegant Gothic Lolita)
Current obsession>> making clothes

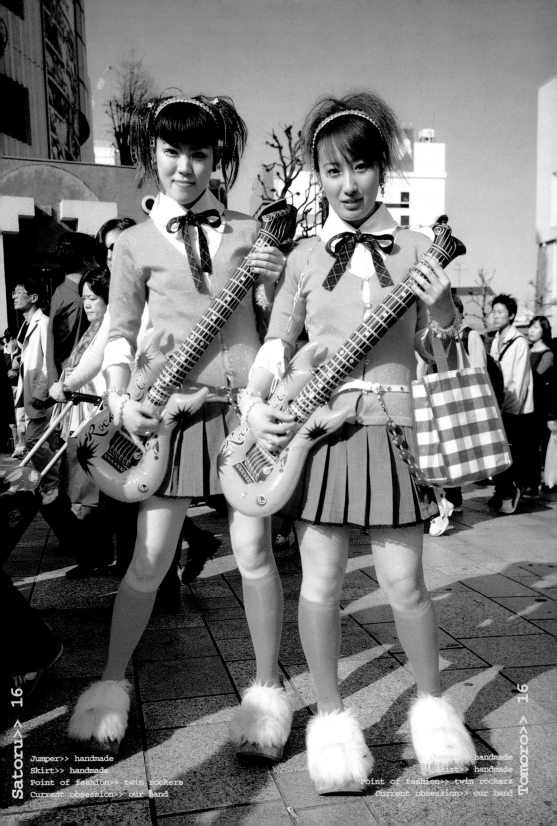

Jumper>> handmade
Skirt>> handmade
Point of fashion>> twin rockers
Current obsession>> our band

Jumper>> handmade
Skirt>> handmade
Point of fashion>> twin rockers
Current obsession>> our band

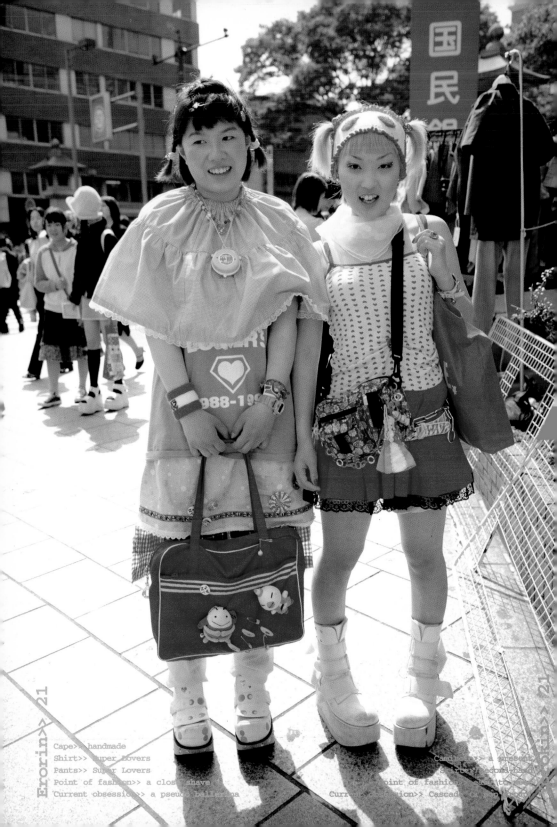

Cape>> handmade
Shirt>> Super Lovers
Pants>> Super Lovers
Point of fashion>> a close shave
Current obsession>> a pseudo ballerina

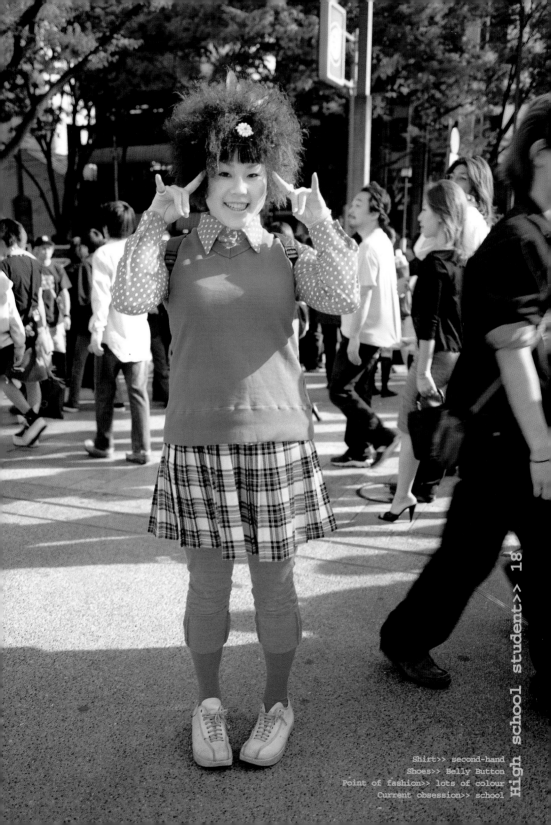

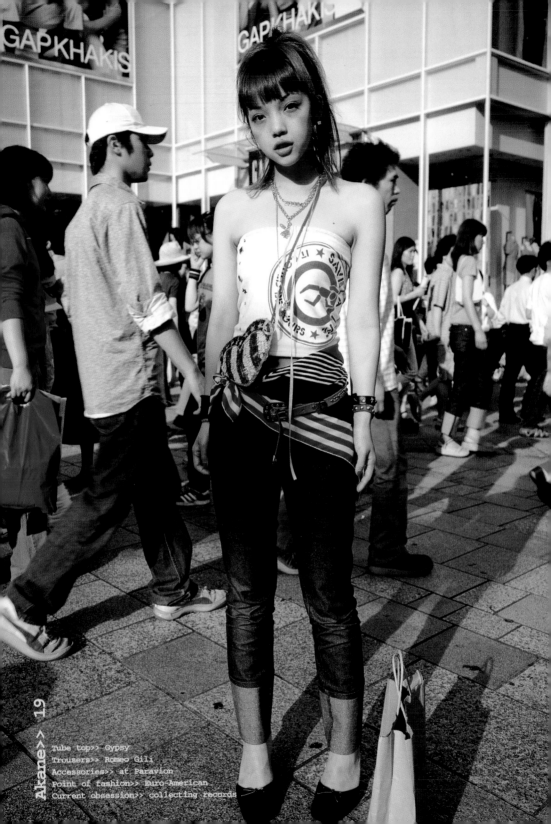

Tube top>> Gypsy
Trousers>> Romeo Gili
Accessories>> at Paravion
Point of fashion>> Euro-American
Current obsession>> collecting records

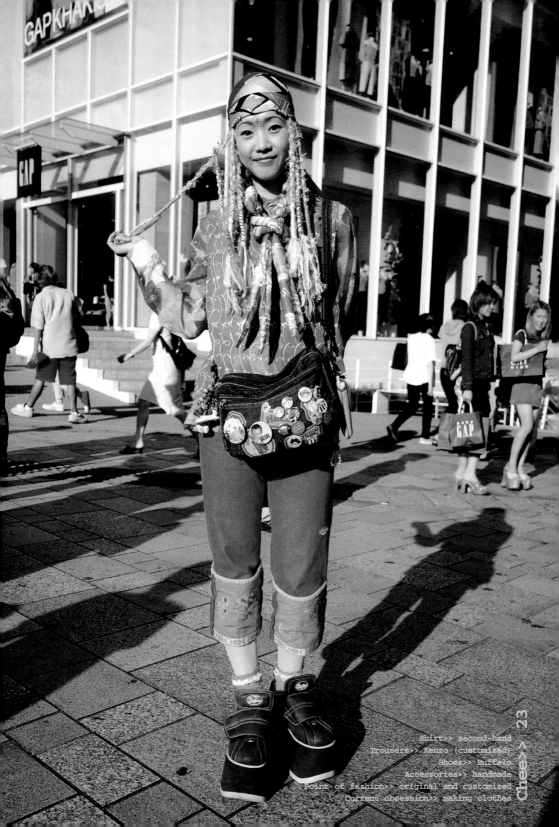

Shirt>> second-hand
Trousers>> Kenzo (customized)
Shoes>> Buffalo
Accessories>> handmade
Point of fashion>> original and customized
Current obsession>> making clothes

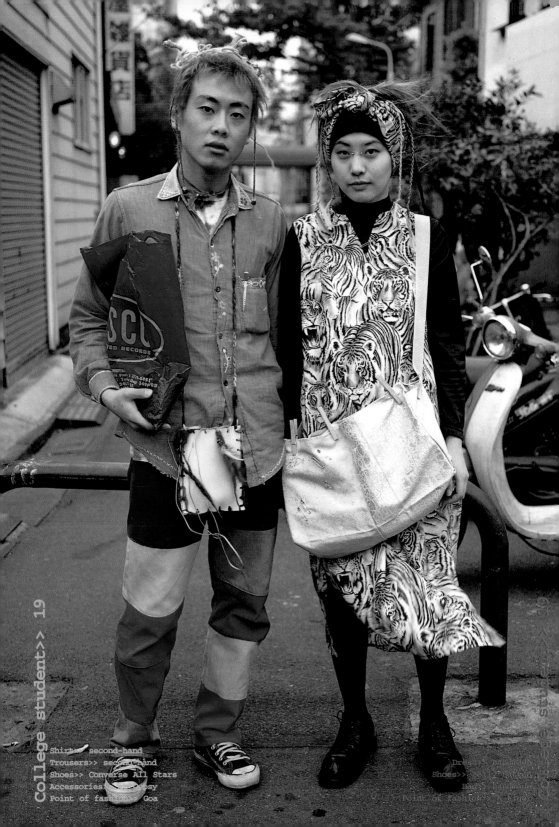

Shirt>> second-hand
Trousers>> second-hand
Shoes>> Converse All Stars
Accessories>> Gypsy
Point of fashion>> Goa

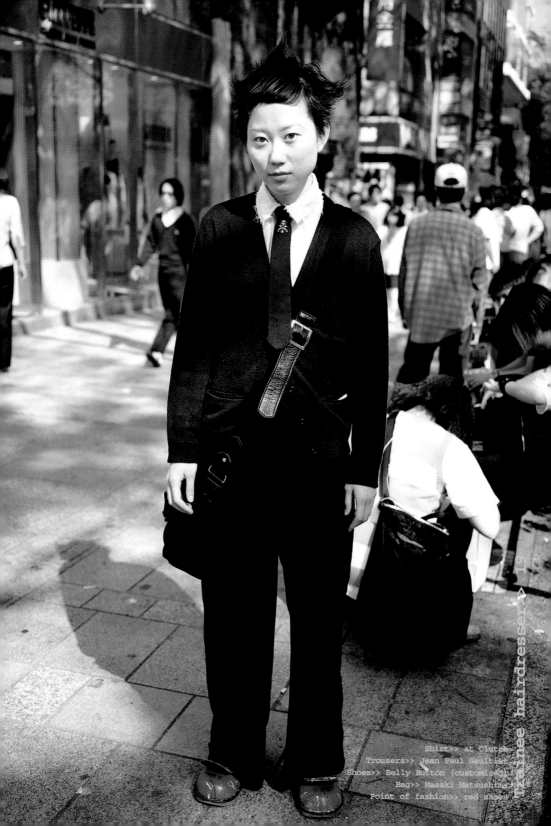

Shirt>> second-hand
Leggings>> second-hand
Shoes>> Reebok
Point of fashion>> Earth's Defensive Army
Current obsession>> Chupa Chups (lollipops)

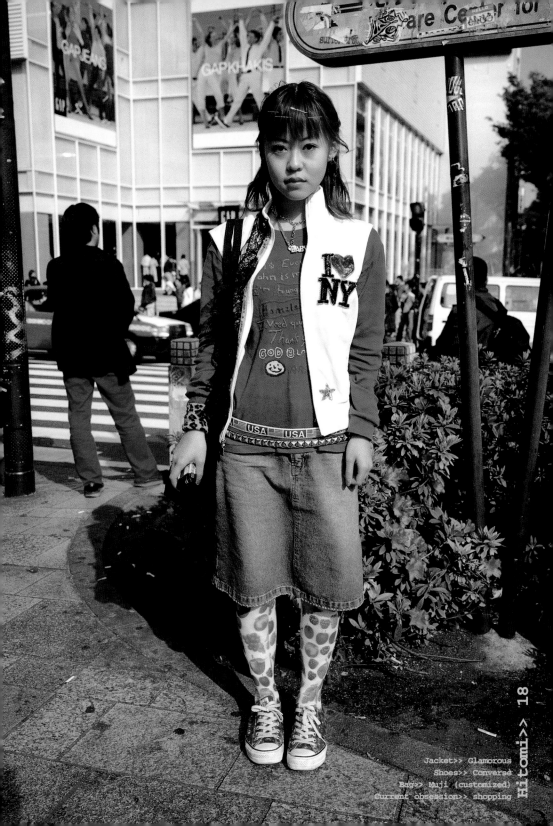

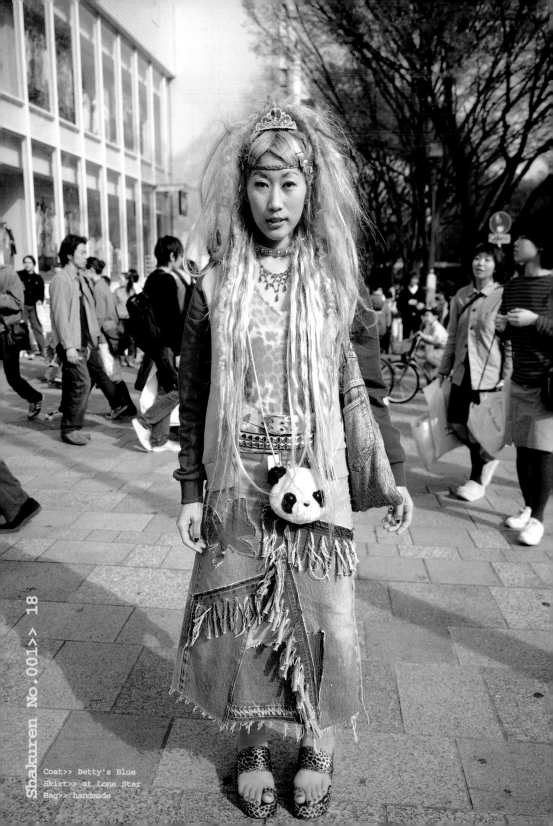

Coat>> Betty's Blue
Skirt>> at Lone Star
Bag>> handmade

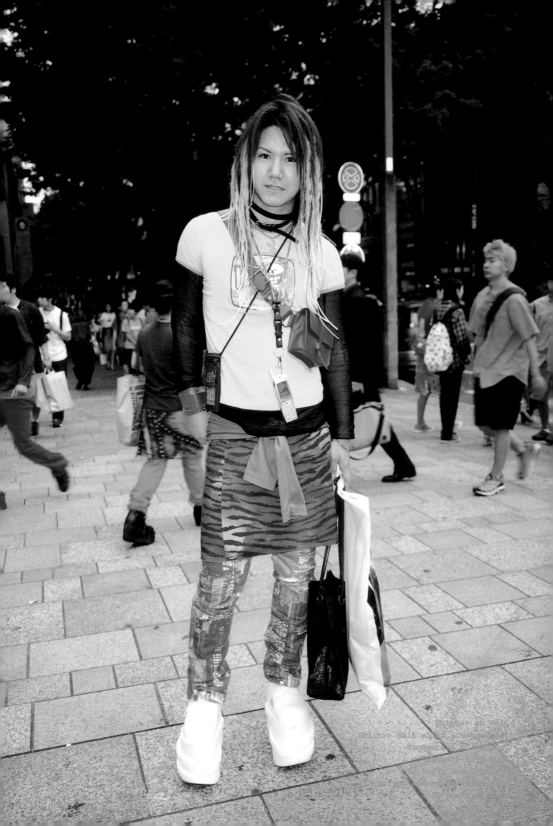

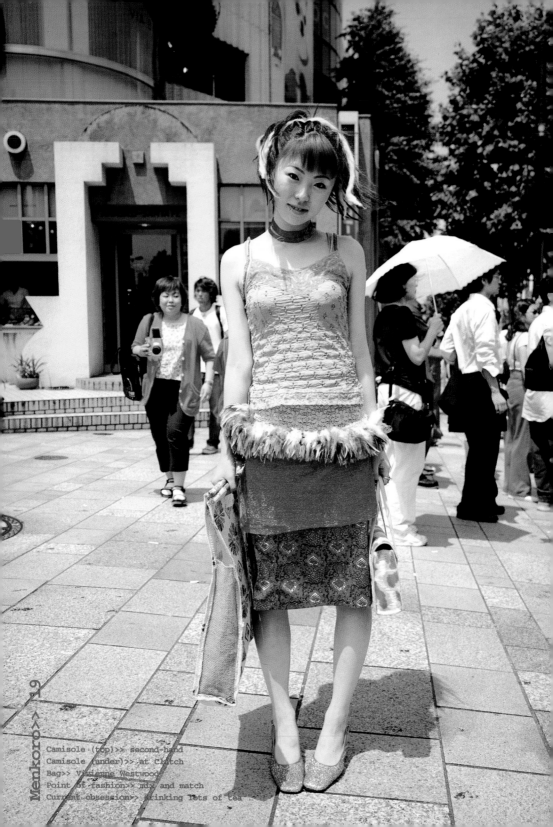

Camisole (top)>> second-hand
Camisole (under)>> at Clutch
Bag>> Vivienne Westwood
Point of fashion>> mix and match
Current obsession>> drinking lots of tea

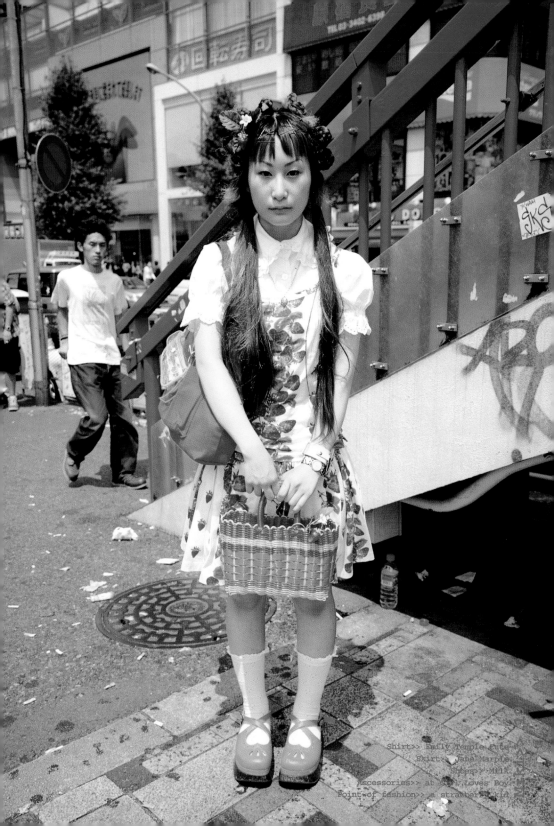

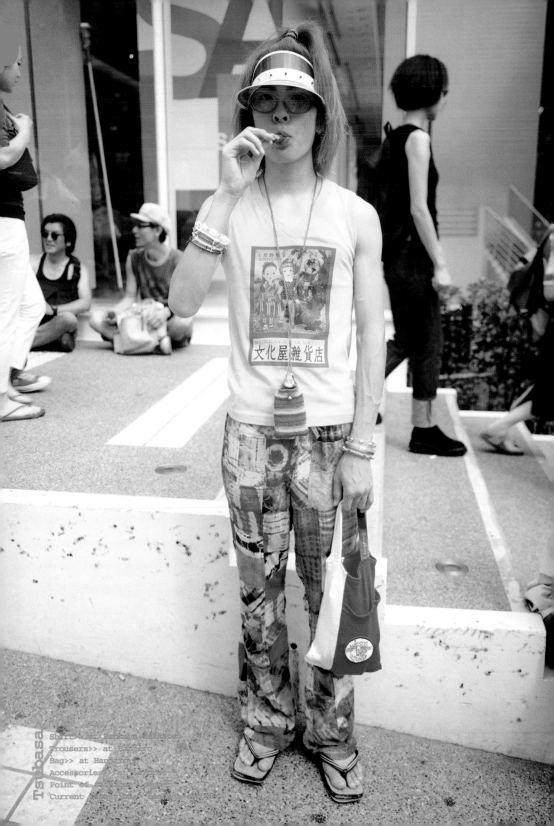

Shirt>> Bunkaya Zakkaten
Trousers>> at Hambero
Bag>> at Hambero
Accessories>> at Hambero
Point of
Current

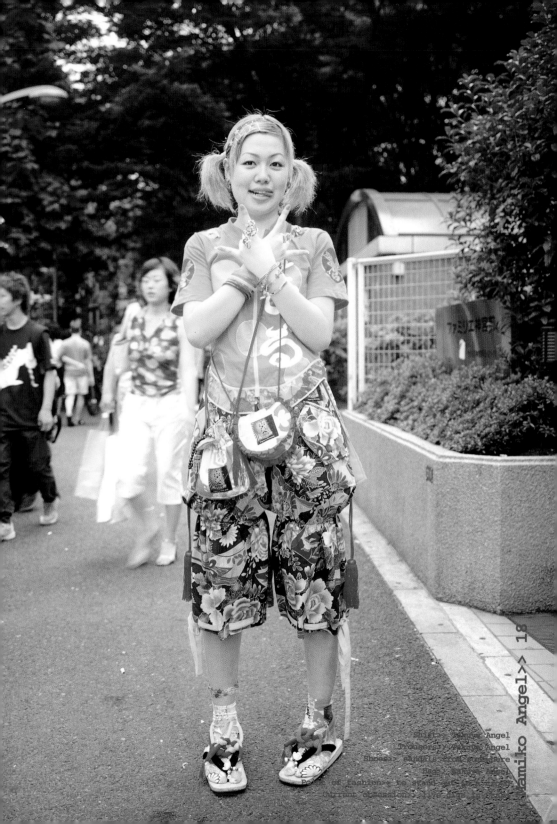

Shirt: Super Angel
Trousers: Super Angel
Shoes: sandals from Harajuku
Bag: Super Angel
Point of fashion: to stand out
Current obsession: live shows

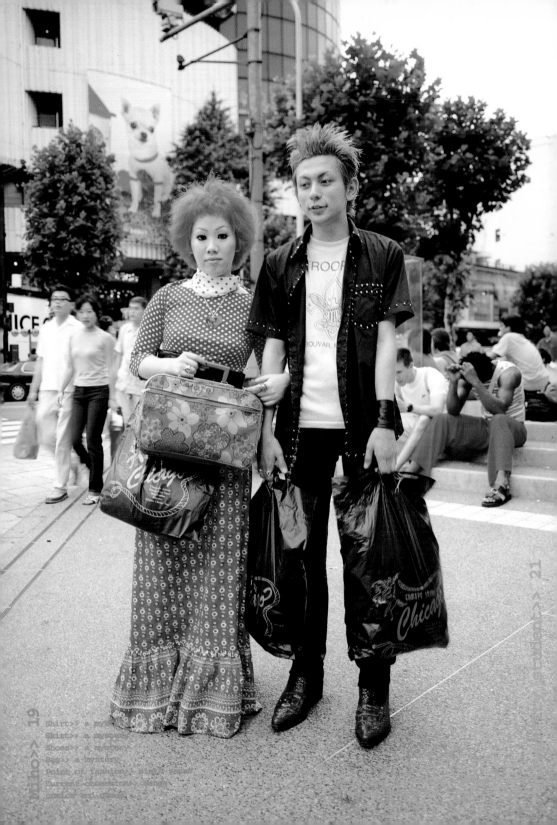

Shirt>> a mystery
Skirt>> a mystery
Shoes>> a mystery
Bag>> a mystery
Point of fashion>>

Jacket>> Glamorous
Shoes>> Peace Now

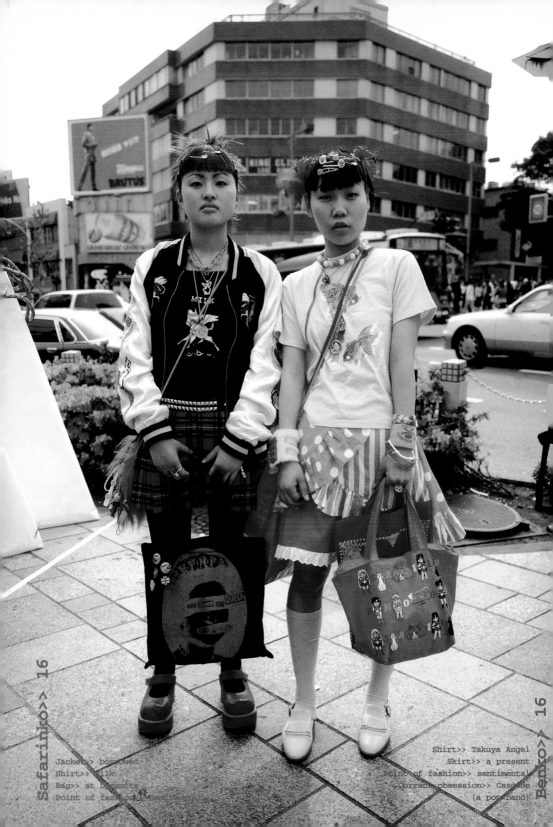

Jacket>> borrowed
Shirt>> Milk
Bag>> at Dynamite
Point of fashion>>

Shirt>> Takuya Angel
Skirt>> a present
Point of fashion>> sentimental
Current obsession>> Cascade
(a pop band)

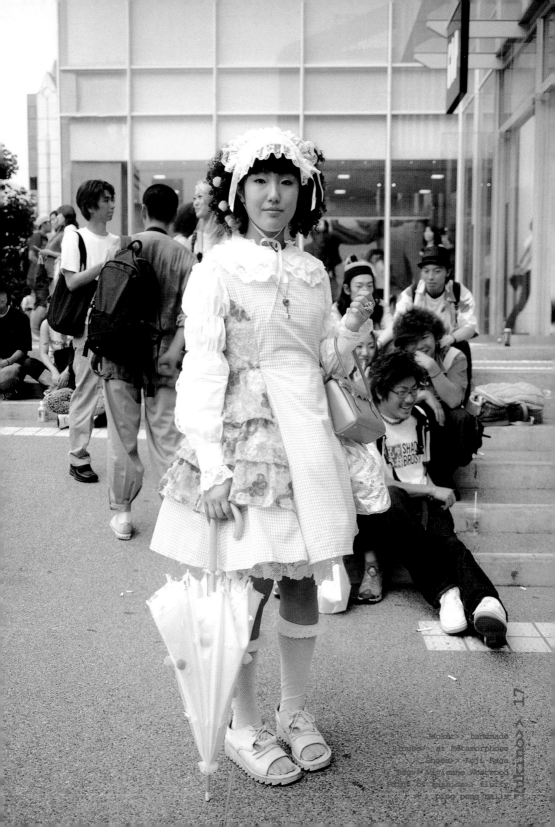

blouse>> handmade
blouse>> at metamorphose
Shoes>> Roll Raga
bag>> Vivienne Westwood
point of fashion>> fluffy
pang pong ga il

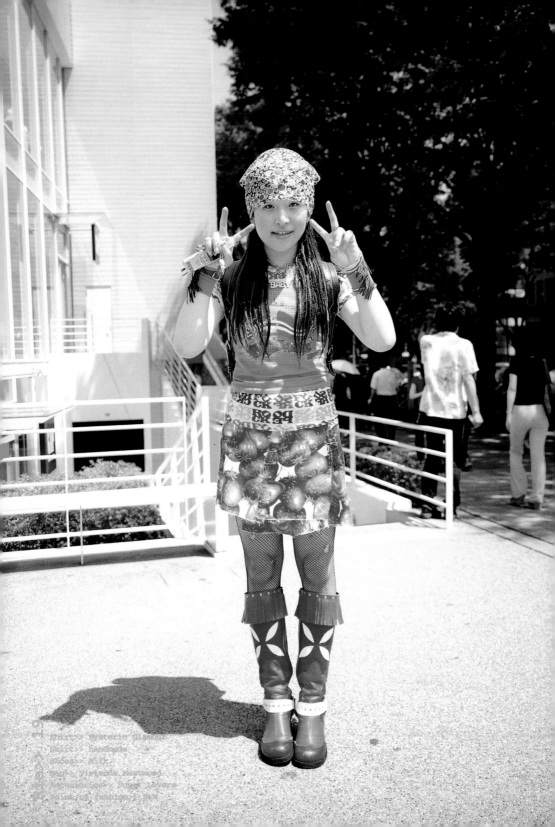

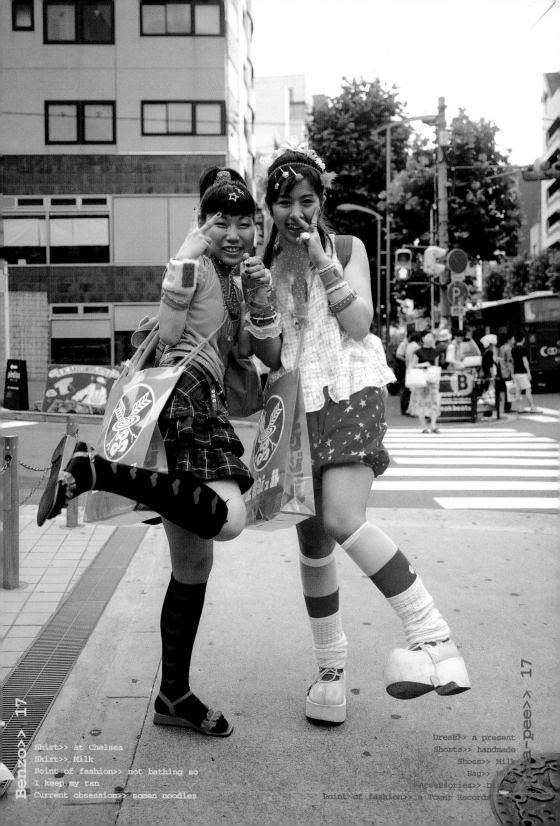

Shirt>> at Chelsea
Skirt>> Milk
Point of fashion>> not bathing so
I keep my tan
Current obsession>> somen noodles

Dress>> a present
Shorts>> handmade
Shoes>> Milk
Bag>> Wh...
Accessories>> Li...
Point of fashion>> a Tower Records

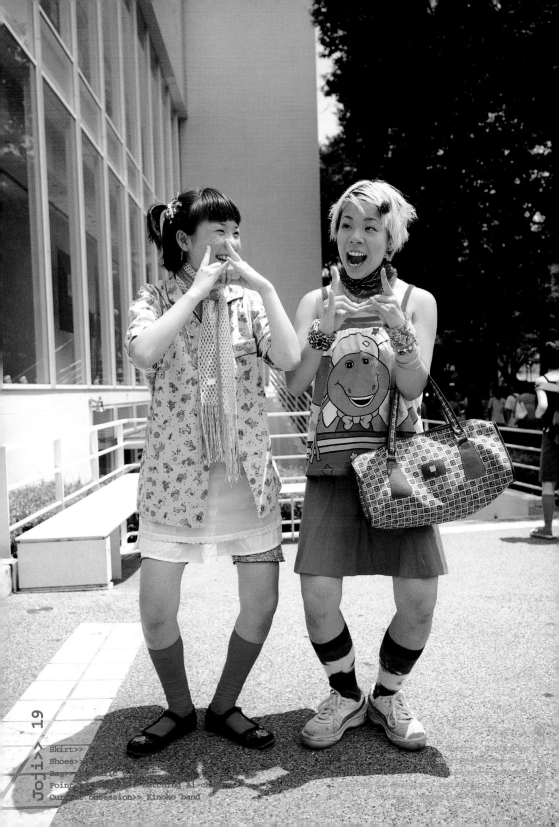

Skirt>>
Shoes>>
Bag>>
Point>> matching Ai-ch
Current obsession>> Kinoko band

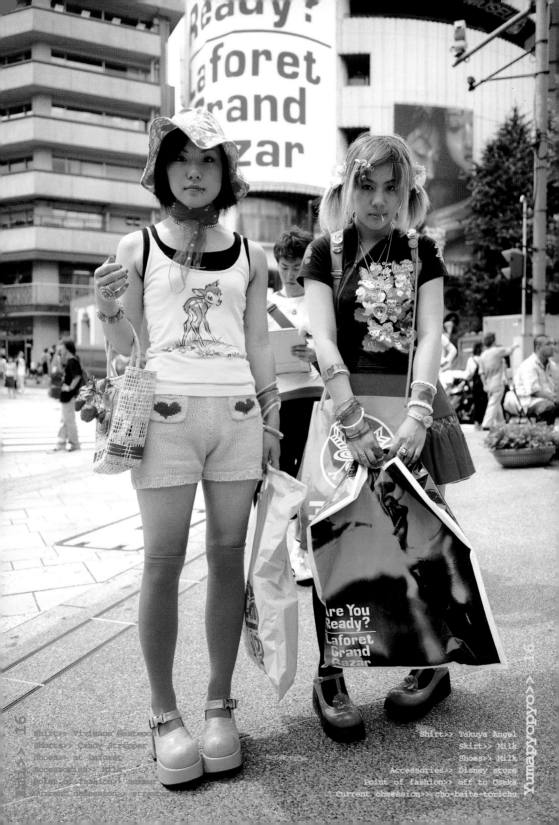

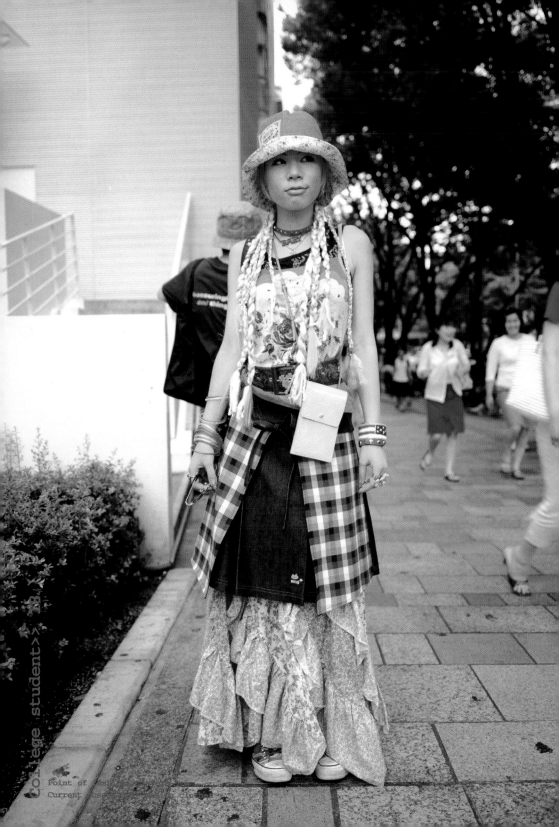

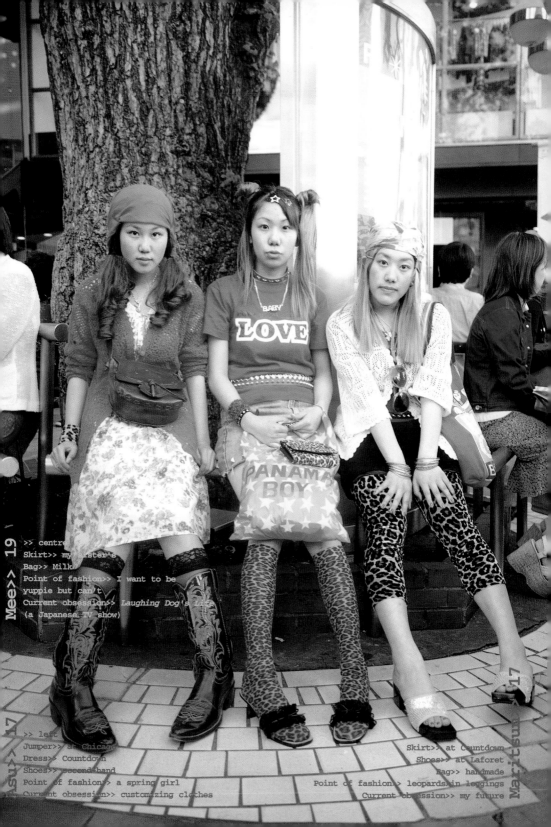

>> centre
Skirt>> my sister's
Bag>> Milk
Point of fashion>> I want to be
yuppie but can't
Current obsession>> Laughing Dog's Life
(a Japanese TV show)

Atsu>> 17

>> left
Jumper>> at Chicago
Dress>> Countdown
Shoes>> second-hand
Point of fashion>> a spring girl
Current obsession>> customizing clothes

Skirt>> at Countdown
Shoes>> at Laforet
Bag>> handmade
Point of fashion>> leopardskin leggings
Current obsession>> my future

Maritsun>> 17

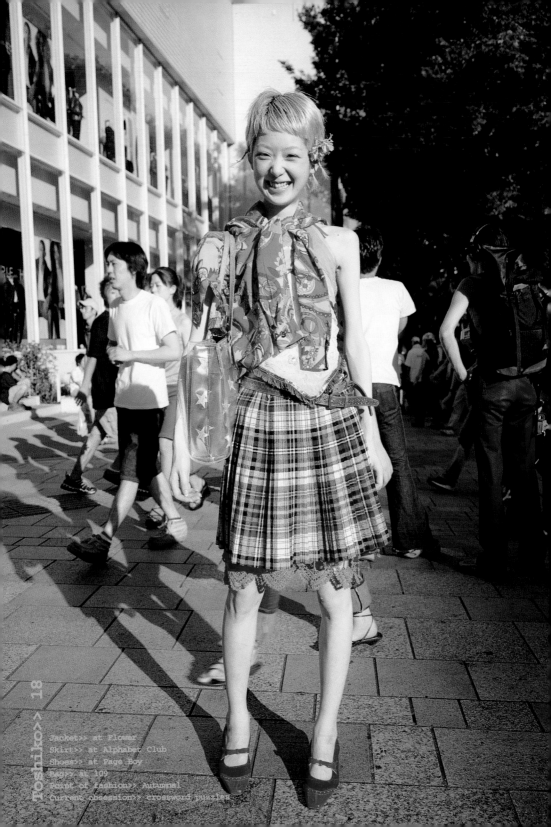

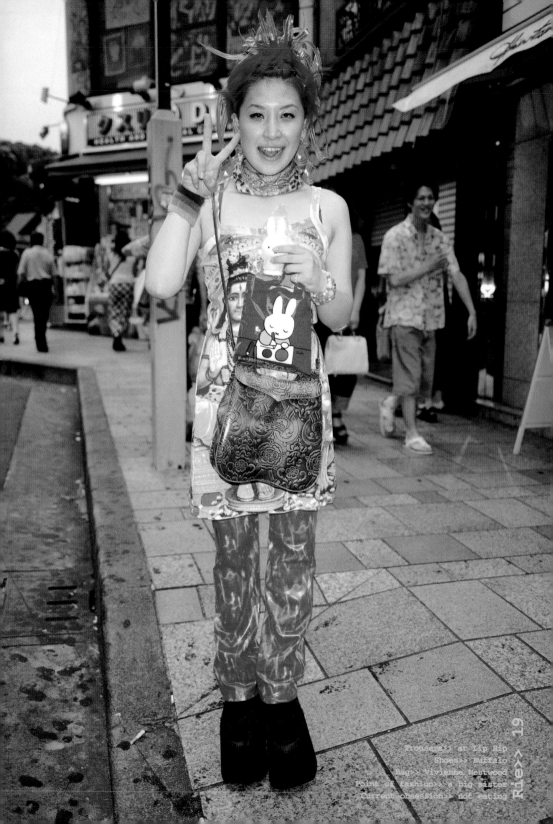

Trousers>> at Lip Rip
Shoes>> Buffalo
Bag>> Vivienne Westwood
Point of fashion>> a big sister
Current obsession>> not eating

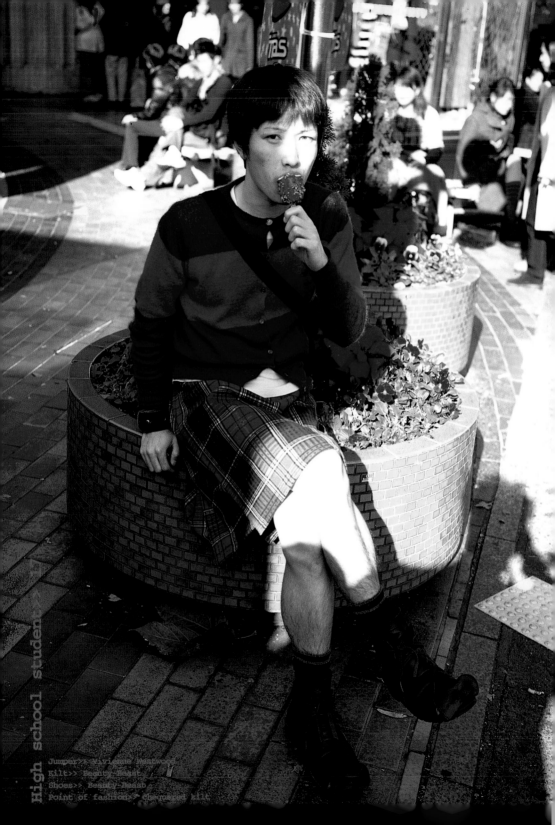

Jumper>> Vivienne Westwood
Kilt>> Beauty:Beast
Shoes>> Beauty:Beast
Point of fashion>> chequered kilt

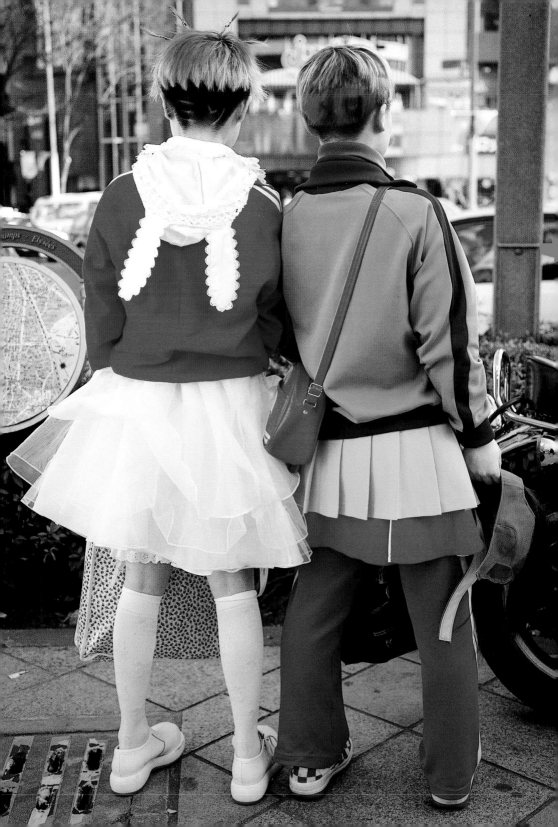

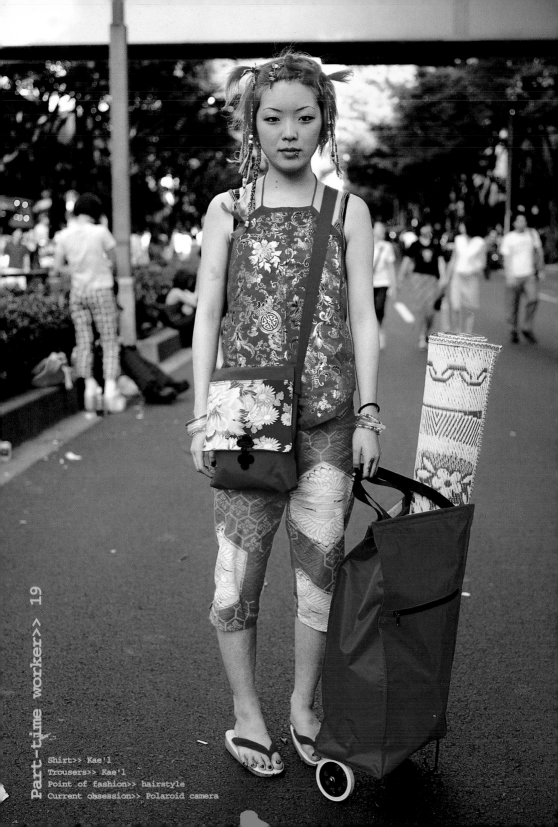

Shirt>> Kae'l
Trousers>> Kae'l
Point of fashion>> hairstyle
Current obsession>> Polaroid camera

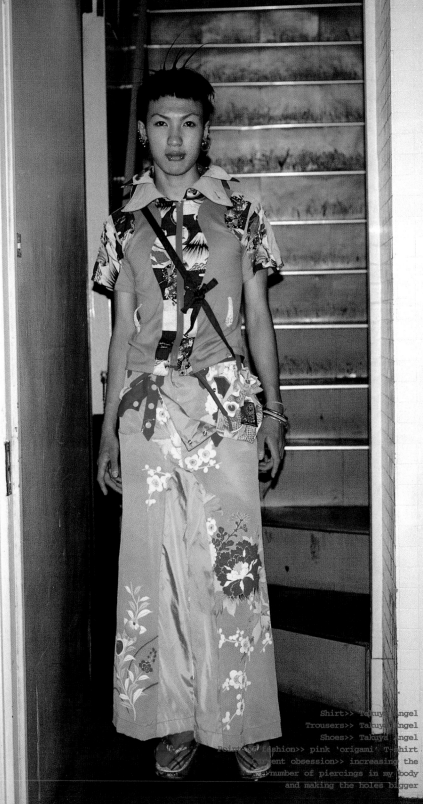

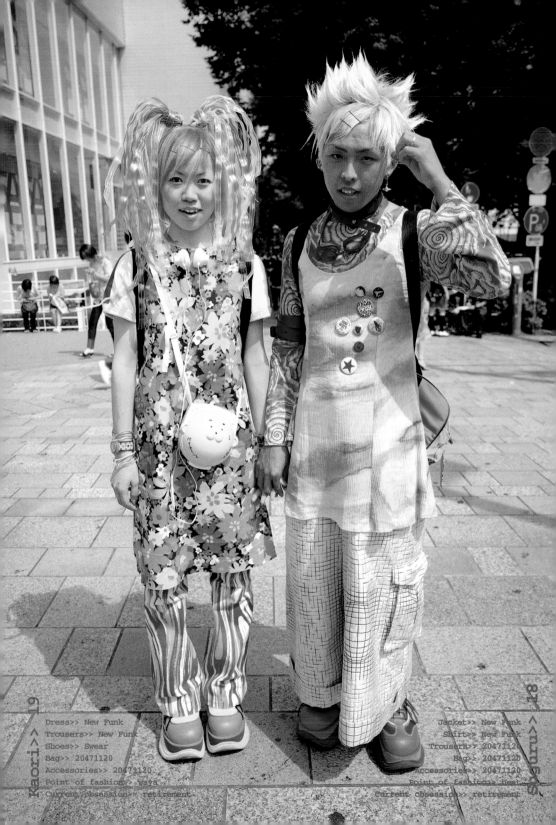

Dress>> New Funk
Trousers>> New Funk
Shoes>> Swear
Bag>> 20471120
Accessories>> 20471120
Point of fashion>> yaya
Current obsession>> retirement

Jacket>> New Funk
Shirt>> New Funk
Trousers>> 20471120
Bag>> 20471120
Accessories>> 20471120
Point of fashion>> heat
Current obsession>> retirement

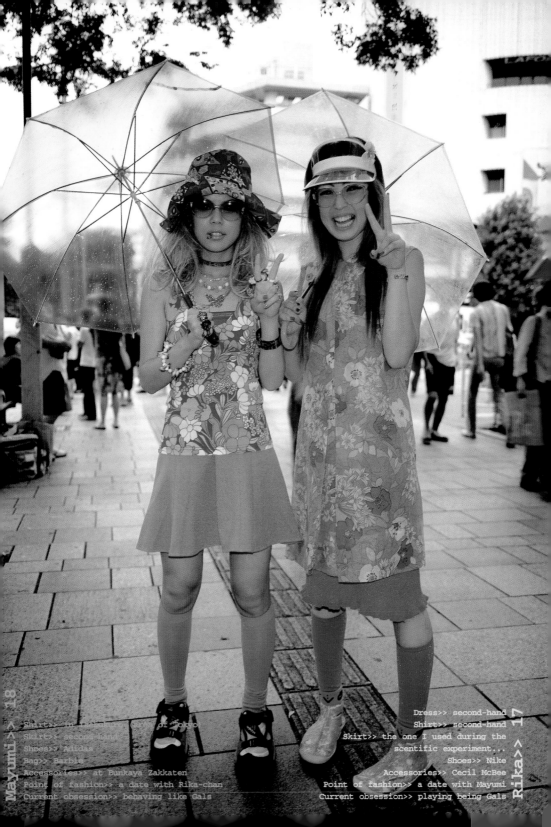

Shirt>> in the back streets of Tokyo!
Skirt>> second-hand
Shoes>> Adidas
Bag>> Barbie
Accessories>> at Bunkaya Zakkaten
Point of fashion>> a date with Rika-chan
Current obsession>> behaving like Gals

Dress>> second-hand
Shirt>> second-hand
Skirt>> the one I used during the
scientific experiment...
Shoes>> Nike
Accessories>> Cecil McBee
Point of fashion>> a date with Mayumi
Current obsession>> playing being Gals

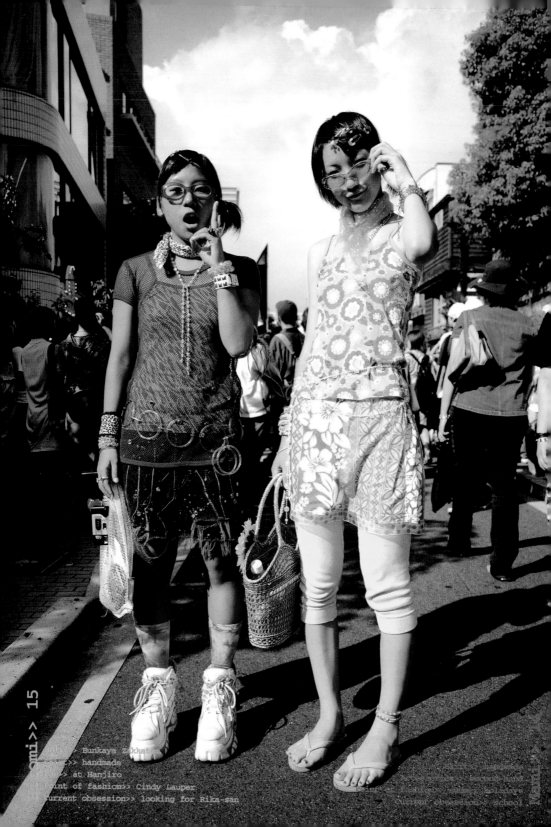

Bunkaya Zakka~
>> handmade
>> at Hanjiro
int of fashion>> Cindy Lauper
current obsession>> looking for Rika-san

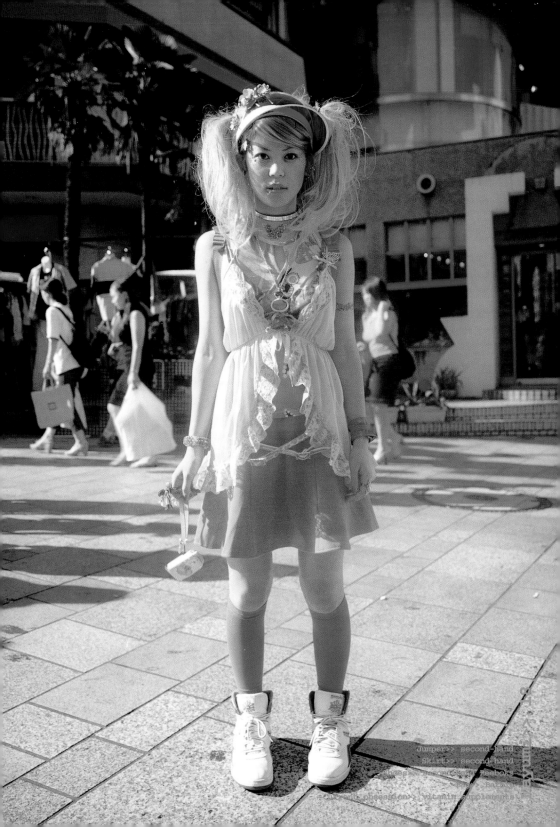

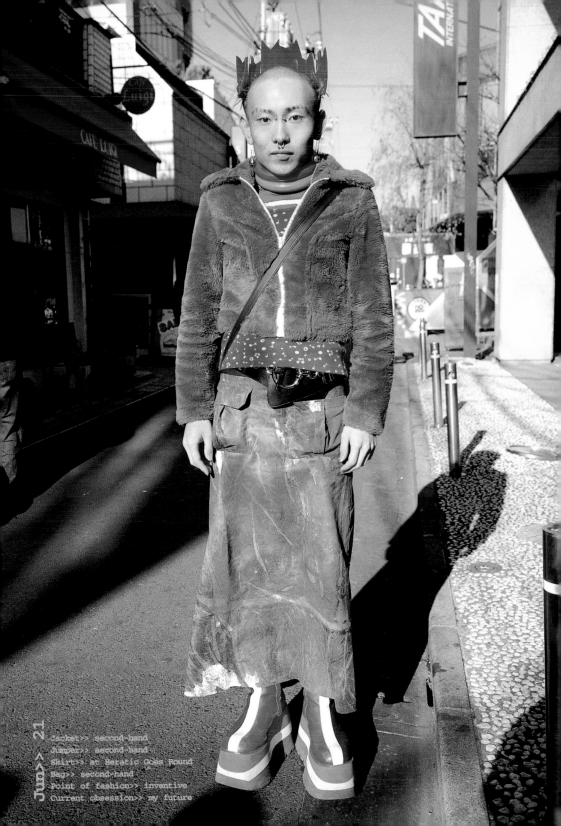

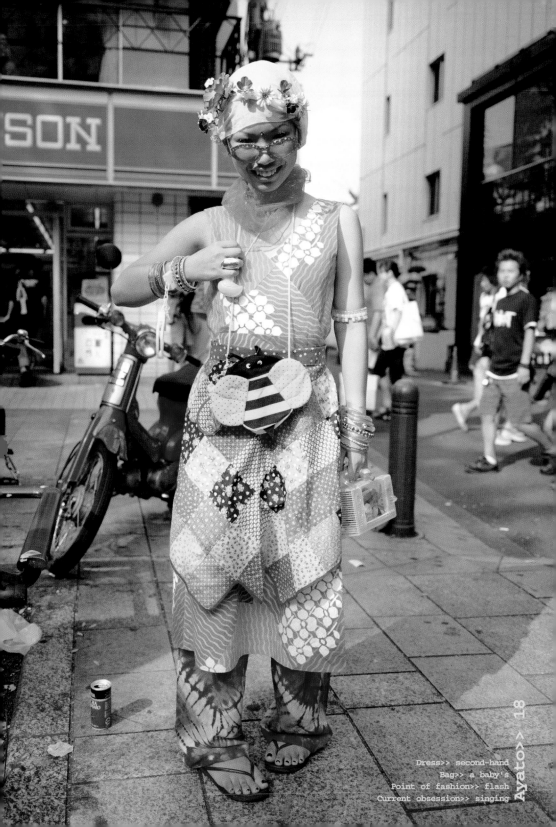

Ayato>> 18

Dress>> second-hand
Bag>> a baby's
Point of fashion>> flash
Current obsession>> singing

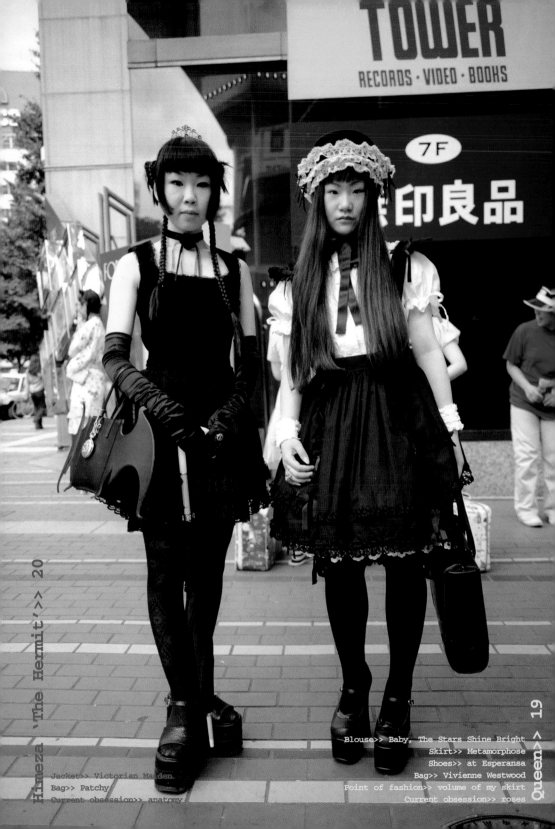

TOWER
RECORDS · VIDEO · BOOKS

7F

無印良品

Jacket>> Victorian Maiden
Bag>> Patchy
Current obsession>> anatomy

Blouse>> Baby, The Stars Shine Bright
Skirt>> Metamorphose
Shoes>> at Esperansa
Bag>> Vivienne Westwood
Point of fashion>> volume of my skirt
Current obsession>> roses

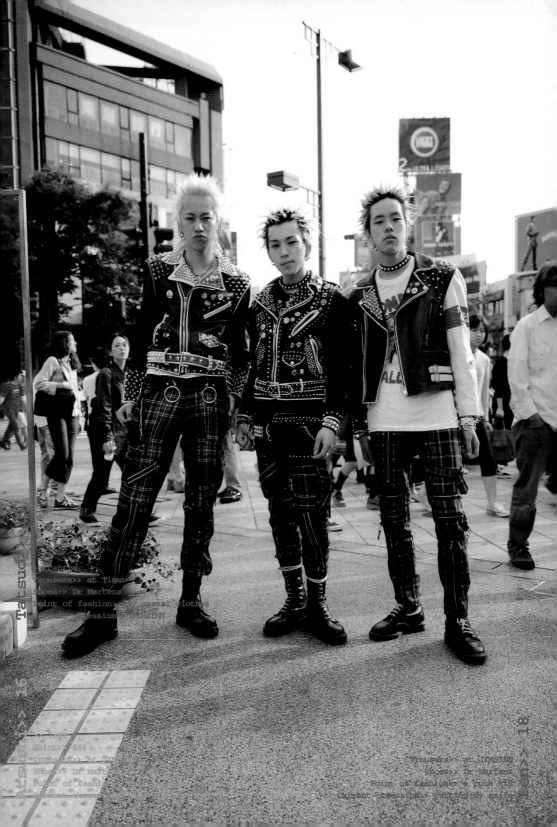

Tatsuo>>
Shirt>>
Trousers>> at Tiger
Shoes>> Dr Martens
Point of fashion>> my casual clothes
Current obsession>> JUSTINN

Shirt>> 666
Trousers>> at Ti
Shoes>> Dr Mart
Point of fashi

Trousers>> at JUNSINN
Shoes>> Dr Martens
Point of fashion>> a punk kid
Current obsession>> cutting my nail

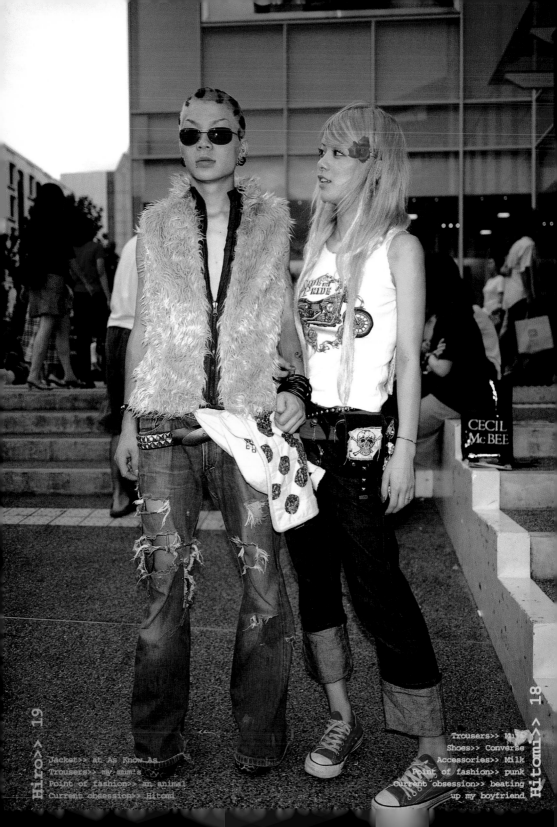

Jacket>> at As Know As
Trousers>> my mum's
Point of fashion>> an animal
Current obsession>> Hitomi

Trousers>> M...
Shoes>> Converse
Accessories>> Milk
Point of fashion>> punk
Current obsession>> beating
up my boyfriend

CECIL
McBEE

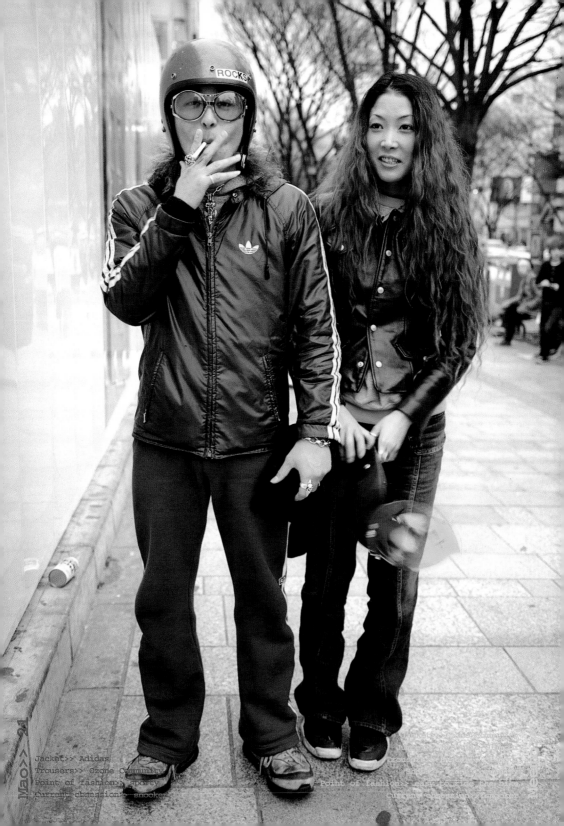

Jacket>> Adidas
Trousers>> Ozone Community
Point of fashion>> sporty
Current obsession>> snooker

Point of fashion>>
Current obsession>> snooker

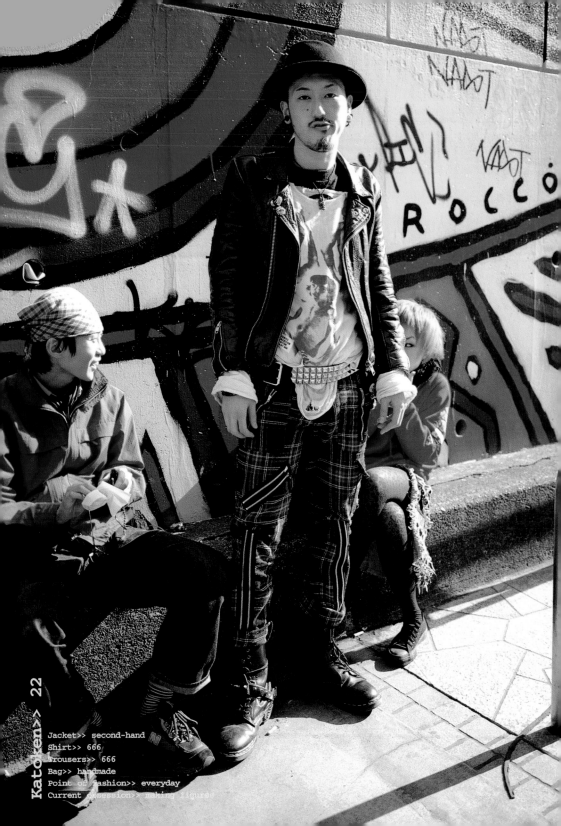

Jacket>> second-hand
Shirt>> 666
Trousers>> 666
Bag>> handmade
Point of fashion>> everyday
Current obsession>> making figures

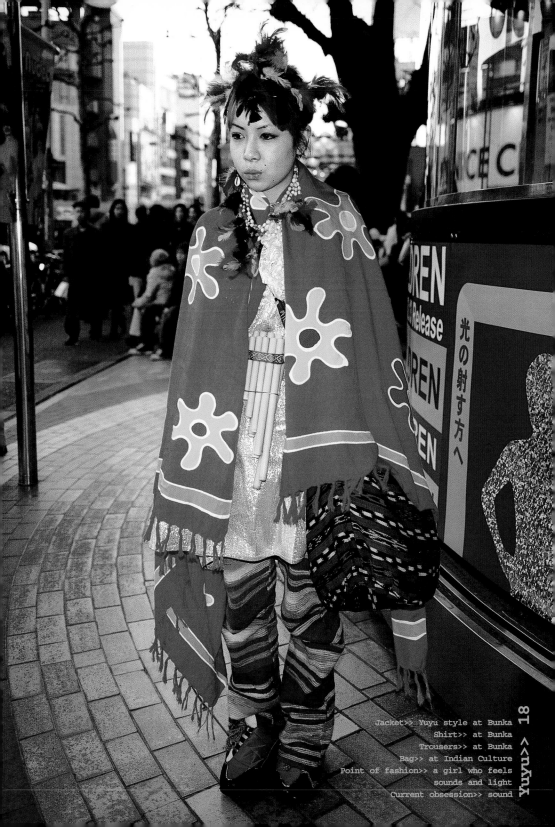

Jacket>> Yuyu style at Bunka
Shirt>> at Bunka
Trousers>> at Bunka
Bag>> at Indian Culture
Point of fashion>> a girl who feels
sounds and light
Current obsession>> sound

Yuyu>> 18

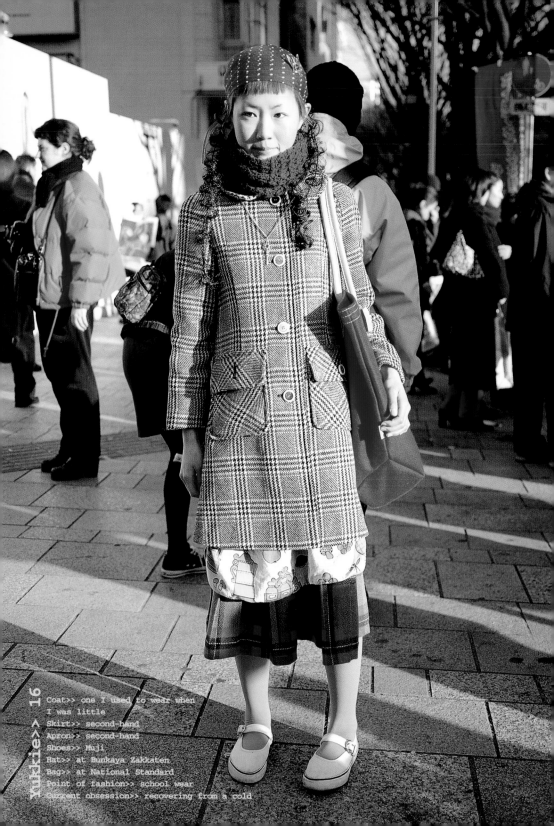

Coat>> one I used to wear when
I was little
Skirt>> second-hand
Apron>> second-hand
Shoes>> Muji
Hat>> at Bunkaya Zakkaten
Bag>> at National Standard
Point of fashion>> school wear
Current obsession>> recovering from a cold

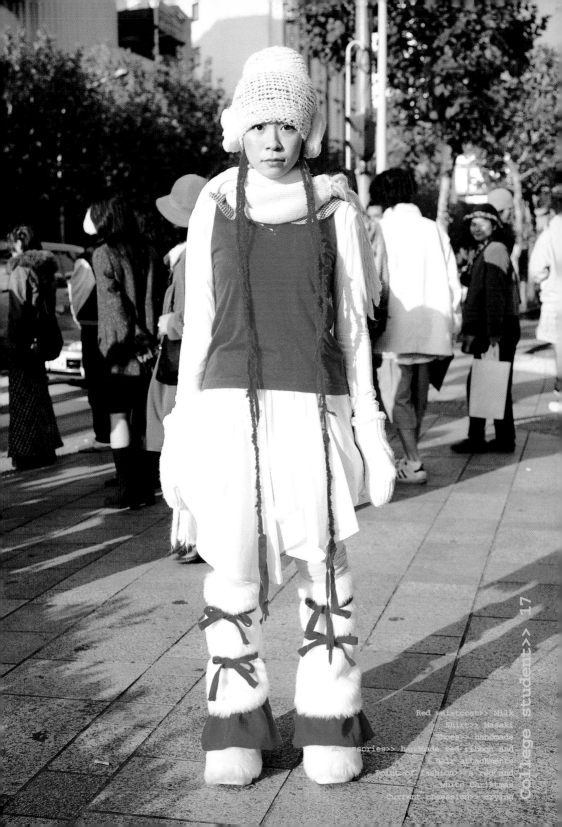

Red waistcoat>> Milk
Shirt>> Masaki
Shoes>> handmade
...sories>> handmade red ribbon and
...hair attachments
Point of fashion>> a red and
white Christmas
Current obsession>> crying

College student>> 17

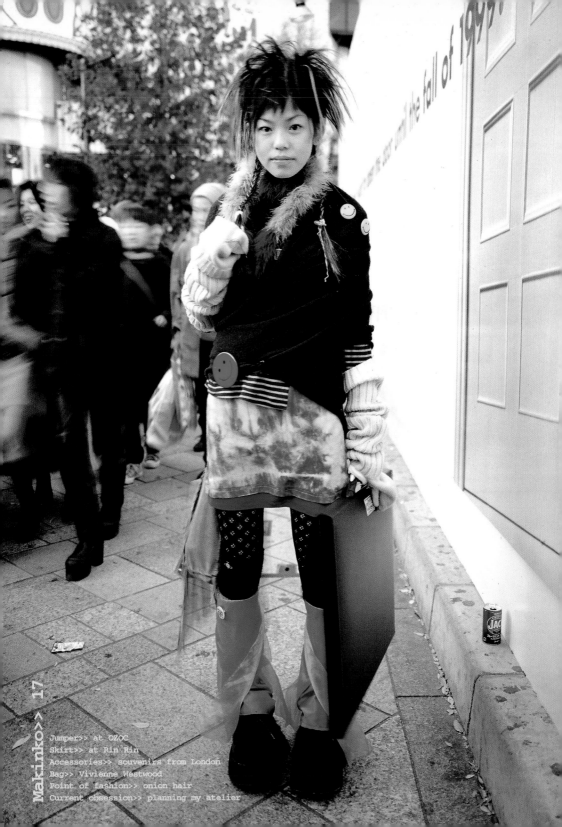

Jumper>> at OZOC
Skirt>> at Rin Rin
Accessories>> souvenirs from London
Bag>> Vivienne Westwood
Point of fashion>> onion hair
Current obsession>> planning my atelier

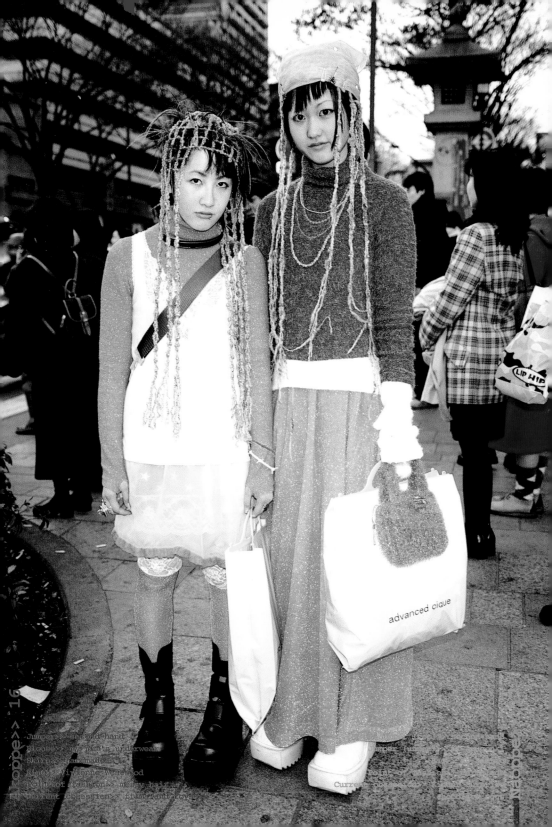

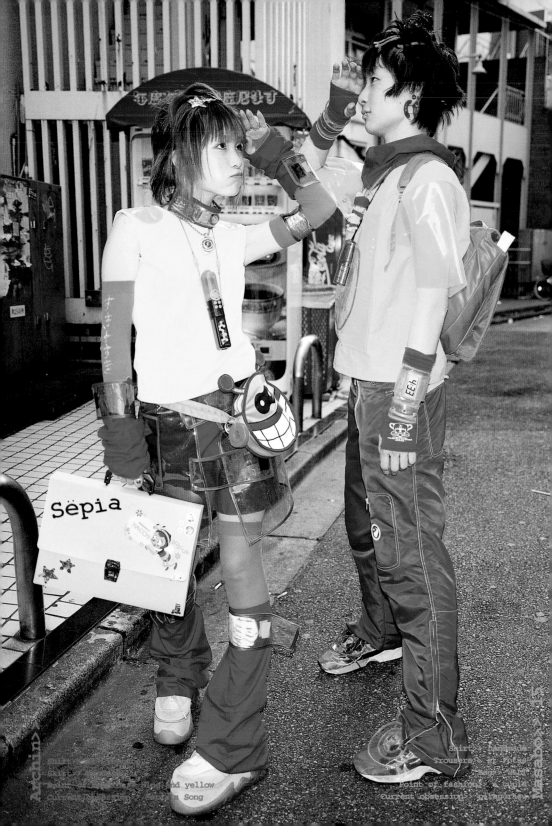

Sepia

SHIRT ...
Skirt : ...
... black, red, and yellow
Current obsession : ...s Song

Shirt : ... Inamada
Trousers : in Yote...
Bag : ...
Point of fashion : ...
Current obsession : dragon...